DESIGNING FOR THE GREATER GOOD

HarperCollins books may be purchased for educational, business, or sales promotional use.
For information, please write: Special Markets Department, HarperCollinsPublishers,
10 East 53rd Street, New York, NY 10022.

First published in 2010 by:
Collins Design
An Imprint of HarperCollinsPublishers
10 East 53rd Street
New York, NY 10022
Tel: (212) 207-7000
Fax: (212) 207-7654
collinsdesign@harpercollins.com
www.harpercollins.com

Distributed throughout the world by:
HarperCollinsPublishers
10 East 53rd Street
New York, NY 10022
Fax: (212) 207-7654

Art Direction by Peleg Top, www.pelegtop.com
and Jonathan Cleveland, www.clevelanddesign.com

Book Design and Layout by Cleveland Design, www.clevelanddesign.com

Copy Editing by Eve Bohakel Lee, www.leecopywriting.com

Library of Congress Control Number: 2009931871

ISBN: 978-0-06-17653-08

Produced by Crescent Hill Books, Louisville, KY.
www.crescenthillbooks.com

Printed in China

First Printing, 2010

DESIGNING FOR THE GREATER GOOD

THE BEST IN CAUSE-RELATED MARKETING AND NONPROFIT DESIGN

COLLINS DESIGN

An Imprint of HarperCollins Publishers

CONTENTS

FOREWORD

DAVID HESSEKIEL
PRESIDENT
CAUSE MARKETING FORUM

After nearly a decade of studying cause marketing campaigns, I know that strong design is absolutely crucial to success. A gifted design team can breathe life and power into work that might otherwise be lost in the twister of advertising messages that swirls around us from morning to night.

If the world were just and fair, the virtue of a message alone would make it stand out in the marketplace of ideas. Alas, that is not the case. Doing good is not good enough. Association with a worthwhile cause is not some sort of magical pixie dust that eliminates the need for excellent communication strategy, tactics and design.

Great design is especially crucial to cause-related work because the media budgets behind it are so often miniscule. A commercial campaign with a $100 million budget behind it can survive mediocre design. A cause-related effort relying primarily on donated media must jump off the page, handbill or screen to grab the attention of every consumer that sees it.

And yet this truth—that design is key to cause marketing success—is not universally appreciated in the nonprofit world, an arena in which marketing itself was considered a necessary evil by many not long ago. Organizations driven by consensus decision making are especially challenged to produce programs incorporating great design—anyone who has attempted art direction by committee knows how often that produces muddled work.

Designing for the Greater Good is a valuable addition to the cause marketing literature for several reasons. It is a unique showcase of campaigns that stand out from the crowd. This collection of work, often created in spite of low budgets and organizational impediments, should be an inspiration to creatives, nonprofit and corporate marketers alike.

Do not make the mistake of keeping this book to yourself. Explore its pages and mark your favorite examples. Then share your discoveries with colleagues to help them envision how much more effective your efforts could be with an investment in great design.

PELEG TOP

"Most designers and creative agencies, no matter their industry niche, will do some nonprofit or cause-related work at some stage of their career," says veteran designer Peleg Top. "This work helps us create a sense of purpose that is bigger than us. It connects us to our community, helps us leave a legacy and be part of something bigger than our own work." And he should know: Peleg has dedicated the large part of his design career to working with clients and organizations that make a difference.

A self-taught designer, Peleg Top founded Top Design from his garage at the age of 23 and grew it to be one of Los Angeles' most notable and sought after design firms specializing in cause related work. The Top Design team had a clear purpose: a mission to help organizations who do good achieve great success and effect change by providing them high-impact visual communication.

For nearly two decades, Peleg and his creative team worked with all sizes of cause-related organizations from small grass roots nonprofits to corporate giants. Some of his more prominent

clients included Toyota, The National Academy of Recording Arts and Sciences (The GRAMMY'S), Steven Spielberg's Shoah Foundation, AIDS Healthcare Foundation, City of Hope Cancer Center and Tiger Woods Foundation.

These days, Peleg brings his design experience and entrepreneurial spirit to helping other creative professionals improve their business development and marketing skills, become better leaders and live spiritually fulfilling lives.

Peleg Top's unique blend of artistic and business sense has helped him become a leader in the creative community. He is a frequent speaker at national conferences, teaches business development workshops and leads business mastermind groups.

As a curator of design excellence, Peleg is the author of *Design for Special Events* (Rockport Publishers) and *Letterhead & Logo Design* (Rockport Publishers). He is also the author of *The Designer's Guide to Marketing and Pricing* (HOW Books).

Visit **www.pelegtop.com** and say hello.

GAY MEN'S
CHORUS
OF LOS ANGELES

1

The RECORDING
ACADEMY
HONORS™

2

3

UNITARIAN
UNIVERSALIST
CHURCH

4

KADIMA
HEBREW ACADEMY
קדימה

5

$300
SAVES A LIFE
aidshealth.org

6

1

ORGANIZATION
Gay Men's Chorus of Los Angeles
CREATED BY
Peleg Top

2

ORGANIZATION
The Recording Academy
CREATED BY
Peleg Top
Rebekah Albrecht

3

ORGANIZATION
The Recording Academy
CREATED BY
Peleg Top

4

ORGANIZATION
Unitarian Universalist Church
CREATED BY
Peleg Top

5

ORGANIZATION
Kadima Hebrew Academy
CREATED BY
Peleg Top
Rebekah Albrecht

6

ORGANIZATION
AIDS Healthcare Foundation
CREATED BY
Peleg Top
Rebekah Albrecht

1

ORGANIZATION
Shoah Foundation
CREATED BY
Peleg Top

1

1
ORGANIZATION
The Recording Academy
CREATED BY
Peleg Top

1

ORGANIZATION
Spotlight Health
CREATED BY
Peleg Top
Rebekah Albrecht

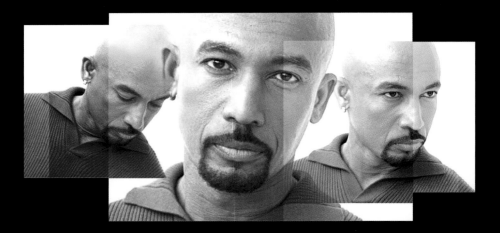

MS picked the wrong person.

"When I was diagnosed, the answers weren't easy to come by. Now they are."

Emmy Award-winning talk show host Montel Williams knows first-hand what it's like to feel excruciating pain and lose his vision and balance. But until he heard the three little words, "You have MS," he had no idea why.

Since his diagnosis with multiple sclerosis in 1999, Montel has made the commitment to find a cure for this often debilitating disease.

"MS picked the wrong person. I make my living talking and I have one of the biggest mouths on this planet. I'm going to continue flapping it until everyone knows the facts, gets the treatment they need and a cure is found."

Experience Montel's inspiring and candid story via streaming video coupled with the very latest medical information from the world's foremost MS experts – all on the most comprehensive and dynamic Web site designed to educate, support and encourage MS patients, their caregivers and loved ones.

www.spotlighthealth.com

1

2

1 • 2

ORGANIZATION
Toyota Motors, USA

CREATED BY
Peleg Top

3 • 4

ORGANIZATION
Tiger Woods Foundation

CREATED BY
Peleg Top
Rebekah Albrecht

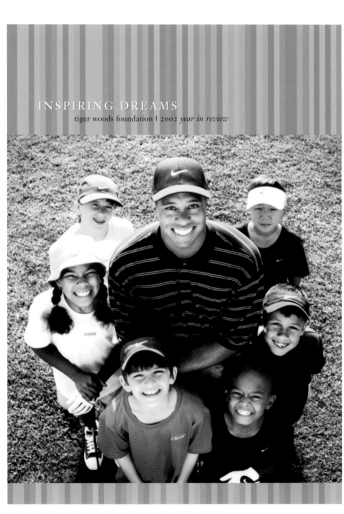

3

4

1

ORGANIZATION
Junior Blind of America

CREATED BY
Peleg Top
Rebekah Albrecht
Marcelo Coelho

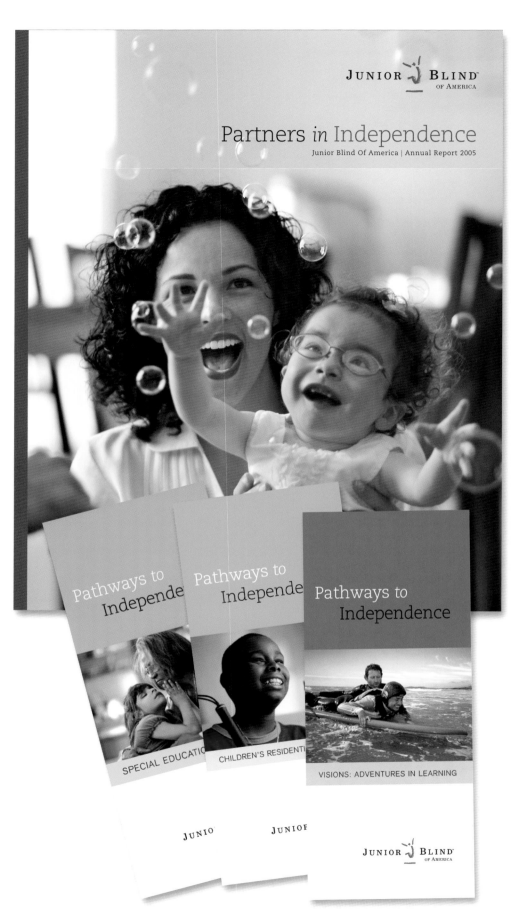

1

ORGANIZATION
MusiCares Foundation

CREATED BY
Peleg Top

1 • 2
ORGANIZATION
City of Hope
CREATED BY
Peleg Top

3 • 4 • 5
ORGANIZATION
Toyota Motors, USA
CREATED BY
Peleg Top
Rebekah Albrecht

1

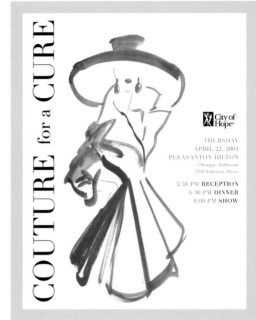

2

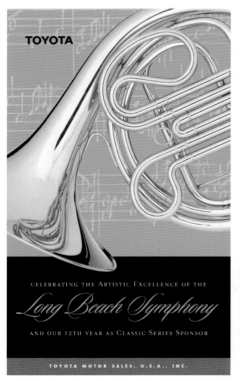

3

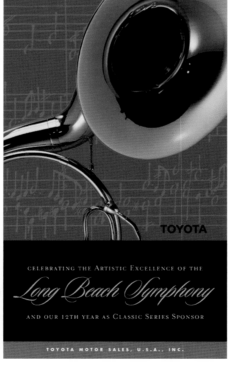

4

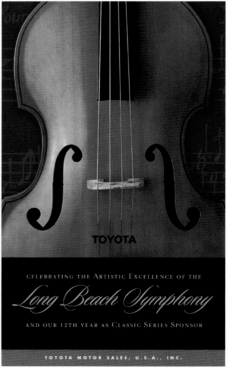

5

1

ORGANIZATION
AIDS Healthcare Foundation

CREATED BY
Peleg Top
Dorit Thies

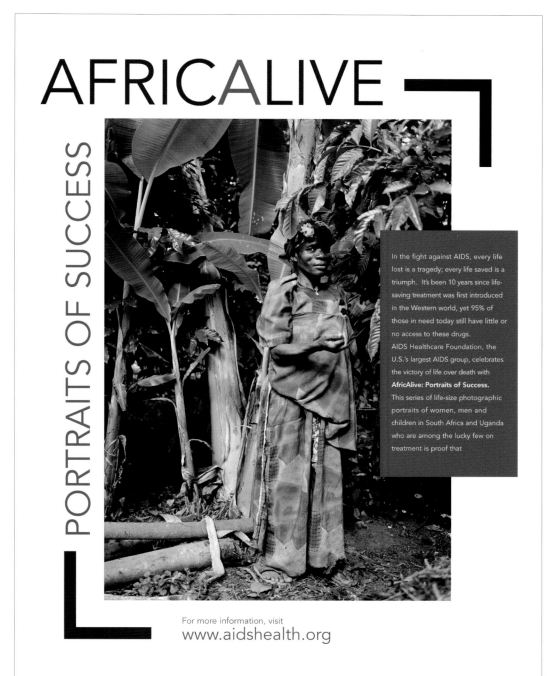

AFRICALIVE

PORTRAITS OF SUCCESS

In the fight against AIDS, every life lost is a tragedy; every life saved is a triumph. It's been 10 years since life-saving treatment was first introduced in the Western world, yet 95% of those in need today still have little or no access to these drugs. AIDS Healthcare Foundation, the U.S.'s largest AIDS group, celebrates the victory of life over death with **AfricAlive: Portraits of Success.** This series of life-size photographic portraits of women, men and children in South Africa and Uganda who are among the lucky few on treatment is proof that

For more information, visit
www.aidshealth.org

JONATHAN CLEVELAND

Every graphic designer strives to make an impact. Throughout his career, Jonathan Cleveland has also strived to make a difference.

As founder and principal of Cleveland Design, an award-winning graphic design and communications firm in Boston, Jonathan is recognized both for his creative talent and his passionate belief in the power of design to drive positive social change.

For more than two decades, Jonathan has balanced his work for commercial clients—from global corporations to small startups—with a deep personal commitment to nonprofit and cause marketing. His belief that great design springs from smart strategic planning has made him a trusted advisor for leading companies in a range of industries, as well as numerous regional nonprofit organizations.

Jonathan's work has made a difference for a wide range of organizations and causes, from promoting literacy and inspiring at-risk youth to driving support for AIDS research and education.

He doesn't keep his passion for, and commitment to, important causes to himself. With a pro bono project nearly always underway, Jonathan inspires his colleagues at Cleveland Design to share in the uniquely satisfying challenge of designing for positive change.

A member of the Cause Marketing Forum, Jonathan's work has been published in design books and recognized through national awards. Under his leadership, Cleveland Design was named one of the Top 20 Design Firms in New England by *Boston Business Journal.*

"Creating innovative design for causes is very rewarding," Jonathan says. "One project can have a tremendous impact on the lives of so many people. Knowing you've helped others is a great feeling; it keeps you coming back for more."

www.clevelanddesign.com

AMERICA'S CLASSIC 12 metre
SAILING FOUNDATION

1

EMMANUEL
EPISCOPAL CHURCH

2

Bella's Gang
Friends Helping Friends

3

1

ORGANIZATION
America's Classic 12 metre
Sailing Foundation

CREATED BY
Jonathan Cleveland
Jenny Daughters

2

ORGANIZATION
Emmanuel Episcopal Church

CREATED BY
Jonathan Cleveland

3

ORGANIZATION
Bella's Gang

CREATED BY
Jonathan Cleveland
Sharon Alama

4

ORGANIZATION
East End House

CREATED BY
Jonathan Cleveland
Jenny Daughters
Chrissy Souder

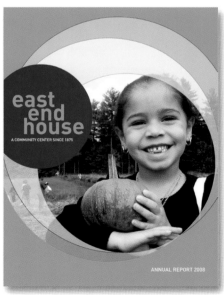

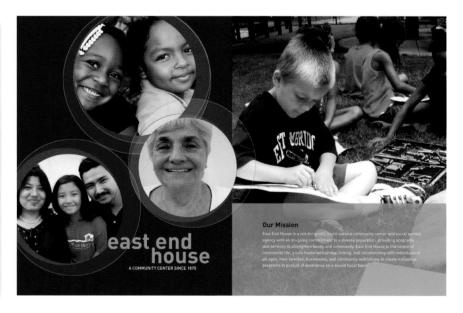

4

1

ORGANIZATION
East End House
CREATED BY
Jonathan Cleveland
Jenny Daughters

1

Our primary goal is to provide services to lower-income families and individuals of all ages and abilities. East End House encourages wide participation from all who come across our door and excludes no one. Within this framework, our goals are to:

- Serve community members of all ages with programs, services, and referrals to other agencies,
- Create opportunities and experiences for individuals and families who have been traditionally denied access due to social and economic barriers,
- Use volunteers to build a sense of community and to strengthen the capacity of the agency to address the needs of its community,
- Continuously seek innovative ways to reach out and better serve the community, and
- Maintain a highly motivated and well-trained staff.

A historical past.
A promising future.

Originally established in 1875 as one of the country's earliest settlement houses, East End House has been making a difference in the lives of children, families, and individuals living in the Greater Boston area ever since. From well-baby clinics at the turn of the century, to New Deal Programs during the Great Depression, to multilingual energy audits for lower-income families in the seventies, to the new community center facility completed in 1993, East End House has evolved with the needs of the community.

Today we are a not-for-profit, multi-service community center and social service agency committed to providing programs and services to strengthen family and community in East Cambridge, Cambridge and the Greater Boston area.

East End House is particularly unique in that we have been committed to improving the lives of community members for over 125 years. As a result of programs at East End House, parents are able to work to provide for their families, children are able to develop in a safe, nurturing, and educational environment, seniors no longer have to live in isolation, hungry families are fed, and the surrounding neighborhoods have a place to come together in the spirit of community.

Programs and Services

Child Care and School Age Programs • Adult Education • Senior Activities • Emergency Food Program • Volunteer and Community Programs • Computer Technology Center • Teen Activities • Violence Prevention Initiatives • Community Outreach and Education • Information and Referral Services • Home of Grassroots and Volunteer Community Groups

Child Care and School Age Programs

In an effort to support lower-incomes families who are struggling to make ends meet, East End House provides affordable, quality child care and school age programs, and offers financial aid and flexible payment plans. The waiting lists for East End House's Child Care and School Age Programs are dramatic indications of the need for these kinds of accessible and quality programs. The Child Care Program serves children ranging in age from 15 months to 5 years. The School Age Programs serve children ranging in age from 5 to 14 in the Afternoon Adventure Program during the school year and the Summer Fun Program, a full day program during the summer months.

programs at
East End House

Senior Activities

In 1997, East End House invited neighborhood senior residents to utilize the center as a meeting place, which gave rise to East End House's Sunrise Club. Today, seniors participate in potluck lunches, holiday celebrations, volunteer opportunities, field trips, and classes in art, exercise, computers, health and safety, and nutrition. The program allows seniors a chance to get out and meet with friends, learn new things, and give back to the community through volunteer activities.

Emergency Food Program

Each month our Emergency Food Program provides dry goods, frozen foods, and fresh produce to individuals and families who struggle to feed themselves. Through the Emergency Food Program, East End House reaches thousands of households each year. Additionally, the Thanksgiving Basket Give-Away Project provides hundreds of families with Thanksgiving baskets that includes turkeys and all the fixings.

Volunteer and Community Programs

East End House sees the Volunteer Program as a crucial way to build a sense of community, to increase the capacity of East End House programming, and to provide program participants, area residents, and area employees with a meaningful way to give back to the community. Volunteers contribute thousands of hours of volunteer service each year. Individuals, families, community members, and corporate groups volunteer at special events or on an ongoing basis. Volunteers teach classes to children, adults, and seniors on subjects ranging from cake decorating to computers to improving our facilities by planting gardens and painting classrooms. Current and former program participants come back to East End House to volunteer as a way to give back and feel connected to the agency and the community.

As a community center, East End House is fully committed to providing quality services that are effective, culturally and linguistically competent, strengths-based, developmentally appropriate, individual- and family-centered, and outcome-oriented. In order to continue to make a difference in the lives of community members, East End House has established an agency-wide quality assurance system to measure our service delivery and outcomes. Each program area develops and maintains a Quality Management Plan that effectively reviews all services, corrects problems in a timely manner, and pursues opportunities to improve services. In addition to these formalized quality management procedures, each program team gathers feedback on an informal basis and regularly incorporates this feedback into future planning.

Striving
for Perfection

To meet the needs of our everchanging community, East End House continues to expand and improve our services. Community programs have included classes in English as a Second Language, Karate, dance, computers, card making, reflexology workshops, tax preparation workshops, special events, and classes to accommodate the interests of the community.

Computer Technology Center

Armed with donated computers and software, East End House opened its computer lab in spring 2001. East End House continues to upgrade this lab as funding and donations allow, with a goal of creating an up-to-date and state of the art computer lab for people of all ages to access. East End House invites area residents of all ages to use the computers during open lab hours and to attend classes in computer applications and job-related skills.

Teen Activites

East End House recognizes the need for teen programming to creatively engage young people who have "aged out" of school age programming, but are eager for structured peer interaction. The core concept of this programming is to develop teen leadership through youth-adult partnerships, with an emphasis on community involvement and service.

1

ORGANIZATION
Harvard Divinity School

CREATED BY
Jonathan Cleveland
Logan Seale

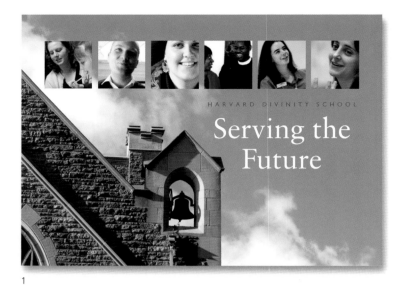

HARVARD DIVINITY SCHOOL

Serving the Future

1

"I want to tell women's positive stories about their relationship to religion."

PALWASHA LENA KAKAR

As a Muslim woman interested in contemporary "feminism" and as the daughter of an Afghan physician, Palwasha Lena Kakar, a second-year Master of Theological Studies student, had hoped to do a field placement in 2002 working with women in Afghanistan. Transforming political events intervened, but at Harvard, Polly, as she is also known, has discovered a wealth of courses and other resources that vitally connect Islam and women's issues. "The academic work has helped me develop the idea that empowerment for women can come from within Islam, and from within tribal and community structures, rather than just from Western ideas or political thought," she said. Kakar, 25, who recently chaired the student-run Islam in America conference at Harvard, grew up in Seattle and graduated from Bethel College, a Mennonite school in Kansas. Her father and her mother, an Iowa-born physician, both work for the World Health Organization in Pakistan, where she lived for a period of years. Kakar, who is married to a fellow MTS student, said she could not have come to Harvard without financial aid and that to make ends meet she has needed to work 20 hours per week in the HDS computer lab and at the financial aid office of the Education School. She hopes to go to Pakistan or Afghanistan after getting her degree, to make documentary films that will preserve the stories and memories of Muslim women. "Many people have the misconception that religion is a tool of victimization," she said. "Here at Harvard I am finding that there is also great power for women in religion."

MARK JENNINGS

"This," said Mark Jennings, indicating the interior of a Dorchester church, "is the Divinity School for me: taking the theory and making it work." Jennings is a tireless 26-year-old native of Washington, D.C., in his second year of the Master of Divinity program, and he was speaking of being a seminarian in residence at Azusa Christian Community, a church that actively addresses its neighborhood's many economic and cultural challenges. Jennings has been ordained in the Church of God in Christ, the largest black pentecostal denomination in the United States, and is pursuing faith-based social service. He has already founded Body of Christ Outreach Ministries, which empowers at-risk youth and uses service projects to strengthen unity among Christian denominations. HDS, he said, is giving him the language and the networking skills to do "what I feel God has called me to do." The School is also providing him with most of his tuition. The financial aid "made all the difference" in his decision to go to HDS, Jennings said. But with a new son, he has had to borrow elsewhere and rely on informal aid to cover living costs. Jennings's desire to help others arises partly from his own teen-age experiences in a gang and his expulsion from school, but in a period of despair, he learned to rely on God, he said. He went on to graduate from Howard University and to begin Body of Christ Outreach Ministries. At HDS, Jennings is motivated by the story of his biblical hero, Job, after whom he named his son. "What I see in Job is his faithfulness," he said. "That's what I want in my life—to be faithful to God in everything I do."

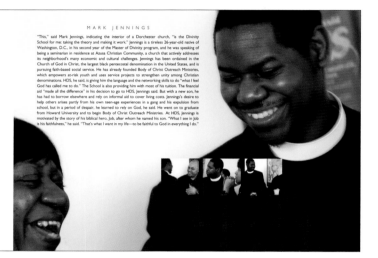

ELIZABETH HAKKEN

A lifelong Presbyterian, Elizabeth Hakken, 24, is finding fresh resources for parish ministry in Calvinist theology. Hakken, a third-year Master of Divinity student who plans to be ordained, says that her HDS experience has helped her better understand the relationship between her religious heritage and the social justice work she wants to undertake. "Harvard has enriched and challenged my faith at the same time," she said. "It's made me think more about what in my tradition will help me realize my goals. My experience has been one of becoming more Presbyterian." When an offer of financial aid made it possible for her to attend HDS, Hakken wanted to study Hebrew and had only vague thoughts of becoming a minister. But her fieldwork at Fourth Presbyterian Church in South Boston, under the guidance of its pastor, the Rev. Burns Stanfield, MDiv '88, crystallized her sense of calling. "I love Fourth Presbyterian and am looking forward to parish ministry, hopefully in an urban setting," she said. In her field placement, Hakken has preached, helped run a food pantry, and worked with teen-age girls. As a Reformed church with a historical emphasis on education, the Presbyterian Church USA requires more theological training than some other denominations. With financial aid from Harvard Hakken has received her theological training, but in a broader context. "I think being at Harvard has motivated me to learn what I bring to the Presbyterian Church while being sensitive to other faith traditions," she concluded.

JAKE MORRILL

Jake Morrill will head home to his childhood church in Tennessee to be ordained after graduation, and his path to the Unitarian Universalist ministry has been a remarkable journey. It included time in South Africa, where he created multicultural programs for township youth; success as a creative writer; playing in punk rock and bluegrass bands; and adult baptism as a Christian within Unitarian Universalism. "It is gratifying to be folding into a particular tradition," said Morrill, 30, an intern at First Parish in Cambridge who hopes to serve a parish and to work on interracial and interfaith issues. Morrill said he considered another seminary that, unlike Harvard, offered aid both for living expenses and for tuition, but even though he will amass substantial debt, he chose the Divinity School because of its focus on world religions. Before HDS, Morrill attended the prestigious Writers' Workshop at the University of Iowa, then went to study writing under the novelist J. M. Coetzee in South Africa. There he got involved in working with black youth in several townships. He explained that weekly worship at a local Methodist church gave him the strength to continue the work. "I realized that worship, rather than being removed, can speak to the needs of the world," he said. While he was prepared for the academic rigor of HDS, he says he was pleased to find a focus on pastoral and justice issues. What draws him to ministry? "Helping people do things they didn't think they could do."

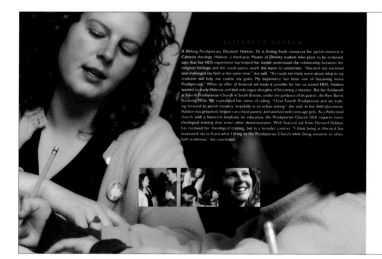

"What I love about ministry is helping people do things they didn't think they could do, teaching people to become teachers."

1 • 2

ORGANIZATION
Fenway Health

CREATED BY
Jonathan Cleveland
Jenny Goeden
Sharon Alama

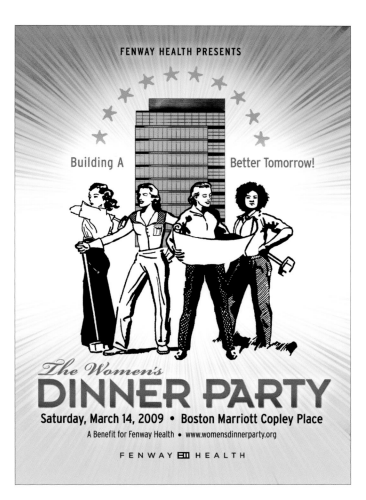

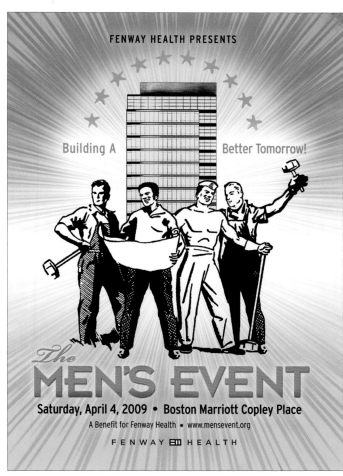

1

2

1 • 2 • 3

ORGANIZATION
Fenway Health

CREATED BY
Jonathan Cleveland
Jenny Goeden

4

ORGANIZATION
Fenway Health

CREATED BY
Jonathan Cleveland
Jenny Daughters

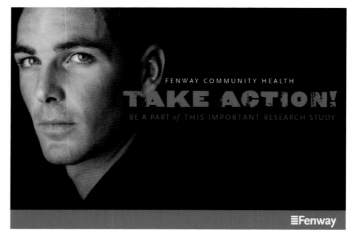

1

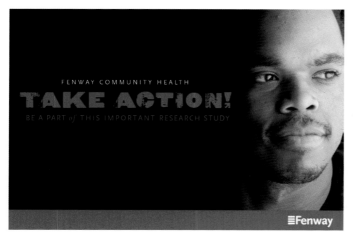

2

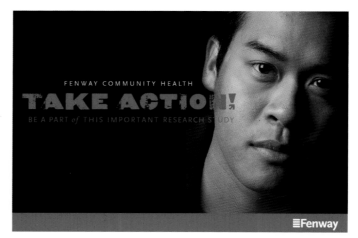

3

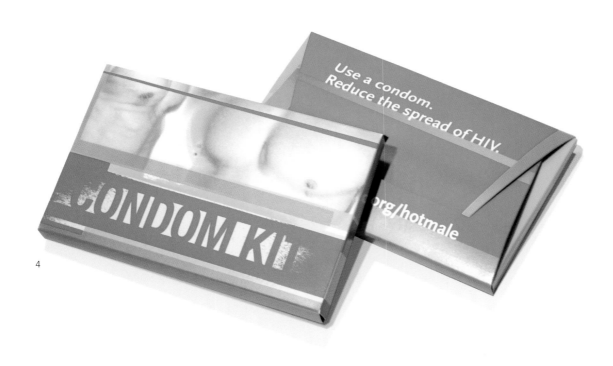

4

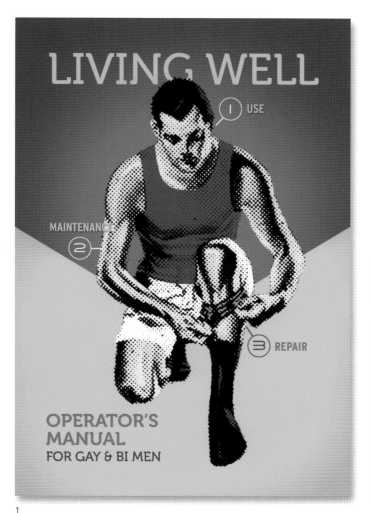

LIVING WELL

① USE

MAINTENANCE ②

③ REPAIR

OPERATOR'S MANUAL
FOR GAY & BI MEN

1

1

ORGANIZATION
Fenway Health

CREATED BY
Jonathan Cleveland
Jenny Goeden

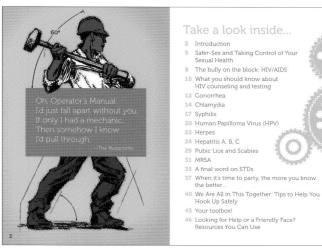

Oh, Operator's Manual
I'd just fall apart without you.
If only I had a mechanic.
Then somehow I know
I'd pull through.
—The Buzzcocks

Take a look inside...

2 3

INTRODUCTION
Welcome to Living Well!

In this Operator's Manual, you will find some keys to safer living. Our mission is to support a stronger community for gay and bisexual men by providing a safe, progressive, friendly and engaging platform to discuss and explore challenging personal and social issues.

It is ironic that something as devastating as HIV/AIDS was so instrumental in pulling the LGBT community together. Now, in a new world where we often enjoy unparalleled acceptance, new excitement awaits. As do some old problems—HIV/AIDS and STDs are still an issue, as are alcohol and substance use. And despite gains we have made as a community, social isolation and loneliness are still a problem for many.

What does the future hold? Who can say? For now, let's look at potential threats to us and our community and tackle them with knowledge and care. Together, we can help shape the world for those who follow.

In this booklet, you will find information on biological threats to our sexual health, like HIV and STDs. We'll also take an unflinching look at things like drugs, and hooking up. This booklet isn't designed to tell you what to do. It's designed to give you the information you need to make decisions that support your safety and freedom.

Remember, you are not alone and, as the metaphysical poet and English clergyman George Herbert (1593-1633) once said, "Living well is the best revenge."

4 Introduction Introduction 5

When it's time to party, the more you know the better...

From time-to-time, we all need help keeping things tuned up and running along happily and healthily.

To find a Boston-Area resource, flip to page 46 >

Some guys like to soup up their good times by using alcohol or club drugs like ecstasy and crystal meth and cocaine. While these drugs do have their attraction, they can also be very harmful, so use with care. Here are some notes about common drugs used by gay and bisexual men—more tools to help keep you safe.

Ecstasy: E, X, XTC, MDMA
Notoriously impure. The real stuff can make you lovey and swooshie and want to dance or snuggle or chat for hours. Mixing with the anti-HIV medication Ritonivir can be fatal. Don't mix with MAOIs. And don't use if you have high blood pressure or heart problems. Try not to take too much, and remember to drink about a quart of water an hour! Not enough water: bad, too much water can also over-tax your body and make you sick!

36 Party Drugs 37

1

ORGANIZATION
Reading Is Fundamental

CREATED BY
Jonathan Cleveland
Jenny Daughters
Dave Cutler

2

ORGANIZATION
Reading Is Fundamental

CREATED BY
Jonathan Cleveland
Jenny Daughters
Russell Benfanti

Reading Is Fundamental BOOK FAIR

A Storybook Adventure IN THE ARCTIC!
Sunday, November 21, 2004, 12:00-3:00pm
World Trade Center Boston

1

Reading Is Fundamental BOOK FAIR

A Storybook Adventure AMONG DINOSAURS!
Sunday, November 20, 2005, 12:00-3:00pm
Seaport World Trade Center, Boston

2

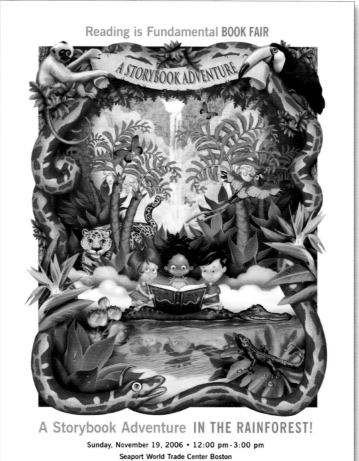

Reading is Fundamental **BOOK FAIR**

A Storybook Adventure **IN THE RAINFOREST!**

Sunday, November 19, 2006 • 12:00 pm - 3:00 pm
Seaport World Trade Center Boston

1

1
ORGANIZATION
Reading Is Fundamental
CREATED BY
Jonathan Cleveland
Jenny Daughters
Ron Berg

2
ORGANIZATION
Reading Is Fundamental
CREATED BY
Jonathan Cleveland
Jenny Daughters
Russell Benfanti

Reading is Fundamental BOOK FAIR

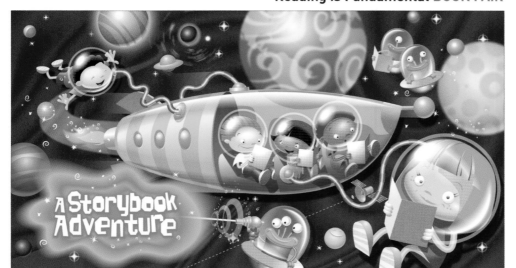

A Storybook Adventure **IN OUTERSPACE!**

Sunday, November 18, 2007, 12:00-3:00pm
Seaport World Trade Center, Boston

2

SPOTLIGHT ON
HURRICANE KATRINA POSTER PROJECT

LEIF STEINER
MOXIE SOZO DESIGN
BOULDER, COLORADO

On a clear August day in 2005, Leif Steiner glimpsed a reality very different from his Boulder, Colorado-based existence. "I was in a bank, and on a TV monitor were these scenes of devastation," he says of his introduction to Hurricane Katrina. "We're concerned about deadlines for things that will be forgotten in two weeks, and here people were dying," he says. "Disasters happen in other places. Not here."

Steiner resisted his initial urge to send cash to the relief effort, deciding to put his creativity to work. He discussed the idea of a fundraising campaign with a handful of colleagues at Moxie Sozo, and sent out a few e-mails. "Within twenty-four hours we were getting calls from all around the world," he says. "People forwarded my e-mail to their friends… Singapore, South Africa, Russia…There was no turning back."

The ensuing enterprise, The Hurricane Poster Project, served a twofold purpose: to raise money for those affected by Katrina, as well as to "provide a voice where artists and designers could comment."

And comment they did. Sales of the nearly two hundred different, limited-edition posters earned fifty thousand dollars for the Red Cross. "It was a very egalitarian system," Steiner says of the project, which accepted all comers from all corners of the globe. "There were students alongside these very famous artists." The posters—poignant, angry, bleak, optimistic and ever political—represent, in Steiner's words, "an unedited reflection of the design world commenting on the disaster situation."

Despite their fragile nature as works on paper, the Hurricane Poster Project is not gone with the wind. The Library of Congress requested—and received—a complete set of images inspired by that terrible day. "One hundred years from now," says Steiner, "these posters will still be around. They're part of the visual record."

1

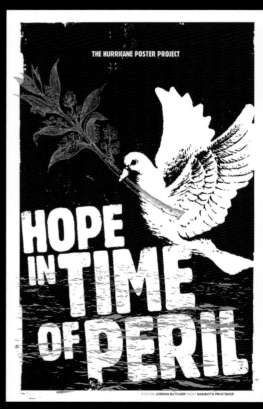

4

2

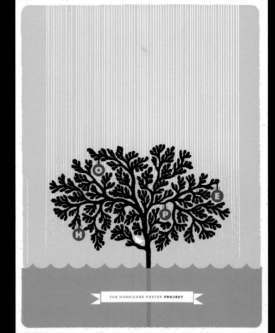

3

1
CREATED BY
Lanny Sommese
Port Matilda, PA

2
CREATED BY
Michael Erazo-Kase
Mutt Ink
Philadelphia, PA

3
CREATED BY
Don Clark
Asterik Studio
Seattle, WA

4
CREATED BY
Jordan Butcher
Squad Studio
Seattle, WA

5
CREATED BY
Jeff Boyes
Visual Technicians
Pitt Meadows, Cana

6
CREATED BY
Richard Boynton
Wink
Minneapolis, MN

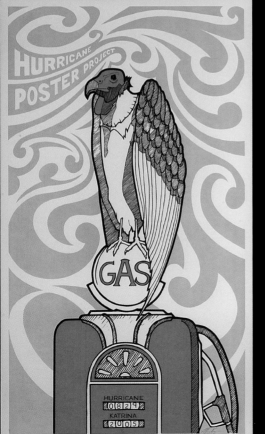

6

1

ORGANIZATION
AmeriCares

CREATED BY
Dwayne Flinchum, Lori Ende

IridiumGroup
New York, NY

Annual Report 2005

AmeriCares®
HUMANITARIAN LIFELINE TO THE WORLD

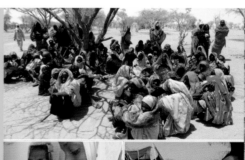

1

HAITI
Political Unrest

In February 2004, violence and civil unrest cut off food and medical supplies to hundreds of thousands of civilians trapped in rebel occupied areas in Haiti. Already facing a serious humanitarian crisis, the country was pushed to the brink.

As President Jean-Bertrand Aristide fled the country, AmeriCares deployed its emergency response team to Port-au-Prince to receive and distribute emergency aid valued at $1.1 million. The airlift carried more than 42,000 pounds of antibiotics, iron supplements, vitamins and medical equipment for the regions hardest hit by the fighting.

HAITI/DOMINICAN REPUBLIC
Flood Relief

After disastrous spring flooding caused deadly mudslides in Haiti and the Dominican Republic, killing and stranding thousands, AmeriCares responded within hours.

Working closely in the Dominican Republic with our partner, the Sovereign Military Order of Malta, AmeriCares swiftly provided shipments of medicines and supplies for clinics and hospitals. Our emergency team braved impassable roads and delivered aid via helicopter to villagers left stranded by the treacherous floods.

CHAD/SUDAN
A People in Crisis

In the past year, more than one million people have been driven from their homes by a brutal civil war in the Darfur region of Sudan. In the early months of 2004, the conflict intensified and nearly 180,000 Sudanese refugees fled across the border into Chad, only to be faced with life-threatening famine and diseases such as cholera and dysentery.

Responding quickly, AmeriCares sent an emergency response team to determine the immediate needs and ensure that supplies would be well positioned in advance of the area's annual rainy season. The lack of clean drinking water was one critical issue, with refugees forced to drink unsafe water due to the searing desert heat.

AmeriCares mobilized 27 tons of relief supplies worth more than $3 million, including enough water purification packets to treat a total of 10,000,000 liters of water. Medicines and supplies were sent to combat the widespread malnutrition, diarrhea and malaria, along with other essential drugs, IV fluids and additional provisions.

"For months we have been racing to address the most urgent medical needs and prevent deaths from disease and malnutrition," said Celina de Sola, AmeriCares' director of emergency response. "With the rainy season posing challenges in the delivery of aid, and disease outbreaks threatening thousands of lives, our work to assist the Sudanese people is only beginning."

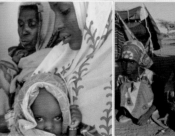

1

2

3

CFGC

4

5

6

1

ORGANIZATION
Homeless Emergency Project

CREATED BY
David Scott

Cosmic
St. Petersburg, FL

2

ORGANIZATION
Xylem Family Resource

CREATED BY
Matt Rhodes

Fox Fire Creative
Highlands Ranch, CO

3

ORGANIZATION
The Gay Lesbian Center in
Long Beach, CA

CREATED BY
Marc Posch

Marc Posch Design, Inc
Long Beach, CA

4

ORGANIZATION
Community Foundation of
Greater Chattanooga

CREATED BY
Brian May, Chris Enter,
Monty Wyne, Glen Austin

Maycreate Idea Group
Chattanooga, TN

5

ORGANIZATION
C.N.G.E.I. Corpo Nazionale Giovani
Esploratori Italiani

CREATED BY
Cristiano Andreani

zerokw
Pesaro, Italy

6

ORGANIZATION
Young Entrepreneurs Organization

CREATED BY
William Brohard

Brohard Design Inc.
Purcellville, Virginia

1

ORGANIZATION
Wonder of Reading
CREATED BY
Kim Baer, Allison Bloss
KBDA
Santa Monica, CA

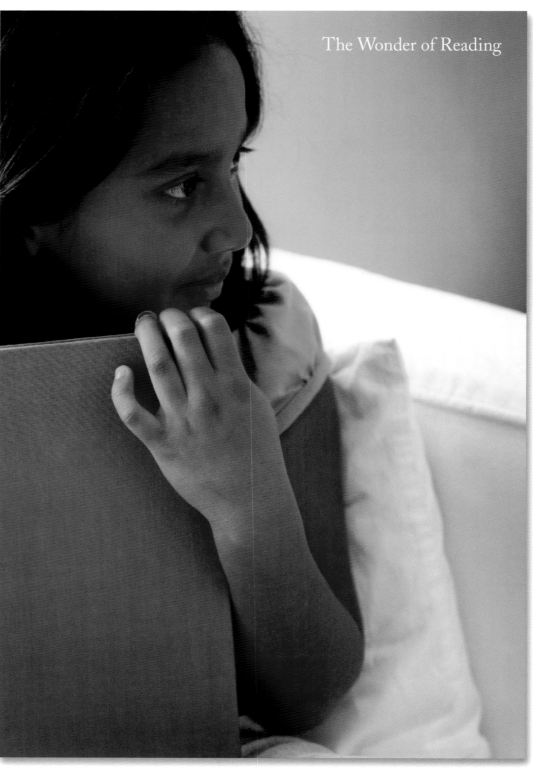

1

← Jaciel

As a student learning English, Jaciel was struggling in school until he was matched with reading partner Mark Glasser. Mark supported Jaciel, eventually suggesting he enter The Wonder of Reading's Fourth and Fifth Grade Essay Contest. The announcement that his essay, a moving story about his immigration experience, was selected as one of the contest winners has not only inspired Jaciel to become a writer, but also encouraged his family to remain in America despite the challenges they faced.

During his summer vacations, Jaciel continues his weekly reading sessions with Mark. "The program doesn't go beyond grammar school, but we'll still keep in touch," Mark confirms.

Jaciel's favorite book is the thesaurus, and he keeps a daily journal in which he composes original science fiction stories. "Sometimes I send my stories to people," he says, referring to his extended family and friends.

Jaciel is now the best English speaker in the family. "My dad takes me to work...so I can help him translate the menus into Spanish." When he grows up, Jaciel wants to be a teacher or a scientist.

At The Wonder of Reading, a not-for-profit organization, we work to inspire in children the love of reading.

Our passion is to help young students enjoy books and encourage them to explore their interests through reading. Our mission is to have a significant impact on reading in Southern California public elementary schools.

OUR TRACK RECORD

- The Wonder of Reading has grown since its inception in 1994 to become the largest children's literacy organization in Los Angeles.

- Through our highly successful 3R Program (Renovate, Restock, and Read), we expand and renovate public elementary school libraries, work with schools to purchase new library books, and train volunteers to read one-on-one with struggling students throughout Southern California.

- We have renovated more than one-third of the public elementary school libraries in the Los Angeles Unified School District (LAUSD), the nation's second-largest school system.

- We have provided elementary school libraries with more than $1.7 million worth of new books and have trained more than 4,600 volunteers to read one-on-one with students on a weekly basis.

- The Wonder of Reading has reached more than 260,000 students and their families, and its innovative library design serves as the model for all new libraries constructed by the LAUSD.

← Daycis

Now in third grade, Daycis was a struggling first-grade reader when she was chosen for the lead in a school play. With the help of her first-grade teacher, she learned her lines. Through this exciting acting opportunity, Daycis became passionate about reading. "It was kind of hard to learn the lines, but it was fun also. After the play, I started to read more and more and more."

Daycis loves the library. When she heard that Langdon Elementary School would receive a Wonder of Reading library, she resolved to make a contribution. Every day for a month, Daycis, with the help of her little brother, diligently collected assorted coins left on the floor of the Laundromat where her mother works. During the library grand opening ceremony, Daycis surprised everyone when she marched up and personally presented the school principal with a crisp $100 bill.

"The library is a wonderful place!" she says. "When I grow up, I want to be a librarian!"

"The Wonder of Reading has met community goals by refurbishing the library and bringing new hope for the community's educational system. The Wonder of Reading works hand-in-hand with neighborhood communities, establishing an ongoing partnership."*

EMPOWERING ENTIRE SCHOOL COMMUNITIES

To implement our 3R Program, The Wonder of Reading partners with schools that demonstrate an abiding commitment to literacy, effectively engage their communities, and are determined to make the library central to all aspects of the school's curriculum.

We are dedicated to making substantial, long-term advances that go well beyond the school library. Before the renovation of each library, the school's principals, teachers, superintendents, students, parents, and volunteers; local businesses; and civic organizations must commit to work together to improve young students' abilities and eagerness to read. Such community building is the foundation of a dynamic and durable partnership between each school and its local supporters—one that often leads to additional school initiatives and further community improvements.

*Eric Garcetti, Los Angeles City Council President

SPOTLIGHT ON
TRAK
CAMPAIGN

KERRY STRATFORD
LINDA COHEN
THE CALIBER GROUP
TUCSON, ARIZONA

Ad people are accustomed to deadlines, but Kerry Stratford's team effort for the Therapeutic Ranch for Animals and Kids (TRAK) may be a record. "A local Ad Fed [competition] gave us twenty-four hours to create a campaign for a nonprofit," says the principal of CALIBER Group in Tucson. CALIBER's assignment was something of a mystery. "We hadn't heard of TRAK, even though it was on a very populated street we'd driven by," she says.

Starting at nine A.M., Stratford's team visited TRAK to see the animals and meet the director, Jill—the beginning of a process that typically would have taken several weeks. After a brainstorming session, the team created the campaign and finished at eight P.M.

The organization's new tagline, "Strengthening kids & community through animal interaction," explains their mission: "TRAK takes troubled or disabled kids out to nursing homes so people there can interact with animals," Stratford says. "Kids come to the ranch, learn respect for animals and responsibility for another life." CALIBER created—in eleven hours, mind you—a billboard, logo, two posters, a Web homepage, a brochure cover, a monument sign, a banner and t-shirts. "It was a learning experience to help our team work better."

Vendors donated many of the materials, such as posters, brochures and the sign, and the local newspaper ran a full-color ad. "We tried to use some of our relationships to help," Stratford says. "Our goal was to increase memberships; the director isn't even paying herself and is barely meeting expenses." The campaign unveiling at an Ad Fed luncheon was similarly rewarding to the CALIBER crew. "Client interaction is a huge part of the process, and we didn't have a lot of time for that," says Stratford. "The first time [the client] saw it was at the luncheon. She was in tears."

• • •

CREATED BY
Linda Cohen, Kerry Stratford, Dave Goldsmith, Alex Parisi, Jodie Lerch, Dana Murray, Jennifer Sterba, Maria Delvecchio

STRENGTHENING KIDS & COMMUNITY THROUGH ANIMAL INTERACTION

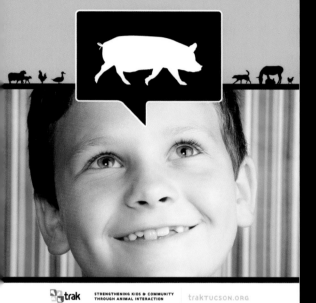

MORE THAN A PLACE TO
HORSE AROUND

Experience trak, a real ranch focused on strengthening kids and community through interaction with our animals. A nonprofit organization, trak offers kids the chance to build self esteem and respect in a fun environment. Support our efforts: take a class, learn how to ride a horse or celebrate your next birthday with us!

For more information go to trakTUCSON.ORG or call (520) 298-9808

trak STRENGTHENING KIDS & COMMUNITY THROUGH ANIMAL INTERACTION | trakTUCSON.ORG

IT'S OKAY TO
QUACK UP

Experience trak, a real ranch focused on strengthening kids and community through interaction with our animals. A nonprofit organization, trak offers kids the chance to build self esteem and respect in a fun environment. Support our efforts: take a class, learn how to ride a horse or celebrate your next birthday with us!

For more information go to trakTUCSON.ORG or call (520) 298-9808

trak STRENGTHENING KIDS & COMMUNITY THROUGH ANIMAL INTERACTION | trakTUCSON.ORG

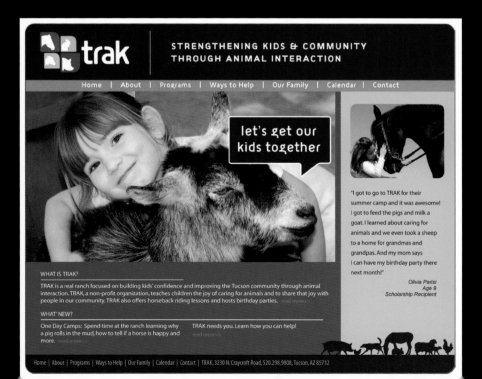

trak STRENGTHENING KIDS & COMMUNITY THROUGH ANIMAL INTERACTION

Home | About | Programs | Ways to Help | Our Family | Calendar | Contact

let's get our kids together

"I got to go to TRAK for their summer camp and it was awesome! I got to feed the pigs and milk a goat. I learned about caring for animals and we even took a sheep to a home for grandmas and grandpas. And my mom says I can have my birthday party there next month!"

Olivia Parisi
Age 9
Scholarship Recipient

WHAT IS TRAK?
TRAK is a real ranch focused on building kids' confidence and improving the Tucson community through animal interaction. TRAK, a non-profit organization, teaches children the joy of caring for animals and to share that joy with people in our community. TRAK also offers horseback riding lessons and hosts birthday parties. read more>>

WHAT' NEW?
One Day Camps: Spend time at the ranch learning why a pig rolls in the mud, how to tell if a horse is happy and more. read more>>

TRAK needs you. Learn how you can help! read more>>

Home | About | Programs | Ways to Help | Our Family | Calendar | Contact | TRAK, 3230 N. Craycroft Road, 520.298.9808, Tucson, AZ 85712

1

ORGANIZATION
Denver Public Schools / Janus
Mutual Funds

CREATED BY
Gaby Brink, Nate Williams, Jeff Iorillo

Tomorrow Partners
Berkeley, CA

2

ORGANIZATION
Central Okanagan Foundation

CREATED BY
Phred Martin

Splash:Design
Kelowna, Canada

3

ORGANIZATION
Community Action Team, Long Beach

CREATED BY
Marc Posch

Marc Posch Design, Inc
Long Beach, CA

4

ORGANIZATION
Chinatown Community
Development Center

CREATED BY
Shardul Kiri, Ann Jordan

UNIT design collective
San Francisco, CA

5

ORGANIZATION
OneChild.org

CREATED BY
David Garcia

Dodos Design
Santa Paula, CA

1

2

GRUNION RUN
LONG BEACH
WWW.GRUNIONRUN.COM

3

Chinatown Community
Development Center

4

Ch1ld.org

5

1

ORGANIZATION
Massachusetts State Science
& Engineering Fair

CREATED BY
Lauren Capers

Capers Design
Middleboro, MA

1

1

ORGANIZATION
Angel Society

CREATED BY
Joshua Murphy
element3media
Phoenix, AZ

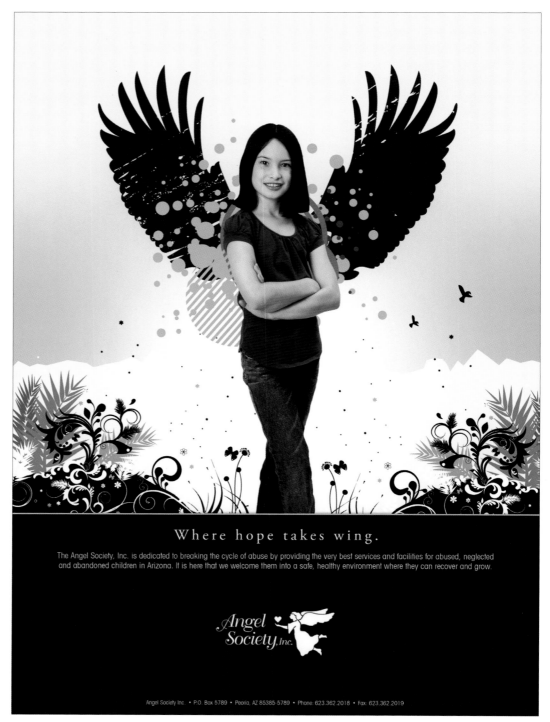

1

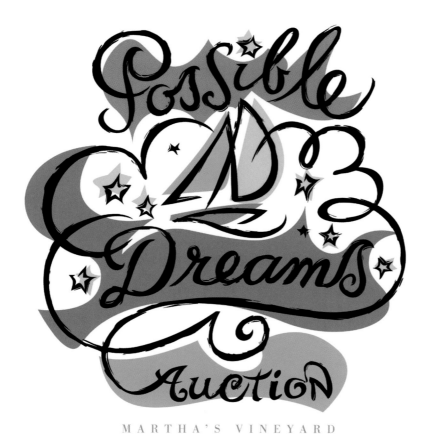

MARTHA'S VINEYARD

1

1

ORGANIZATION
Possible Dreams

CREATED BY
Kathleen Forsythe, Tracy Sabin

Sabingrafik, Inc.
Carlsbad, CA

2

ORGANIZATION
California Association for Micro
Enterprise Opportunity (CAMEO)

CREATED BY
Candice Kollar

Kollar Design | EcoCreative®
San Francisco, CA

3

ORGANIZATION
Cala/Krill Design

CREATED BY
Alyssa Lang, Ronald J. Cala II

Little Utopia, Inc.
Los Angeles, CA

4

ORGANIZATION
Sound Foundation

CREATED BY
Shardul Kiri, Ann Jordan,
Larry Neverkovec

UNIT design collective
San Francisco, CA

California Association for
Micro Enterprise Opportunity

2

3

4

GET LONDON READING

NOEL LYONS
KENTLYONS
LONDON, UNITED KINGDOM

London literature is more than Shakespeare's Globe and Harry Potter's Platform 9-3/4—in fact, residents don't have to travel far to find a familiar setting for a new favorite book. For the Book Trust program Get London Reading, Noel Lyons of KentLyons created a way to help words meet passerby halfway. He created a Google map with which users could find truly local books and review their own titles. Lyons cites his East London office. "Our road is referenced in *Oliver Twist*!" he says. "Yes, it was a hundred and forty years ago and it's fiction anyway, but it's a thing you can see, Bill Sikes running off to the Thames."

Along with the online map, Lyons brought home the notion that "there are stories in books and stories in buildings" in a most literal way. (The logo evokes both buildings and a bookshelf.) "We wanted to get the man and woman on the street interested in literature on their journey to work and where they live," he says, "so we took quotes from books and put them in situ so people could see them, then go to the Web site and see how the two could work together." Dozens of installations went up—and down—around the city, including quotes stenciled on curbs with water-based paint. "We liked the transience of it," Lyons says. "See it, be struck by it, then it's gone the next day."

In meeting the sole goal of getting people to read more books, KentLyons stenciled a quote from Brick Lane by Monica Ali in the Brick Lane area, and vinyl lines from Susanna Clarke's *Jonathan Strange & Mr Norrell* on a Soho Square window—then stepped back to observe. "It was great," Lyons says. "Immediately people stopped to read this excerpt that spoke about their area."

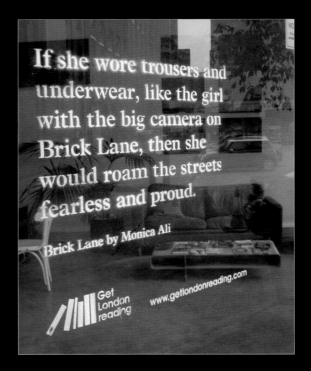

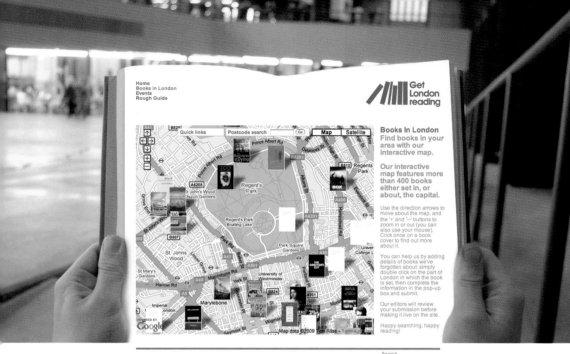

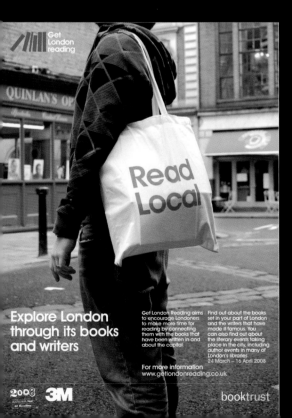
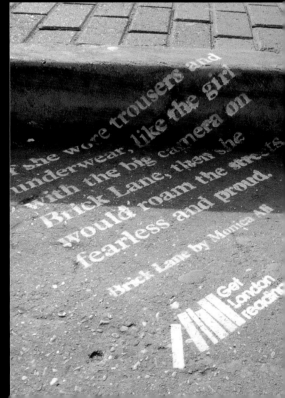

1

ORGANIZATION
JobsFirst NYC

CREATED BY
Peter Levinson, Mistina Picciano,
Steve May

LevinsonBlock LLC
Brooklyn, NY

2

ORGANIZATION
Beaverdale Main Street Initiative

CREATED BY
John Sayles

Sayles Graphic Design
Des Moines, IA

3

ORGANIZATION
Arlin M. Adams Center for Law and
Society, Susquehanna University

CREATED BY
Nicholas Stephenson

Susquehanna University
Selinsgrove, PA

1

2

3

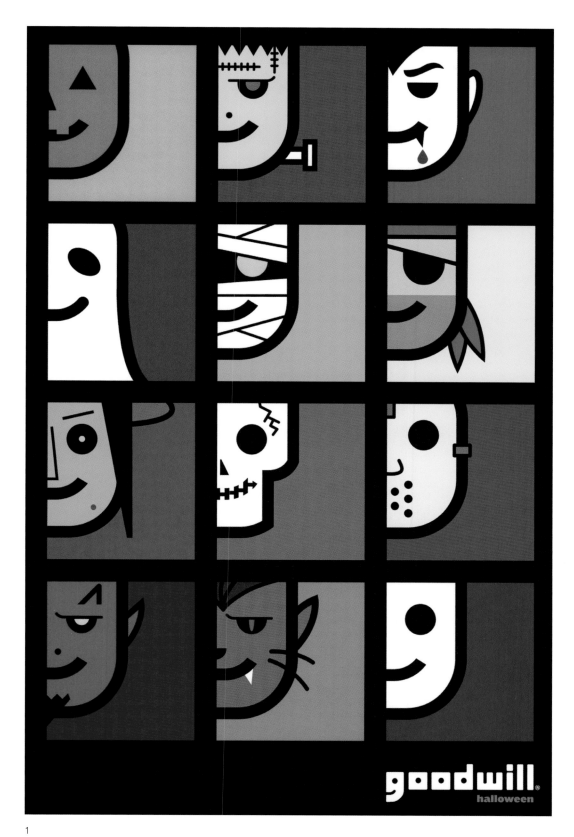

1
ORGANIZATION
Goodwill Southern California
CREATED BY
Renee Miller, Greg Collins,
Shin Kawase, Andy Mueller

The Miller Group
Los Angeles, CA

1 • 2 • 3

ORGANIZATION
United Way

CREATED BY
Alan Russell, Daryl Gardiner,
Kevin Rathgeber, Frank Hoedl

DDB Canada
Vancouver B.C., Canada

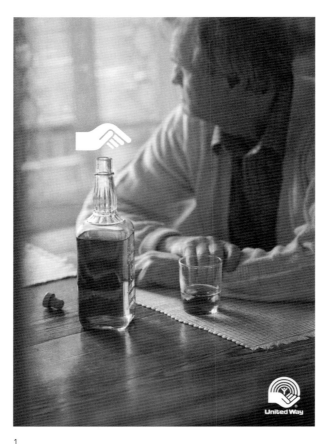

1

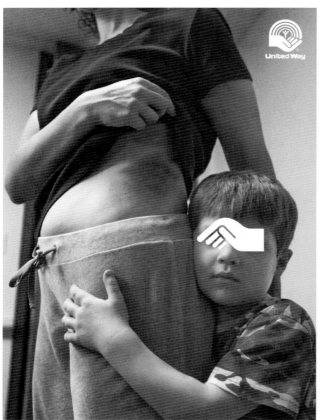

2

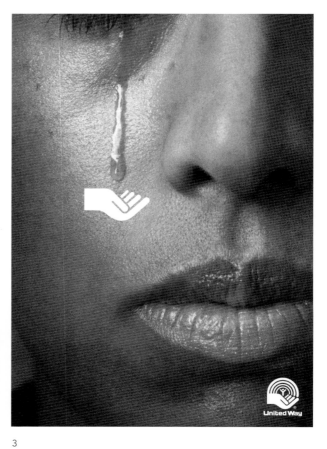

3

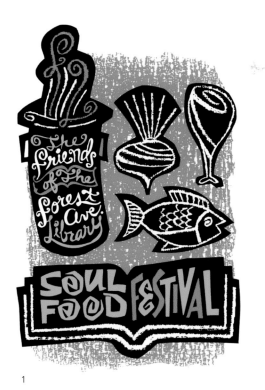

1

2

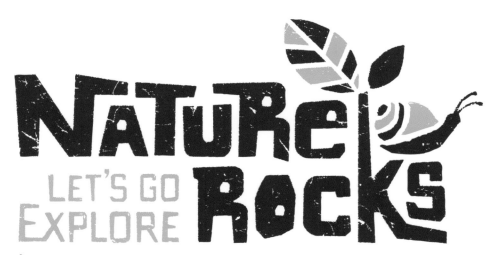

3

4

United in Memory
The 9/11 Victims Memorial Quilt

5

1

ORGANIZATION
Forest Avenue Library
CREATED BY
John Sayles
Sayles Graphic Design
Des Moines, IA

2

ORGANIZATION
Children's Friend
CREATED BY
John Swieter
Range Design, Inc.
Dallas, TX

3

ORGANIZATION
EcoAmerica
CREATED BY
Margo Chase, Jinny Bae
Chase Design Group
Los Angeles, CA

4

ORGANIZATION
Helping East Lanka Progress
CREATED BY
David Bishop, Matthew Webb
Frontmedia
Great Braxted, United Kingdom

5

ORGANIZATION
United in Memory
CREATED BY
Marc Posch
Marc Posch Design, Inc
Long Beach, CA

STEFAN G. BUCHER
344 DESIGN, LLC
PASADENA, CALIFORNIA

You're unlikely to find a DeLorean at the Echo Park Time Travel Mart, but that doesn't mean you can't have fun at this cleverly disguised tutoring center. "The original San Francisco store came about because it was zoned for retail," says Stefan Bucher of Los Angeles' 344 Design. "They could put a pirate supply store there but not a learning center." The San Francisco-based charity 824Valencia has made catching up on your reading skills appealing by creating working storefront markets across the country—with a novel twist.

Bucher's designs still dominate the shelves more than two years after the store's inception, but he notes that it's more than a novelty shop. "It's really an elaborate front for the tutoring center," he says. "The store gives it identity and exposure. People are more likely to write about a time travel store than a tutoring center." The items on the convenience store-type shelves are treasures that contribute as much to fundraising as to fun. "To keep cost low and put every possible dollar into the classes, most of our items are existing products that get relabeled, so a bottle of water becomes Anti-Robot Fluid."

But is a shop with a hundred products along this theme believable or kitsch? "It's comedy and smart writing," Bucher says. "Design becomes the straight man for the joke. You look at something from a distance and say, 'Oh, that's medicine!' When you get close and read the label you get the payoff: It is medicine: leeches! You have to make it look plausible. The whole store is deadpan. It's design improv. Powdered horse milk? What would that look like? It gets kids excited about visiting, and it appeals to adults with a love of the quirky."

• • •

CREATED BY
Stefan G. Bucher, Mac Barnett, Jon Korn

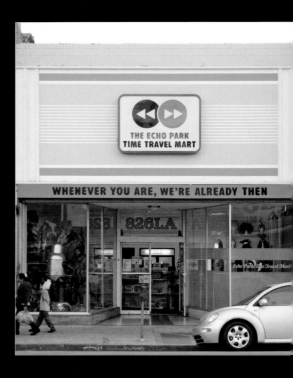

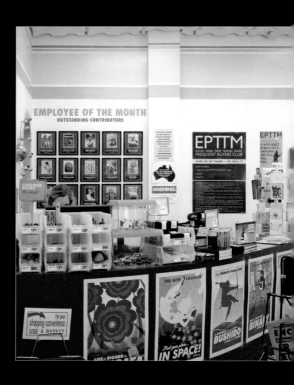

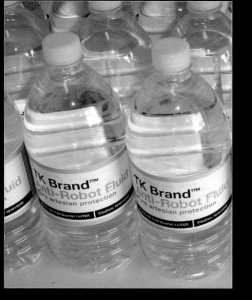

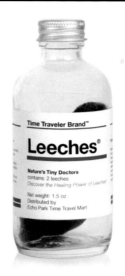

Time Traveler Brand™

Leeches®

Nature's Tiny Doctors
contains: 2 leeches
Discover the Healing Power of Leeches!

Net weight: 1.5 oz.
Distributed by
Echo Park Time Travel Mart

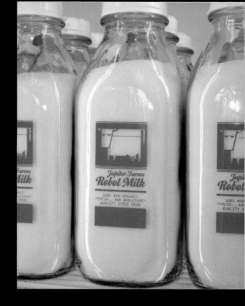

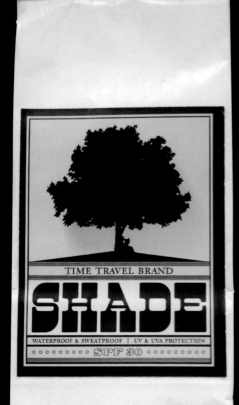

TIME TRAVEL BRAND

SHADE

WATERPROOF & SWEATPROOF | UV & UVA PROTECTION

○○○○○○○○ SPF 30 ○○○○○○○○

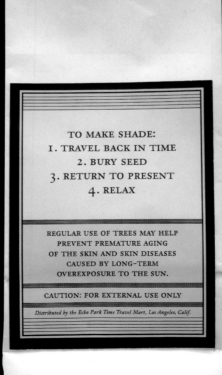

TO MAKE SHADE:
1. TRAVEL BACK IN TIME
2. BURY SEED
3. RETURN TO PRESENT
4. RELAX

REGULAR USE OF TREES MAY HELP
PREVENT PREMATURE AGING
OF THE SKIN AND SKIN DISEASES
CAUSED BY LONG-TERM
OVEREXPOSURE TO THE SUN.

CAUTION: FOR EXTERNAL USE ONLY

Distributed by the Echo Park Time Travel Mart, Los Angeles, Calif.

1

ORGANIZATION
Des Moines Park and Recreation

CREATED BY
John Sayles

Sayles Graphic Design
Des Moines, IA

2

ORGANIZATION
No on 8 Campaign

CREATED BY
Jess Sand

Roughstock Studios
San Francisco, CA

3

ORGANIZATION
Mladina Magazine

CREATED BY
Vladan Srdić, Dragan Arrigler

Studio 360 d.o.o.
Ljubljana, Slovenia

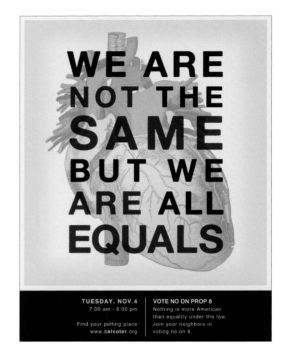

2

3

1

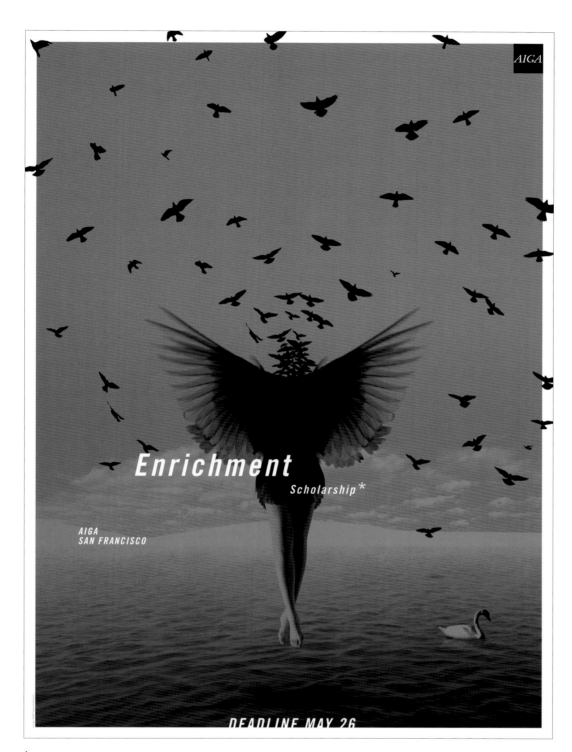

1
ORGANIZATION
AIGA San Francisco
CREATED BY
Christopher Simmons
MINE™
San Francisco, CA

1

1 · 2

ORGANIZATION
Habitat for Humanity

CREATED BY
Katy Listwa

Katy Listwa Graphic Design
Charlotte, NC

3

ORGANIZATION
Fernando Awards

CREATED BY
Nida Sanger, Jean-Marc Durviaux

DISTINC
Los Angeles, CA

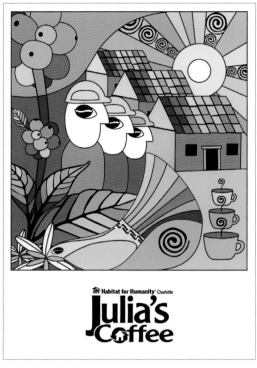

1

2

3

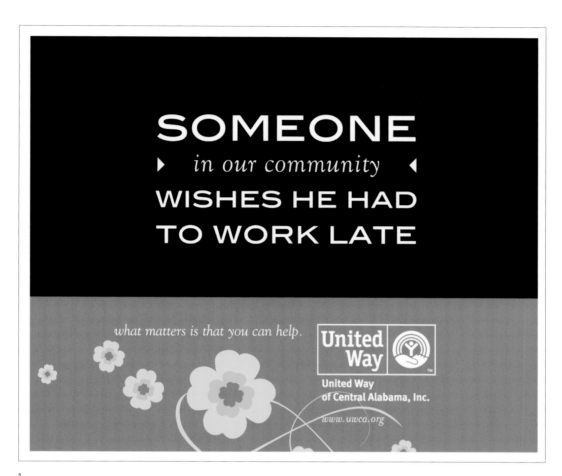

1

1 • 2 • 3

ORGANIZATION
United Way of Central Alabama

CREATED BY
April Mraz, Alan Whitley

Open Creative Group
Birmingham, AL

2

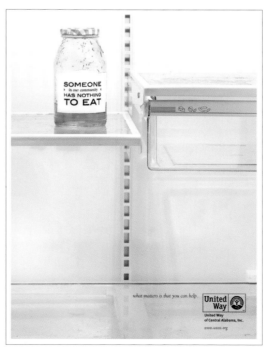

3

1

ORGANIZATION
Southern California Grantmakers

CREATED BY
Petrula Vrontikis

Vrontikis Design Office
Los Angeles, CA

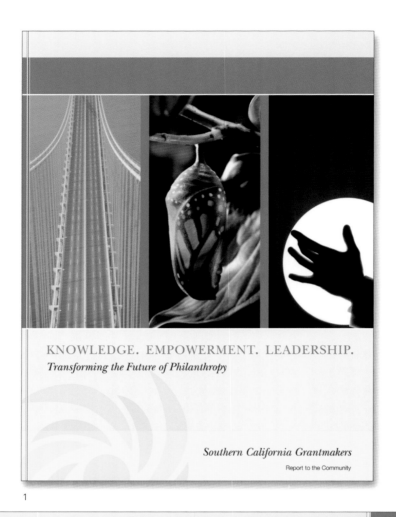

1

1

2

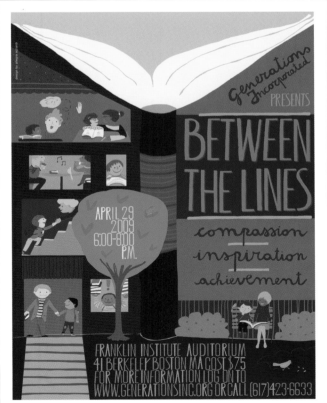

3

1 • 2

ORGANIZATION
Fund for Public Schools,
New York, NY

CREATED BY
John Gavula, Jenna Gavula
Gavula Design
Melrose, MA

3

ORGANIZATION
Generations Incorporated

CREATED BY
Allegra Agliardi
Milano, Italy

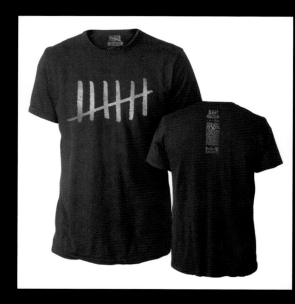

TYLER MERRICK
29 AGENCY
SOUTHLAKE, TEXAS

What with so much attention given to so-called "sin" industries such as alcohol and gambling, it's not surprising that one advertising agency took the idea of the Seven Deadly Sins to heart. "Actually, that's where the idea came from," says Tyler Merrick, founder of Dallas-area firm 29Agency. "For example, it's not about the glutton, but rather the person who is hungry. Focus on peace, not wrath."

With seven inverse values, Project 7, the brainchild of 29Agency's founder, gave the staff an outlet for "everything and anything we want to do for clients but can't," in Merrick's words. "We treat it like a client."

Naturally, like most clients, Project 7 has a message and a product. "We wanted to create a brand that could communicate seven areas of needs. We took bottles of water and turned them into t-shirts, with fifty percent organic cotton and five bottles of water." Yes, five bottles: The shirts themselves contain organic cotton and recycled RPET—but, says Merrick, they aren't scratchy or polyester-like by any means. "They're really, really soft."

Merrick figured even the products' transportation into the equation. "When we designed the outer cases for the bottles of water, we created a new style of box that fits more product when shipping, increasing efficiency and using less gas." He explains how Project 7 turned the saturation of the bottled water market into an asset: "It's not the best thing for the earth, so we're going to do it in the best way possible" with completely recycleable and sustainable plastics, inks and components, while donating half the profits to charity.

"It's becoming more cost effective," he says of the line, carried in chains such as Whole Foods, Fresh Market and now Target. "We're on a pace to own ten percent of the natural gum market."

• • •
CREATED BY
Tyler Merrick, Darren Dunham, Jonathan Rollins

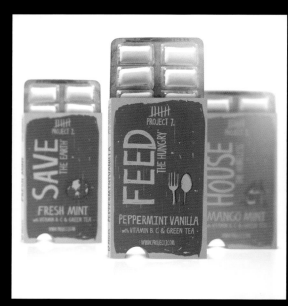

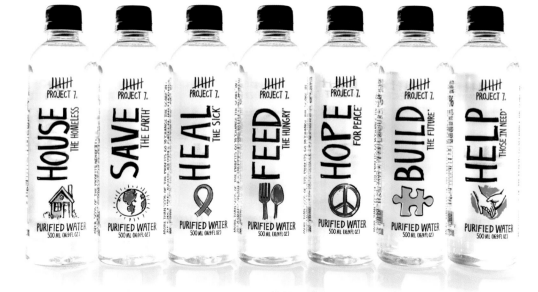

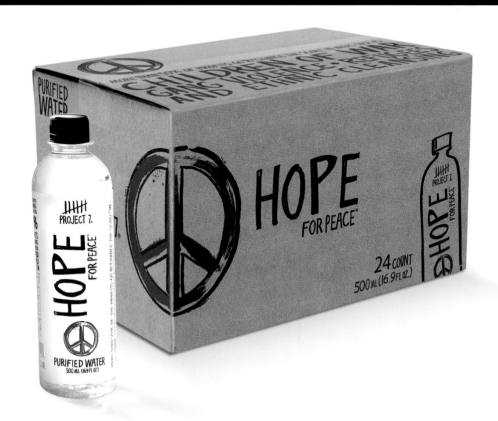

1

ORGANIZATION
Community Design Center
of Minnesota

CREATED BY
Matt Travaille, Andy Weaverling,
Jake Nassif
Rotor
Minneapolis, MN

1

1

ORGANIZATION
The Bridgespan Group

CREATED BY
Deborah Gordon McNeilly,
Carol Trager, Lindsay Coleman

DBG Design
Portsmouth, NH

1

1

ORGANIZATION
Bereavement Center of Westchester

CREATED BY
Brett Traylor, Amanda Neville,
Adam Snetman

Thinkso Creative
New York, NY

2

ORGANIZATION
Community Design Center
of Minnesota

CREATED BY
Matt Travaille, Andy Weaverling

Rotor
Minneapolis, MN

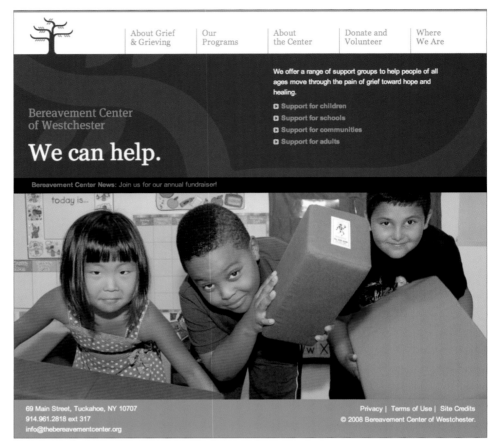

1

2

1

ORGANIZATION
David Wright Foundation
CREATED BY
Suzi Speedling, Willie Petersen,
Tiffany Bachman
Courtney & Co
New York, NY

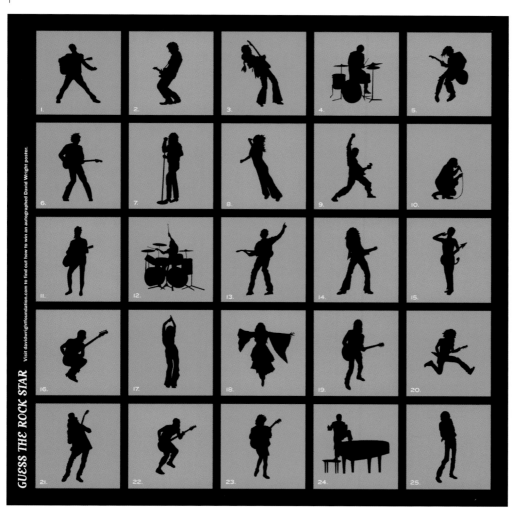

GIVE SOMETHING BACK INTERNATIONAL

EARL GEE
GEE + CHUNG DESIGN
SAN FRANCISCO, CALIFORNIA

It's an old story: Two dot-com era entrepreneurs have an IPO and retire. But, as Earl Gee of San Francisco's Gee + Chung Design tells it, the tale doesn't end there. "Education had been such a driving force" for Give Something Back International's founders, he says, helping out others was the next logical step. "The foundation's basic goal is to provide life-changing educational opportunities for children in need, and a lasting impact for their families."

In creating a brand identity to convey the foundation's educational vision, Gee found the simple image of a child hit the mark. "The design is universal," Gee says of the "contemplative" profile composed up of cyclical arrows. "Arrows symbolize change. The founders are giving something back by creating this foundation, and children give back through their knowledge. This virtuous 'cycle of giving' inspires global change, and encourages international understanding."

To inspire the support of donors and educational institutions— while representing the foundation's diversity and multinational scope—Gee created business cards, stationery, a presentation folder and Web site featuring bright, primary colors evocative of flags from around the world. "We developed a set of secondary icons based upon the logo of a child's profile: a heart, globe and arrow, highlighting a different symbol on each stationery element and business card. By alternating these features," says Gee, "the viewer is not immediately aware that the design elements are used in a modular way. Each piece works together as part of a flexible system."

And while flexible, each piece of the package makes a distinct impression. "People love to receive the foundation's unique business cards," says Gee. "Our versatile branding system has helped to establish the foundation as a vital, dynamic, progressive organization. The identity program is able to change, grow and evolve—as a metaphor for educational development itself."

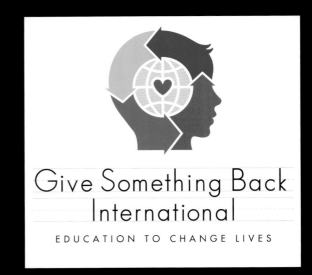

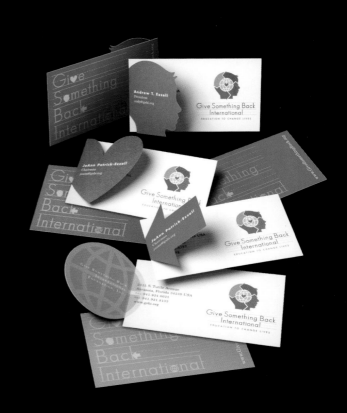

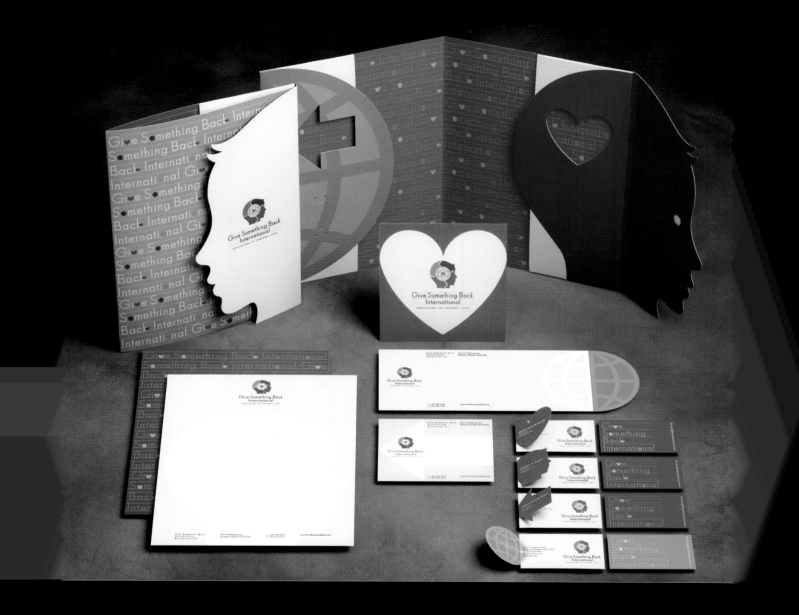

Give Something Back International

about us
virtual classroom
board of directors
sponsors

giving
educational adoptions
make a donation
volunteer positions

news + updates
photo album
press releases

contact us
guestbook

board of directors

A voluntary Board of Directors manages the GSBI Foundation.

JoAnn Patrick-Ezzell, *Chairman*
Andrew Ezzell, *President & CEO*
Paige Scoggin Rea, *Director*
Dr. Maria J. Nardone, *Director*
Jerry Walton, *Director*

JoAnn Patrick-Ezzell, *Chairman*

JoAnn Patrick-Ezzell is one of the co-founders of the GSBI Foundation and serves as Chairman of the Board. She is the President and CEO of Synergistic Systems, a global management consulting firm. Ms. Patrick-Ezzell has more than 30 years of broad international management experience, expertise in telecommunications, and a track record of growing global businesses and championing innovation. She has extensive experience in both Fortune 500 and startup settings.

Prior to joining Synergistic Systems in April 2001, she served as Chairman & CEO of iAsiaWorks, a leading pan-Asian internet hosting provider. Before being recruited by iAsiaWorks, she was President & CEO, AT&T Asia/Pacific, responsible for AT&T's multibillion dollar business throughout the region.

Give Something Back International

about us
virtual classroom
board of directors
sponsors

giving
educational adoptions
make a donation
volunteer positions

news + updates
photo album
press releases

contact us
guestbook

giving

how you can help

As you know, it takes a tremendous amount of time, effort and the help of many people to build an organization like the Give Something Back International Foundation. If you are interested, here are some ways you can get involved and help:

Give the gift of your experience; offer to teach a skill you possess and/or volunteer your time and expertise. We currently need help with fundraising ideas and implementation. You can sponsor a fundraising event for us.

Introduce us to others who may share our vision and would be interested in getting involved and/or providing support. Do you have personal friends or a contact at an organization or a foundation that might support our work? Please let us know and we will contact them.

Check with your employer, some companies will match employee contributions to qualified non-profit educational organizations.

You may also make a tax-deductible charitable contribution. Any amount will be greatly appreciated and put to very good use. The Founders will match each dollar you give with a matching donation of up to a total of $10,000.

1

ORGANIZATION
Moore College of Art and Design
and AIGA Philadelphia

CREATED BY
Ronald J. Cala II, Estelle Barrett

Calagraphic Design
Elkins Park, PA

2

ORGANIZATION
Jeremiah Program

CREATED BY
Brian Danaher, Lance Vicknair,
Mary Connor, Amy Olson

Peggy Lauritsen Design Group
Minneapolis, MN

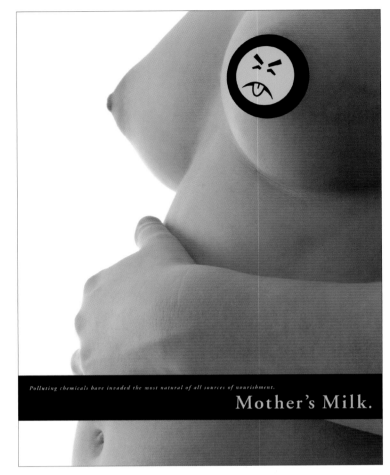

1

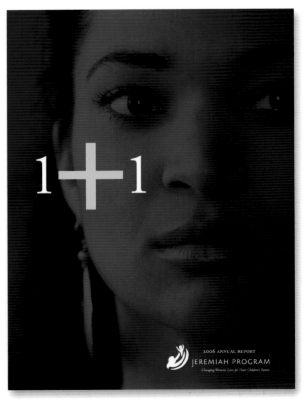

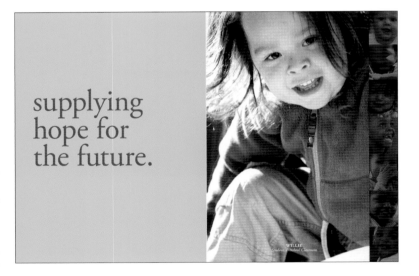

2

1

ORGANIZATION
UICA (Urban Institute for
Contemporary Arts)

CREATED BY
Yang Kim, Michele Brautnick,
Adam Rice, Mitch Ranger
People Design
Grand Rapids, MI

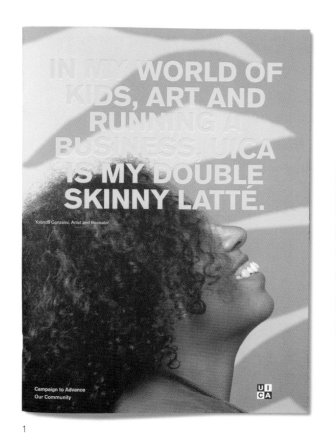

IN MY WORLD OF KIDS, ART AND RUNNING A BUSINESS, UICA IS MY DOUBLE SKINNY LATTÉ.

Yolanda Gonzalez, Artist and Illustrator

Campaign to Advance
Our Community

UICA

1

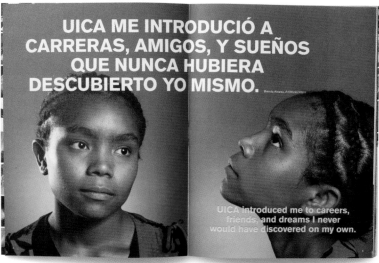

UICA ME INTRODUCIÓ A CARRERAS, AMIGOS, Y SUEÑOS QUE NUNCA HUBIERA DESCUBIERTO YO MISMO.

Brenda Alvarez, ArtWorks Intern

UICA introduced me to careers, friends, and dreams I never would have discovered on my own.

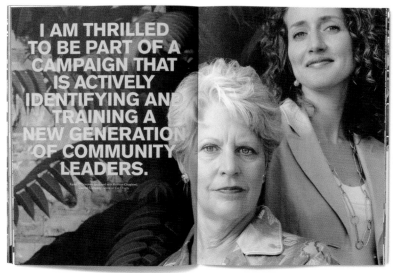

I AM THRILLED TO BE PART OF A CAMPAIGN THAT IS ACTIVELY IDENTIFYING AND TRAINING A NEW GENERATION OF COMMUNITY LEADERS.

1

ORGANIZATION
The Broad Foundations

CREATED BY
David Lai, Hiro Niwa, Barry Chiang,
Scott Arenstein

Hello Design
Culver City, CA

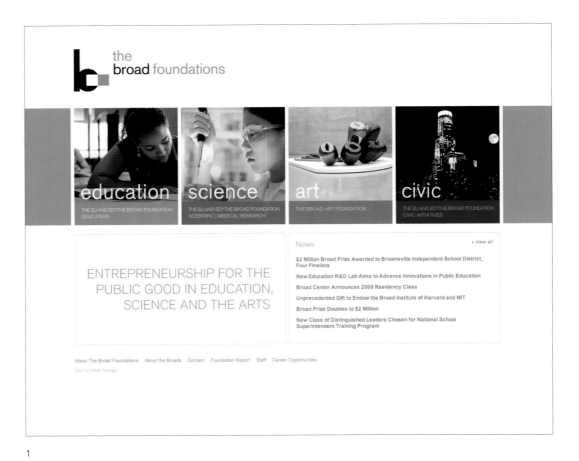

1

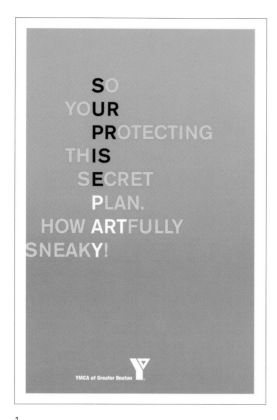

SO
YOUR
PROTECTING
THIS
SECRET
PLAN.
HOW ARTFULLY
SNEAKY!

YMCA of Greater Boston

1

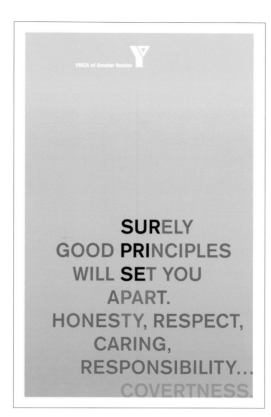

YMCA of Greater Boston

SURELY
GOOD PRINCIPLES
WILL SET YOU
APART.
HONESTY, RESPECT,
CARING,
RESPONSIBILITY…
COVERTNESS.

2

1 • 2
ORGANIZATION
YMCA of Greater Boston
CREATED BY
Dan Stebbings
Fresh Oil
Pawtucket, RI

3
ORGANIZATION
YMCA of Middle Tennessee
CREATED BY
Jade Novak, Amy Olert
Anderson Design Group
Nashville, TN

3

SPOTLIGHT ON
CLASSROOM, INC.

SUZI SPEEDLING
COURTNEY & CO
NEW YORK, NEW YORK

The classroom experience has changed since we've sat in one of those tiny desks, but nothing strikes fear into the hearts of a student like a brown envelope with the words *REPORT CARD ENCLOSED* emblazoned across the front. Such attention-getting measures helped increase the awareness of Classroom, Inc., a nonprofit organization dedicated to improving reading and math skills for middle and high school students through computer simulation-based curriculum and associated printed materials.

The established company's rebranding, says Suzi Speedling, senior designer for Courtney & Company in New York appeals to "teachers and school administrators, donors and end users."

Speedling's team shot actual New York City public school students for the brochure. The annual reports, which arrive in the aforementioned envelopes, along with the introduction of a donor newsletter, increased donations across the board. As for the overall campaign, she explains that Classroom, Inc. "really rallied around the idea of teacher support," not only by setting up the program but continuing an ongoing relationship. The resulting slogan, "Engaging students. Supporting teachers." underscores that mission.

"I can best liken it to a 'Choose Your Own Adventure' story," Speedling says of the software, used in regular classes as well as afterschool and summer programs. Students can choose from fifteen different routes, from working at a paper company to being a sports agent or a doctor. "The students immerse themselves in the business and get their feet wet in the industry," Speedling says. As for the company itself, "They loved the idea of 'What did you do in school today?' It's extremely intriguing for the audience because of the bold, 'grown up' statements coming from kids: 'I just saved 150 acres of forest,' 'I saved a cardiac patient's life,' 'I signed a multimillion-dollar contract.' That was really the core of our concept."

• • •

CREATED BY
Suzi Speedling, Mark Courtney

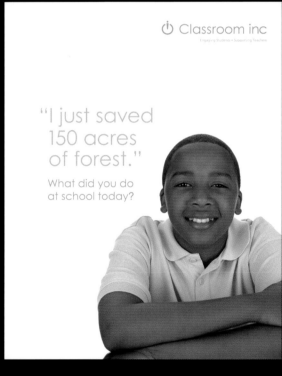

Instructional Programs

Our curriculum includes computer simulations and an array of related print materials.

Learn more.

Coming in October

Look for Classroom, Inc.'s Learning Environments, a comprehensive software, print, and professional development program that provides teachers with what they need, when and where they need it, to improve their students' academic performance while keeping them fully engaged.

Find out more.

Our Supporters

For over 15 years, Classroom, Inc. has received generous support from individuals, corporations and foundations.

Learn about our supporters.

"I saved a cardiac patient's life."

What did you do at school today?

Read our mission.

Report Card

Date FY 2006

Name Classroom, Inc.

Subject Area	Page	Grade	Comments
Letter from Chairman & President	3	A	Has completed assign...
Results	5	A	Work quality is cons... frequently scores w...
Student Testimonials	9	A	Always has positive... well with others.
Donors	15	A	Enthusiastic abou... has improved ste...
Board of Directors	21	A	Asks for respon... through volunt...

Name Classroom, Inc.

Date FY 2006

Grade Middle & High School

Dear Friends

As we reflect on Classroom, Inc.'s 2006 fiscal year, we recognize that there is more to the share beginning adolescent literacy remains our top priority. National research indicates that many urban students are "lost" during the middle school years. One study shows that students entering middle schools with even one of four risk factors have only a 50% chance of graduating from high school. The four factors are falling English, failing math, poor behavior and truancy.

At Classroom, Inc., we believe that the problem of poor student interest and performance is of such critical concern, that we continually assess whether our programs are effective in helping struggling students enhance their fluency in reading and math and regain interest in school.

The answer is a resounding yes! Classroom, Inc. makes a difference.

In NYC, where Classroom, Inc. does 80% of its work, last year's summer school program had remarkable results. When tested by the NYC Department of Education, 54% of the eighth-graders who read at the "Below Basic" level before summer school scored up to the "Basic" level after using Classroom, Inc.'s program for just five weeks, an extraordinary accomplishment.

In the spring of 2005, the Miami-Dade school system asked Classroom, Inc. to help turn around some of its most troubled middle schools. One year later, test scores for students using our program made headlines. A June 24, 2006 Miami Herald article reported unprecedented gains in reading at Miami's middle schools. According to the paper, Classroom, Inc.'s schools made some of the largest gains — the percentage of students reaching reading proficiency standards increased from 40% to 51%. At sixth grade, 67% reached the reading proficiency standard.

Accordingly, the theme of this annual review is "Results." Classroom, Inc.'s programs help struggling students to substantially improve their literacy and math skills. And with better skills—those students are far more likely to succeed in school and beyond.

But we could not have achieved this success without you. We thank each of you for your generous support and for joining us in our commitment to a better education for everyone.

As ever,

Lewis B. Bernard
Chairman

Stephen Pelletier
President

1

ORGANIZATION
SOS Children's Village

CREATED BY
Davor Bruketa, Nikola Zinic,
Imelda Ramovic, Mirel Hadzijusufovic

Bruketa&Zinic OM
Zagreb, Croatia

2

ORGANIZATION
Girl Scouts of the San Francisco
Bay Area

CREATED BY
Bill Cahan, Sharrie Brooks

Cahan & Associates
San Francisco, CA

3

ORGANIZATION
Concord Education Fund

CREATED BY
Priscilla White Sturges

Waterman Design
Concord, MA

4

ORGANIZATION
Washington Regional
Afterschool Project

CREATED BY
Josh Oakley

Weather Control
Seattle, WA

5

ORGANIZATION
Circle of Hope, Inc.

CREATED BY
Lauren Capers

Capers Design
Middleboro, MA

6

ORGANIZATION
Homeless Emergency Project

CREATED BY
David Scott

Cosmic
St. Petersburg, FL

klub prijatelja

SOS-DJEČJE SELO HRVATSKA

1

Girl Scouts Save the Bay

2

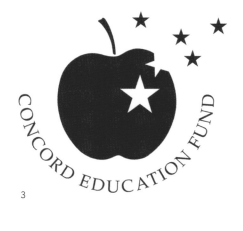

3

4

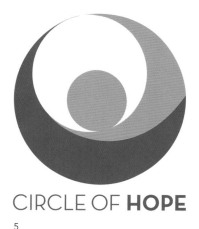

CIRCLE OF **HOPE**

5

women who care

6

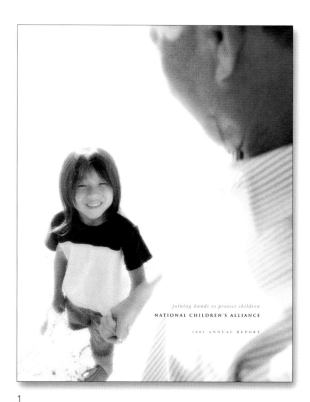

1

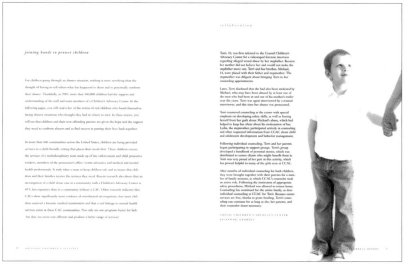

1

ORGANIZATION
National Children's Alliance

CREATED BY
Mary Ellen Vehlow, Amy E. Billingham

pensaré design group
Washington, DC

2 • 3

ORGANIZATION
The Women's Fund of Central Ohio

CREATED BY
Bev Bethge, Bonani Ray,
Jenn Stevens, Sarah Pirtle

Ologie
Columbus, OH

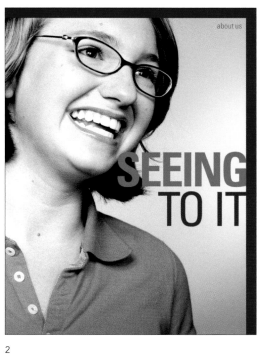

2

3

1 • 2 • 3

ORGANIZATION
Music For Everyone

CREATED BY
Craig Welsh

Go Welsh
Lancaster, PA

1

2

3

1

2

3

1

ORGANIZATION
Managing the Media Monster

CREATED BY
Taylor Martin, Anthony Begnoche

Taylor Martin Design
Stamford, CT

2 • 3

ORGANIZATION
Institute For Safe Families

CREATED BY
Peter Camburn

About Face Design
Philadelphia, PA

SPOTLIGHT ON
LA'S BEST
(BETTER EDUCATED STUDENTS FOR TOMORROW)

JEAN-MARC DUVIAUX
DISTINC
LOS ANGELES, CALIFORNIA

Twenty years is a long time for an organization to go without taking a look at itself to evaluate what works and what doesn't, but when LA's BEST (Better Educated Students for Tomorrow) afterschool program decided to examine its direction, Jean-Marc Durviaux of Los Angeles' DISTINC was in the right place at the right time. "I was hired to do the program for their sixteenth anniversary party," he says, "and four years later they had me assess their overall communication plan, identity and marketing strategy." Along with a new marketing director, Durviaux assembled LA's BEST's finest—school staff—for a daylong retreat to revisit the core values upon which the program was founded. "We wanted to and clarify who they are and why they matter."

The eight-month process ultimately involved the program's stakeholders—parents, politicians and taxpayers at the state and federal level. "We sat down with the constituents and assessed awareness and positioning in the city," Durviaux explains. "LA's BEST is one of the early successful afterschool programs, and we capitalized on what worked."

Durviaux focused on the positive, evaluating how far the organization had come, then turned it into an exercise in strategic marketing. "We helped consolidate parts of their organizational structure from a branding perspective," he says. DISTINC created a theme and visual assets built around the theme of "Change Starts Here": a comprehensive presentation press kit, an annual report and two fundraising events a year with all the trimmings. The collateral depicts actual student participants in the afterschool program, chosen from Durviaux's newly assembled library of over four hundred images.

"It's like night and day between now and what it's been done before and how we talk about the program," Durviaux says of the continued relationship. "We're showing [stakeholders] what it's about and creating an identity for the program."

• • •
CREATED BY
Nida Sanger, Jean-Marc Duviaux

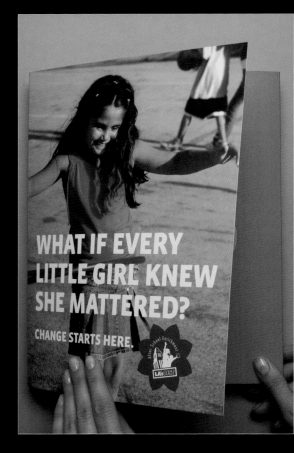

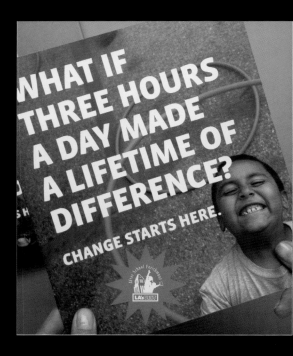

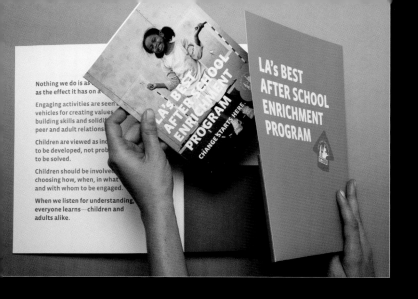
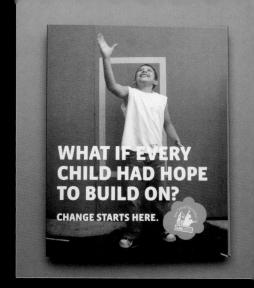
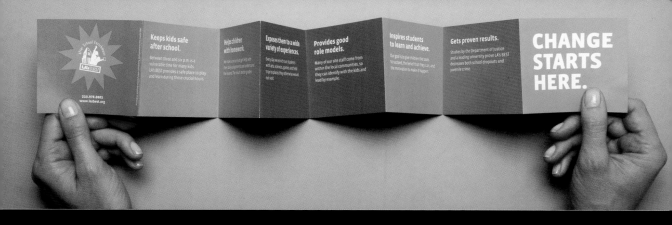
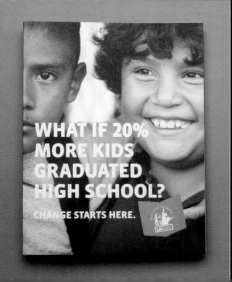
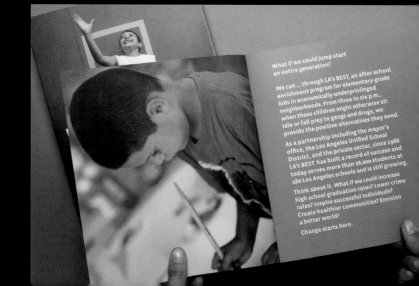

1

ORGANIZATION
Junior Blind of America

CREATED BY
Linda Warren, Soo Shin,
Candace Pearson,
Sheharazad Pezeshkpour

Warren Group | Studio Deluxe
Culver City, CA

2

ORGANIZATION
Broadway Youth Center

CREATED BY
Dawn Hancock, Nako Okubo,
Antonio Garcia

Firebelly Design
Chicago, IL

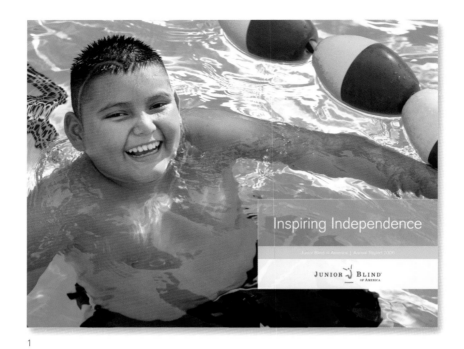

Inspiring Independence

Junior Blind of America | Annual Report 2006

JUNIOR BLIND OF AMERICA

1

BYC

BROADWAY YOUTH CENTER
a program of Howard Brown Health Center
and our community partners

2

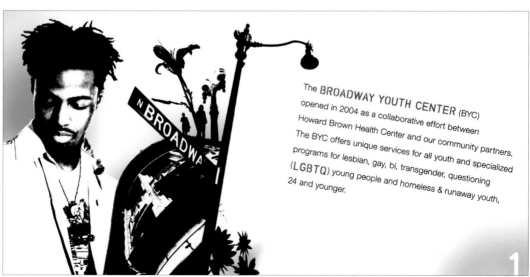

The BROADWAY YOUTH CENTER (BYC)
opened in 2004 as a collaborative effort between
Howard Brown Health Center and our community partners.
The BYC offers unique services for all youth and specialized
programs for lesbian, gay, bi, transgender, questioning
(LGBTQ) young people and homeless & runaway youth,
24 and younger.

1

1

1 • 2 • 3
ORGANIZATION
Angel Society
CREATED BY
Joshua Murphy
element3media
Phoenix, AZ

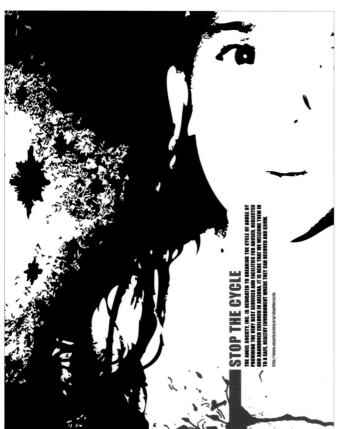

2

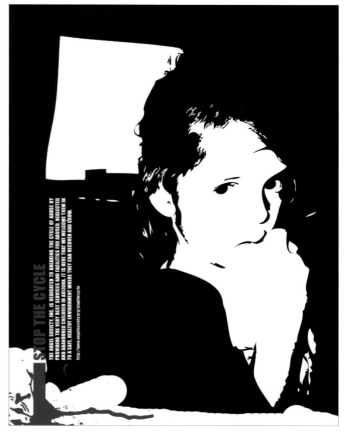

3

1

ORGANIZATION
Children's Bureau

CREATED BY
Beth Goldfarb

b.g. design
Los Angeles, CA

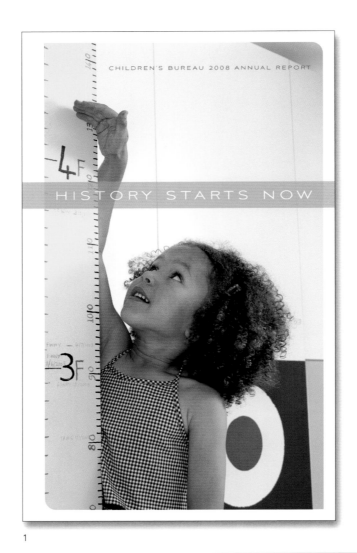

CHILDREN'S BUREAU 2008 ANNUAL REPORT

HISTORY STARTS NOW

1

CONTENTS

ROBERT KIRBY SOCIETY

Children's Bureau gratefully acknowledges the following members of the Robert G. Kirby Society for Children. Named in honor of a long-time friend, the Kirby Society was formed to recognize those caring individuals who assure our future stability and program effectiveness through planned gifts. We know that many of our friends have included Children's Bureau in their wills. If you or a loved one has made — or would like to make — a charitable provision in your will or estate plan that includes Children's Bureau, please contact Carmine Salvucci, chief development officer, at 213.342.0141 or carmines@vacofall4kids.org.

KIRBY SOCIETY MEMBERS
Wilma and Robert* Campion
Lisa-Mae and Mark Carlin
Ruby and Edmund Dana
Mary Anne and A. Redmond Doms

Linda S. Gordon
Dr. M. Alfred Haynes and Mrs. Hazel Haynes
Ambassador James D. Hodgson and Mrs. Maria Hodgson
Tina M. Johann
Marvel and Robert* Kirby
Barbara Knight
Judy and Rex Licklider
Louise Lisor
Martha and Alex Morales

Dr. James and Judy Nelson, in honor of Janet
Royal Radtke
Carmine Salvucci
Sandy Shaben
George A. Shafer
Ara Emerlini and Schuyler Villar
Alice Wiltberg
Three Anonymous Members

PLANNED GIVING

Children's Bureau continues to grow to meet the ever-increasing needs of abused and neglected children. We are grateful to our special friends who are helping to assure our future stability and effectiveness through planned gifts. Your planned gift is a significant investment in changing the course of children's lives for generations to come. There are several simple ways for your kindness and generosity to endure. We suggest you consider:

CHARITABLE REMAINDER TRUSTS Children's Bureau offers information and assistance on the establishment of charitable remainder trusts (CRTs) and charitable lead trusts. Donors can provide a substantial future charitable gift to Children's Bureau while usually increasing their lifetime income and reducing their income taxes. Appreciated assets may be contributed to the CRT and then sold with no capital gains tax paid. The total proceeds of sale are then reinvested for the benefit of the donor.

CHARITABLE GIFT ANNUITIES Children's Bureau is licensed by the California Department of Insurance to issue charitable gift annuities. These are established by transferring cash, securities or other assets to us in exchange for fixed payments for life. The benefits include: Fixed payments for life, partial tax-free return, charitable income tax deduction and potential capital gains savings.

BEQUESTS Gifts through wills and living trusts are simple to arrange, do not require a current transfer of assets and are completely revocable should the donor change his/her mind at a future date. These gifts may be made to the donor's own name or in the name of a loved one. You may also name Children's Bureau as the beneficiary of a life insurance policy.

MORE INFORMATION Regardless of the size of the assets you might choose to donate, Children's Bureau can help you make a planned gift that will reach the lives of thousands of vulnerable children for generations to come. For more information and personal assistance, please call Carmine Salvucci, chief development officer, at 213.342.0141 or carmines@vacofall4kids.org.

 The Valley Economic Alliance

Better businesses. Better jobs. Better communities.

1

BRIDGE08

2

3

4

Blue

Building Lives Up Everywhere

5

Fueling Good℠

6

 autonomous women's house zagreb

7

1 • 2

ORGANIZATION
The Mentoring Partnership
of Minnesota

CREATED BY
Brian Danaher

Peggy Lauritsen Design Group
Minneapolis, MN

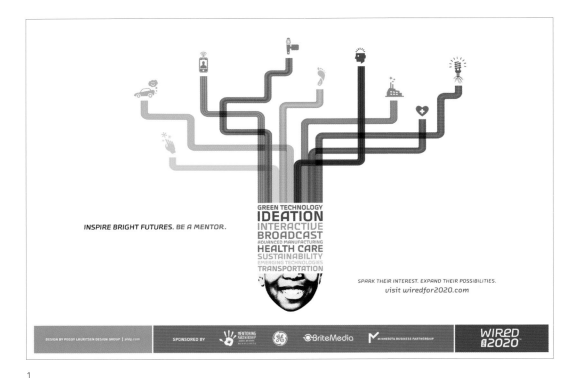

INSPIRE BRIGHT FUTURES. BE A MENTOR.

GREEN TECHNOLOGY
IDEATION
INTERACTIVE
BROADCAST
ADVANCED MANUFACTURING
HEALTH CARE
SUSTAINABILITY
EMERGING TECHNOLOGIES
TRANSPORTATION

SPARK THEIR INTEREST. EXPAND THEIR POSSIBILITIES.
visit *wiredfor2020.com*

DESIGN BY PEGGY LAURITSEN DESIGN GROUP | pldg.com SPONSORED BY MENTORING PARTNERSHIP GE BriteMedia MINNESOTA BUSINESS PARTNERSHIP WIReD 2020

1

HEALTHCARE

ADVANCED
MANUFACTURING

TRANSPORTATION

EMERGING
TECHNOLOGIES

SUSTAINABILITY

GREEN
TECHNOLOGY

INTERACTIVE

IDEATION

BROADCAST

2

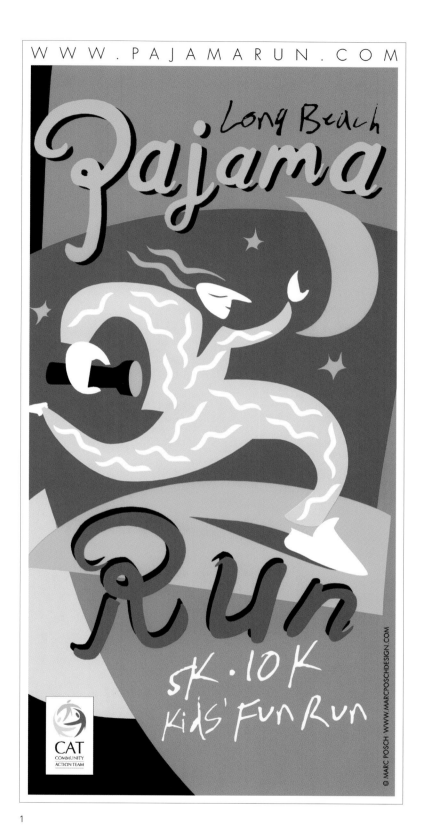

1

ORGANIZATION
Community Action Team,
Long Beach

CREATED BY
Marc Posch

Marc Posch Design, Inc.
Long Beach, CA

2 • 3

ORGANIZATION
LAUP
(Los Angeles Unified Preschool)

CREATED BY
Ruben Esparza, Terri H. Rosales,
Paula Favio, Terry Kanakri

RED Studios
West Hollywood, CA

SPOTLIGHT ON
GREENWOOD PHINNEY ARTWALK

ROBYNNE RAYE
MODERN DOG DESIGN CO.
SEATTLE, WASHINGTON

Of all the neighborhoods in Seattle, Robynne Raye's Modern Dog Design Co. picked the one most conducive to creativity. "We're on the border of Greenwood and Phinney Ridge," she says. "The studio is in a house on a commercial street so we're very visible."

The street, Greenwood, is the site of ArtWalk, an annual juried arts festival sponsored by the Phinney Neighborhood Association and featuring fifty to seventy venues showcasing local artists. "Businesses ranging from coffee shops and bakeries to dance studios and a florist, open their doors for two days showcasing sculpture, photography, painting and performance art," Raye says. "It's great for businesses, great for artists, great for people who like art."

Raye felt the neighborhood's warm embrace immediately after moving into the neighborhood in late 1994. "The first ArtWalk was in May of '95. So we've been working with them for fourteen years." The posters, she says, are "really reflective of the neighborhood and all the things the organization does for the neighbors," including volunteer home repair projects for the elderly and no-cost tool rental for residents. The posters themselves feature bright, fanciful and accessible graphics that vary from year to year but never leave any doubt as to their roots in what Raye says is Seattle's most tolerant neighborhood. "I try to mix it up," she says. "[From year to year] the colors are different and I try not to do the same thing over and over again."

The posters, which merchants both in the Greenwood and Phinney Ridge area and surrounding neighborhoods display in their windows, are a labor of love for Raye, who always finds something new to create each year. "They're cool pieces of art—and every year I have fun trying to out do what I've done before."

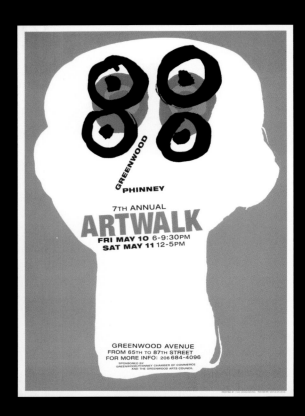

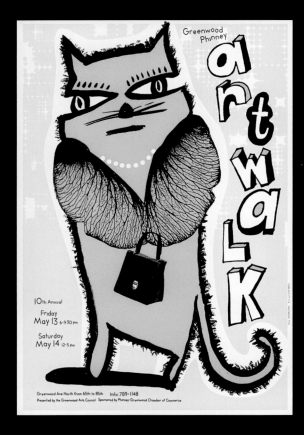

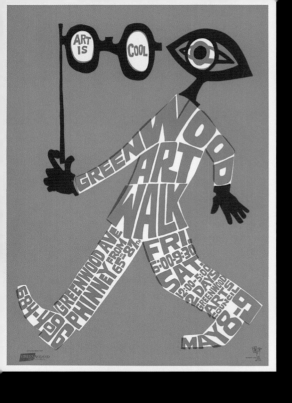

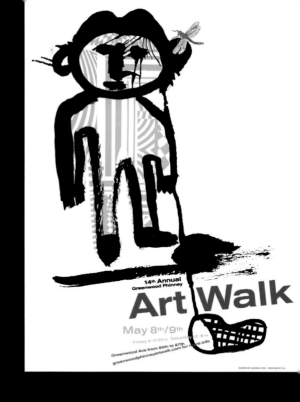

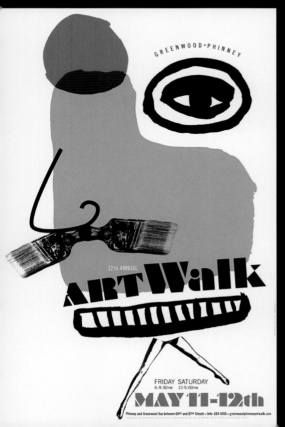

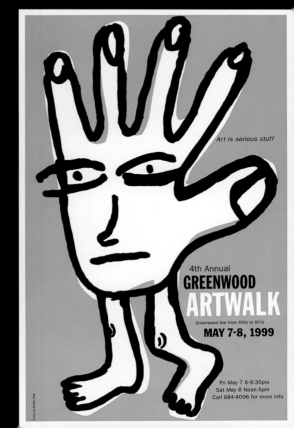

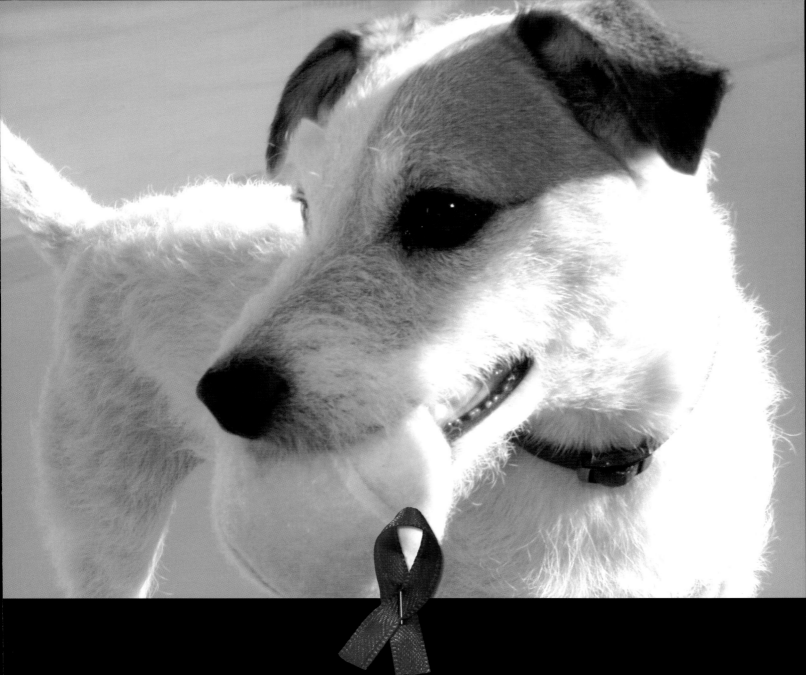

SPOTLIGHT ON
DOGS TRUST
ANNUAL REVIEW

ANTHONY ORAM
HOLD
BRIGHTON, ENGLAND

The UK's largest dog welfare agency, Dogs Trust, puts out an Annual Review every year to keep members informed about its efforts, as well as all the facts and figures. Anthony Oram, co-founder of Brighton's Hold, has a special affinity for man's best friend, starting with an earlier project for the Trust. "We originally pitched for *Wag!* magazine," he says. "It's published three times a year for supporters of the Trust and goes out to 650,000 people." Following that success, the Trust chose Hold to produce its annual report, supplying only copy, photographs and a theme. "They came up with the tagline—'For the Love of Dogs'—and our job was to bring across what they do, what the Trust does for dogs."

Oram conveys this through a lively mix of bright colors and pictures of the dogs themselves, who showcase the year's statistics in circles that may as well be balls for playtime. The reports, with their full-color bleeds and expressive photography, look very expensive, but to Oram, it's the perfect balance. "We saved the Trust money over the [previous designers' editions]. They want to give members value for their money, but at the same time have as much as possible left over for the dogs."

One (human) member wrote specifically to praise the design team for the ease with which she found the information, including the level of honesty and openness about the Trust's finances. "They say it gets more and more creative every year," says Oram. "Usually you only hear about it if it goes wrong."

The Trust's board of directors aren't the only ones who contribute to Oram's creative process at the office. "I do have a dog—a Springer spaniel—snoring underneath my desk," he says. "He rides on the train and comes to meetings with me."

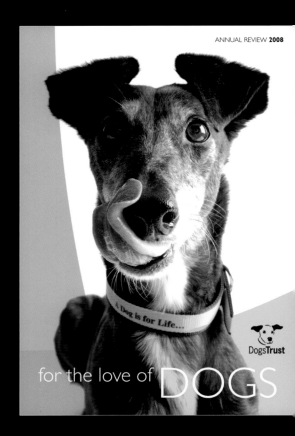

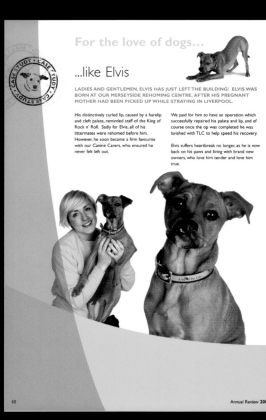

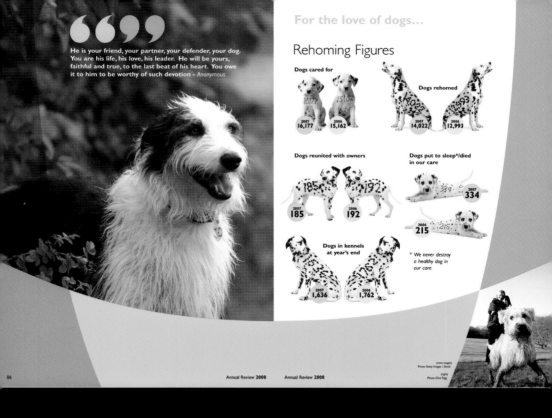

> He is your friend, your partner, your defender, your dog. You are his life, his love, his leader. He will be yours, faithful and true, to the last beat of his heart. You owe it to him to be worthy of such devotion - *Anonymous*

Rehoming Figures

Dogs cared for
2007 16,177
2006 15,162

Dogs rehomed
2007 14,022
2006 12,993

Dogs reunited with owners
2007 185
2006 192

Dogs put to sleep*/died in our care
2007 334
2006 215

Dogs in kennels at year's end
2007 1,636
2006 1,762

* We never destroy a healthy dog in our care

(main image)
Photo: Getty Images / iStock

(right)
Photo: Clive Tagg

For the love of dogs…

…Canine Care Card

GUARANTEE A SAFE, HAPPY FUTURE FOR YOUR BEST FRIEND.

Mickey is a handsome 12 year old black Cocker Spaniel. He had lived as a much loved companion with his owner since he was just 10 weeks old. When his owner sadly passed away Mickey could have faced an uncertain future as none of his owner's family or friends could take him on.

Fortunately his owner carried the free Dogs Trust Canine Care Card. This expressed her wishes that Dogs Trust care for Mickey and find him a loving home should anything happen to her.

Mickey came to Dogs Trust Harefield where he was adopted by Richard, the Centre Manager. Mickey was initially nervous of his new surroundings, but after being socialised with other dogs and people he has become a popular, happy, smiling face in the reception area.

For more information about how the free Canine Care Card can ensure a safe future for your dog, or to request an application form, please call us on 020 7837 0006.

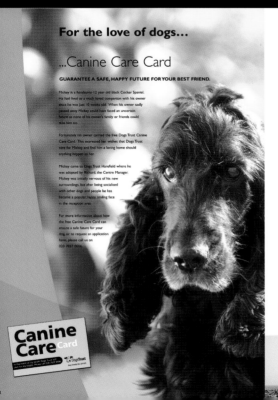

For the love of dogs…

…but especially Greyhounds!

HERE AT DOGS TRUST WE LOVE ALL DOGS, BUT WE HAVE A SPECIAL INTEREST IN THOSE GRACEFUL, ELEGANT, SLEEPY DOGS - GREYHOUNDS.

Our Chief Executive, Clarissa Baldwin, was one of the assessors for Lord Donoughue's independent report into Greyhound racing, launched at the end of the year. The report contains a wealth of recommendations for improving the sport itself, but, more importantly, the welfare of the animals. For a copy of the report please see: www.greyhounds-donoughue-report.co.uk

We will continue to do all we can to improve the lot of the racing Greyhound. In the meantime, if you've ever thought about rehoming a rescue dog, then please do consider giving a home to a retired Greyhound - they really do make wonderful, loving pets.

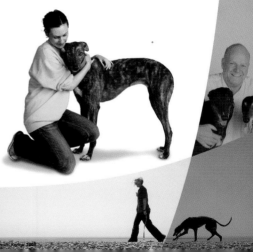

Canine Care Card

1

ORGANIZATION
The Leakey Foundation

CREATED BY
Rod Lemaire, Zach Hochstadt,
Ozzie Thoreson

Mission Minded
San Francisco, CA

1

What does it mean to be a Primate?

Join Leakey Prize Laureates **Jane Goodall**, PhD, DBE and **Dr. Toshisada Nishida** to find out.

The Leakey Prize was established in 1990 to reward intellectual achievement and express appreciation for research performed with courage and perseverance in the fields of ape and human evolution. The intention of the award is to honor a scientist for achievement transcending the boundaries of his or her discipline and linking widely differing branches of science. The Leakey Prize is to encourage multi-disciplinary science as well as to stimulate research which gives evidence of broad interest and ingenuity.

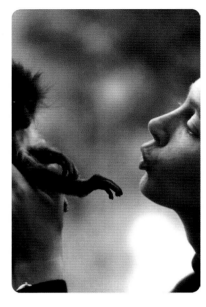

The Leakey Prize U.S. Primatology

Film Screening

Please join us for an inspiring evening of cinematic discovery and discourse on the past, present, and endangered future of our closest living relatives, the great apes. The Leakey Foundation will host the U.S. screening of 2 award-winning primatology films, selected at the 2008 International Primatological Society Congress in Edinburgh, Scotland. The films will be chosen for their original, scientifically accurate, and compelling presentation of the stories of endangered primates, the humans devoted to understanding and advocating for them, and the vast, constantly growing body of knowledge they impart to us on what it means to be a primate, and what it means to be a human.

Thursday, October 30, 2008.
Reception at 6 o'clock. Film at 7 o'clock in the evening.
California Academy of Sciences, San Francisco.

$15 general admission. $10 members* and students.
For ticket information, please contact City Box Office
at 415.392.4400 or visit the website: www.cityboxoffice.com.
Seating is limited and tickets are available on a first-come, first-served basis.
*Including members of The Leakey Foundation,
California Academy of Sciences and The Jane Goodall Institute.

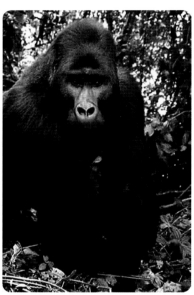

The Leakey Prize Laureate

Lectures

Featuring Jane Goodall, PhD, DBE & Dr. Toshisada Nishida

Jane Goodall, PhD, DBE and Dr. Toshisada Nishida will discuss the highlights of their pioneering careers. With the encouragement of Dr. Louis Leakey, Dr. Goodall's work began in 1960 and became the foundation for future primatological research. Dr. Nishida's research began in 1965 and established him as an authority on chimpanzee culture. Through their diligent work, these scientists have shaped the field of primatology and uncovered pivotal findings which help us better understand one of our closest living relatives, the chimpanzee.

Friday, October 31, 2008.
7 o'clock in the evening. Reception to follow.
The Herbst Theatre, San Francisco.

$35 general admission. $30 members* and students.
For ticket information, please contact City Box Office
at 415.392.4400 or visit the website: www.cityboxoffice.com.
Seating is limited and tickets are available on a first-come, first-served basis.
*Including members of The Leakey Foundation,
California Academy of Sciences and The Jane Goodall Institute.

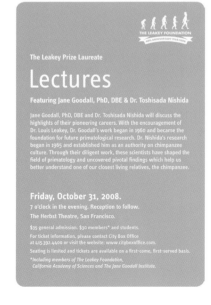

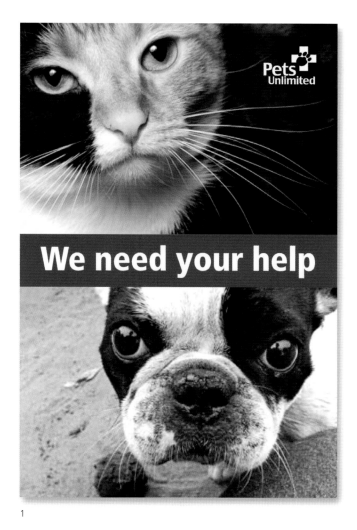

1

1

ORGANIZATION
Pets Unlimited

CREATED BY
Jennie Winton, Zach Hochstadt,
Rod Lemaire, Pat Boyd

Mission Minded
San Francisco, CA

**Where do you go when you are sick
and your owner dies?**

A sweet and shy cat, Indigo had a hard start in life. Her first
owner abused her. Her second owner was much kinder, but
sadly, she passed away, and Indigo found herself in a shelter
once again. There it was discovered that cancer had spread to
her ears and nose.

At almost any other shelter, an illness like this in a cat means
she will be euthanized. Instead, Pets Unlimited rescued
her and gave her new hope. As with many pets rescued
by Pets Unlimited, other shelters were unable to help Indigo.
Pets Unlimited was her place of last resort.

Through the support of generous donors like you, Pets
Unlimited removed the cancer on her nose and amputated
her ears, saving her life. We nursed her back to health, and
after months in our caring shelter we helped Indigo find a
new and loving home.

"Indigo is doing very well, she
loves her massages and chin
rubs. Over the last year she has
become quite frisky, which to
me says she's comfortable and
happy being here with me."

— Russell Rover, Indigo's guardian

Pets in need depend on you.

**Through Pets Unlimited,
you can give them the help they need.**

When you give to Pets Unlimited, you support one
of the most highly acclaimed veterinary centers in
the country. You provide charitable care for pets of owners
who have limited means to pay for the care of their pets.
And you sustain a no-kill shelter that saves dogs and cats
in need — pets that other shelters would euthanize.

1

ORGANIZATION
The Center for Lost Pets

CREATED BY
Art Javid, Kevin Javid

Graphicwise, Inc.
Irvine, CA

2 • 3

ORGANIZATION
Boonshoft Museum of Discovery

CREATED BY
Errin Siske, Diane Farrell, Teri Schoch

Dayton Society of Natural History
Dayton, OH

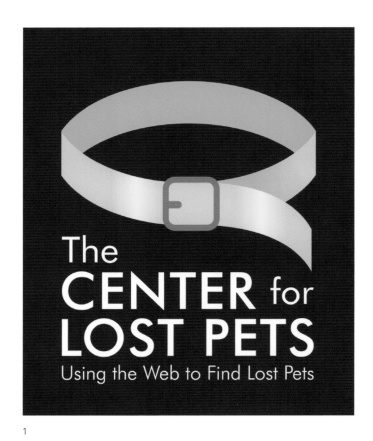

1

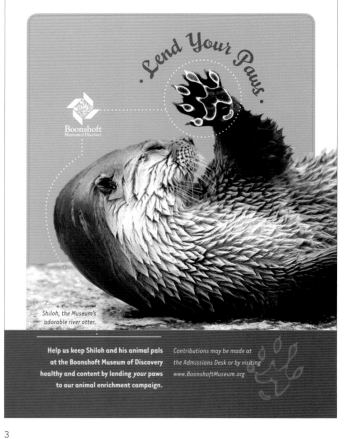

2

3

photos to the rescue™

focused on homeless pets

1

2

3

4

1

ORGANIZATION
Photos To The Rescue

CREATED BY
Rob Gough

Sproutreach
Bradford, MA

2

ORGANIZATION
Vatsalya Animal Shelter

CREATED BY
Sudarshan Dheer

Graphic Communication Concepts
Mumbai, India

3

ORGANIZATION
The Bristol Animal Shelter

CREATED BY
Thomas Roskelly

Roskelly, Inc.
Portsmouth, RI

4

ORGANIZATION
Mondog

CREATED BY
Deborah Huelsbergen
Ric Wilson

Type-a-licious
Columbia, MO

1 • 2 • 3

ORGANIZATION
Community Action Team,
Long Beach

CREATED BY
Marc Posch

Marc Posch Design, Inc.
Long Beach, CA

1

2

3

1 · 2

ORGANIZATION
SPCA of Central Florida

CREATED BY
David Scott
Cosmic
St. Petersburg, FL

1

2

1
ORGANIZATION
Humane Society of Tampa Bay
CREATED BY
David Scott
Cosmic
St. Petersburg, FL

1

ORGANIZATION
Dogs Trust
CREATED BY
Anthony Oram
Hold
Brighton, England

1

1

2008

Whiskers
Wine & Dine

2

3

The Marine
Mammal Center

4

1
ORGANIZATION
State College Pet Extravaganza
CREATED BY
Lanny Sommese
Sommese Design
Port Matilda, PA

2
ORGANIZATION
Coalition: Humane
CREATED BY
Ric Wilson, Deborah Huelsbergen
Type-a-licious
Columbia, MO

3
ORGANIZATION
Cat Adoption Team
CREATED BY
Jeff Fisher
Logo Motives
Portland, OR

4
ORGANIZATION
The Marine Mammal Center
CREATED BY
Ron Vandenberg, Alice Bybee,
Teresa Liu
Anthem
San Francisco, CA

1

ORGANIZATION
The Marine Mammal Center

CREATED BY
Doug Ross

Eye Think
Santa Cruz, CA

1

1

ORGANIZATION
Seal Watch San Diego/
Animal Protection and Rescue League
CREATED BY
Doug Ross

Eye Think
Santa Cruz, CA

2
ORGANIZATION
Georgetown Animal Shelter
CREATED BY
Nick Ramos

Graphismo
Georgetown, TX

2

SPOTLIGHT ON
AFRICAN WILDLIFE FOUNDATION

STEVE BEAVER
BEAVER DESIGN GROUP
ATLANTA, GEORGIA

Your average urban-dwelling American doesn't think much about endangered species in his daily life, but Atlanta's Steve Beaver does. He cites Beaver Design Group's guiding question, *Is this work that matters?* His annual reports for the African Wildlife Foundation (AWF) provide the answer: *Yes.*

When it comes to supporting AWF, Beaver knows that "How can I get involved?" usually means "How can I get involved financially?" To get potential donors in the U.S., Europe and Africa interested, Beaver designed a series of reports to appeal to donors' fiscal and emotional sense. AWF "wanted it to look high end but not like they're bad stewards of the money they were given," he says. "We wanted to show the magnificent photography, and tell the story of the mission—why it's worth the energy to save these animals."

Surprisingly, though, much of the resistance to the AWF's mission comes from the very people in areas most in need of help. "The wildlife and the land are inseparable, and you can't have any kind of impact without the people who live there being involved," Beaver explains. "A family has a hut and an elephant tramps through their garden, or a nomadic rancher's cows are killed by a lion. Why should they want to help? [The reports] show how local communities are benefited directly by embracing conservation."

Copywriter Alan Gold distills these benefits down to four points based on the AWF's mission: landscape conservation, species conservation, conservation enterprise (such as villagers profiting from beekeeping or tourism) and conservation leadership (providing scholarships and raising the educational standard within the community). Original images, largely donated by world-class wildlife photographers, illustrate the plight of the people and animals served by the AWF. "They're worth protecting, and we wanted to tell it in a really beautiful way," says Beaver.

• • •

CREATED BY
Steve Beaver, Alan Gold, James Weis, Craig R. Sholley, Maryke Gray

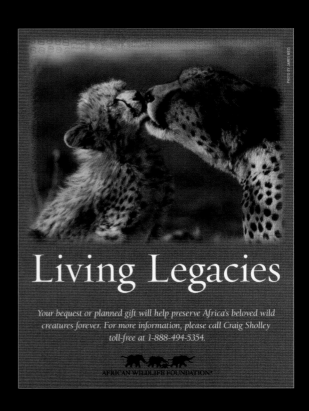

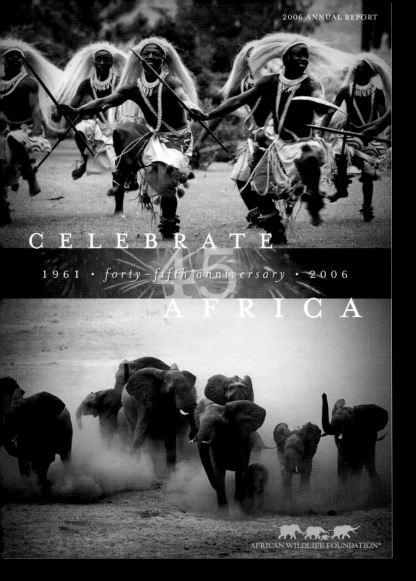

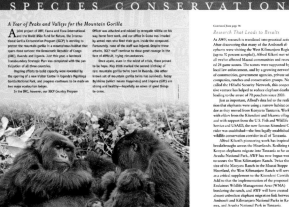

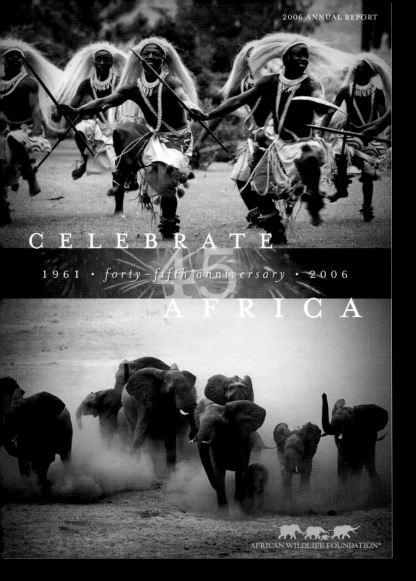

CELEBRATE

1961 · *forty-fifth anniversary* · 2006

AFRICA

AFRICAN WILDLIFE FOUNDATION®

ANNUAL REPORT
2003

conserving *Wildlife*

protecting *Land*

empowering *People*

AFRICAN WILDLIFE FOUNDATION

SAVING AFRICA'S WILDLIFE & WILDLANDS

A video from the African Wildlife Foundation

SPECIES CONSERVATION

A Year of Peaks and Valleys for the Mountain Gorilla

A joint project of AWF, Fauna and Flora International and the World Wide Fund for Nature, the International Gorilla Conservation Program (IGCP) is working to protect the mountain gorilla in a mountainous habitat that spans three nations: the Democratic Republic of Congo (DRC), Rwanda and Uganda. Just this year, a landmark Transboundary Strategic Plan was completed with the participation of all three countries.

Ongoing efforts to build capacity were rewarded by the opening of a new Visitor Centre in Uganda's Mgahinga Gorilla National Park, and progress continues to be made on two major ecotourism lodges.

In the DRC, however, our IGCP Country Program Officer was attacked and robbed by renegade militia on his way home from work, and our office in Goma was invaded by armed men who fled their guns inside the compound. Fortunately, none of the staff was injured. Despite these attacks, IGCP staff continue to show great courage in the face of difficult, trying circumstances.

Once again, even in the midst of crisis, there proved to be hope. May 2006 marked the second birthday of rare mountain gorilla twins born in Rwanda. (No other known set of mountain gorilla twins has survived.) Today Byishimo (which means Happiness) and Impana (Gift) are strong and healthy—hopefully an omen of good things to come.

Continued from page 76

Research That Leads to Results

At AWF, research is translated into practical action. After discovering that many of the Amboseli elephants were visiting the West Kilimanjaro Region (up to 70 percent sampled), Alfred Kikoti met with all twelve affected Maasai communities and recruited 24 game scouts. The scouts were supported by local law enforcement, and by a growing network of communities, government agencies, private safari companies, ranches and conservation groups. Now called the Hifadhi Security Network, this cooperative venture has helped to reduce elephant deaths—leading to the arrest of 70 poachers since 2003.

Just as important, Alfred's data led to the realization that elephants were using a narrow habitat corridor as they moved from Kenya to Tanzania. Working with elders from the Kitendeni and Irkaswa villages, and with support from the U.S. Fish and Wildlife Service and USAID, the now famous Kitendeni Corridor was established—the first legally established wildlife conservation corridor in all of Tanzania.

Alfred Kikoti's pioneering work has inspired breakthroughs across the Heartlands. Realizing that Kenyan elephants migrate into Tanzania as far as Arusha National Park, AWF has now begun work to secure the West Kilimanjaro Ranch. Twice the size of the Manyara Ranch in the Maasai Steppe Heartland, the West Kilimanjaro Ranch will serve as a critical supplement to the Kitendeni Corridor. Add to that the implementation of the proposed Enduimet Wildlife Management Area (WMA) bordering the ranch, and AWF will have created an almost unbroken elephant migration link between Amboseli and Kilimanjaro National Parks in Kenya, and Arusha National Park in Tanzania.

That such simple (if painstaking) research would lead to enormous fruit is no surprise to Alfred. "I work with elephants because they're the biggest guys out there. They have more impact on people. They are more vulnerable to habitat loss. If we help the elephants," says Alfred, "we help every other species. Including our own."

Elephant Population Surges in Southern Africa

In AWF's three-nation Zambezi Heartland, complaints about human-elephant conflict have skyrocketed. But is it because there are more elephants, or more people?

This past year, AWF conducted a Heartland-wide aerial survey of large mammals. While results are still being analyzed, it appears that the elephant population has increased dramatically on the Zambia side of the Heartland in the last three years. This is good news for conservation—but perhaps bad news for communities trying to keep up with increasing damage to crops.

That's why AWF's top priority is now to develop a Heartland-wide management strategy for elephants, and to work with communities to avoid human-wildlife conflict. Meanwhile in the nearby Kazungula Heartland, AWF is seeking funding for a joint project with the Zambia Wildlife Authority (ZAWA) to mitigate elephant-human conflict in the Mosesi Chiefdom—located on the Zambian side of the Zambezi River just downstream of Victoria Falls. Strategies include better monitoring of elephant movement, improved warning systems and encouraging elephant-friendly livelihoods.

Poor elephants are a good problem to have when you consider that elephant numbers are still dropping continent-wide. But with more wildlife comes more responsibility—a challenge that AWF is pleased to accept.

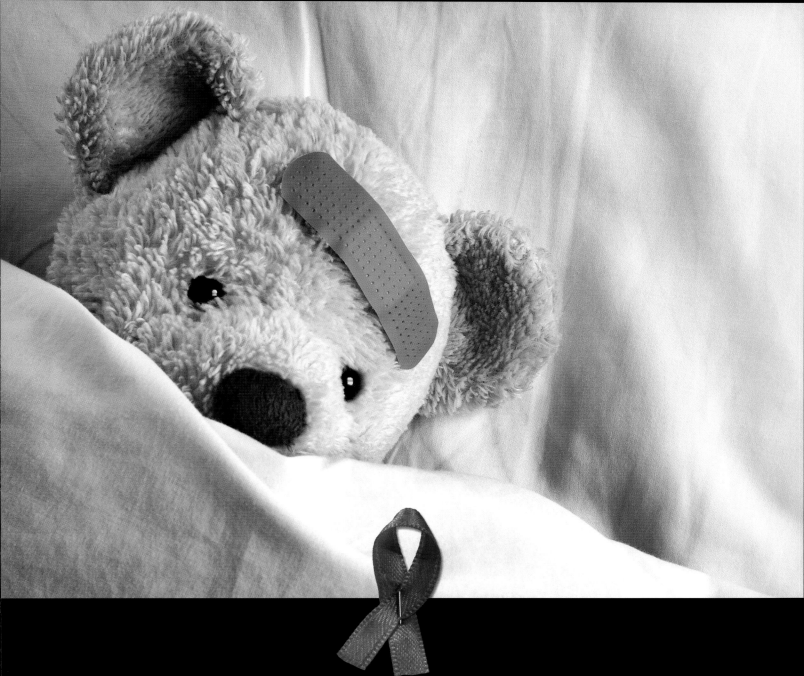

SPOTLIGHT ON
PURE PREVENTION

SCOTT KETCHUM
MOLLY CONLEY
BBMG
NEW YORK, NY

Illness prevention is an often-overlooked option, especially when it comes to breast cancer, where only one out of ten women diagnosed has a family history of the disease. "We were shocked when we learned that," says Scott Ketchum of BBMG in New York. "So we wanted to make that the central part of the campaign, to take a step back and focus more on the environmental causes of breast cancer and what people can do to prevent getting it in the first place."

The client, The Breast Cancer Fund and LUNA Bar, had worked together tangentially for a long time but BBMG aimed to bring them closer. The dominant images—a pair of peaches, a pair of sudsy buckets and a pair of makeup compacts—suggest breasts in a light but thought-provoking way. "It's things women use in their everyday lives, juxtaposed and creating even a comical effect," Ketchum says. "It instantly produces a mindshift so someone can say, 'Wow, that's more serious than I realized.' Visually it took us several months to come up with the concept, but once we came up with two simple objects on a white background, it fit."

BBMG chose the topics thoughtfully to convey one theme, "What's your breakfast got to do with breast cancer?" "We're talking about what women put in their bodies, on their bodies and use around their homes," he explains. "Peaches can be the most toxic fruit you can eat, because they tend to absorb the most pesticides. You may put your hands into these chemicals when cleaning the house, and you put on makeup every day."

The effort—led by Ketchum and principal Raphael Bemporad, featuring senior designer/photographer Molly Conley and copywriter Sharon Ng—continues to appear all over the Web and the landscape, including in prominent ads in *O*, Oprah Winfrey's magazine.

• • •

CREATED BY
Scott Ketchum, Raphael Bemporad, Molly Conley, Sharon Ng, Shannan Lynes

What's your *make-up* got to do with breast cancer?

Did you know that only 1 in 10 women who have breast cancer have a genetic history
of the disease? Pure choices, like using natural, safe cosmetics, can make a difference.
To get the facts about the environmental causes of breast cancer and learn simple ways
you can ask, act and live to reduce your risk, visit www.pureprevention.org.

What's your *cleaner* got to do with breast cancer?

Did you know that only 1 in 10 women who have breast cancer have a genetic history
of the disease? Pure choices, like using natural, toxin-free cleaning products, can make a difference.
To get the facts about the environmental causes of breast cancer and learn simple ways
you can ask, act and live to reduce your risk, visit www.pureprevention.org.

pure
prevention
Ask. Act. Live. To reduce breast cancer.

DONATE
JOIN US
NEWSROOM
CONTACT US
SEARCH

about pure	ask	act	live

Learn how these simple *pure choices* can help reduce your risk.

 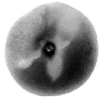

spotlight

Watch our Public Service Announcements featuring film and television actress Sarah Carter.

Listen to our podcast | Share the PURE eCards | MySpace, YouTube and Facebook pages

get the facts

Read the science about the environmental causes of breast cancer and get answers to your questions.

FAQs | Research and Evidence | Resources

take action

Share your knowledge with family and friends by showing them simple, everyday steps they can take to help reduce their risk.

Take the Pledge | Tell a Friend | Donate

Privacy | Site Map
Pure Prevention © 2008
Created by BBMG

 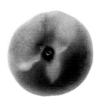

What's your *breakfast* got to do with breast cancer?

Did you know that only 1 in 10 women who have breast cancer have a genetic history
of the disease? Pure choices, like eating organic, natural foods, can make a difference.
To get the facts about the environmental causes of breast cancer and learn simple ways
you can ask, act and live to reduce your risk, visit www.pureprevention.org.

pure
prevention
Ask. Act. Live. To reduce breast cancer.

1

ORGANIZATION
Foodprints
CREATED BY
John Gavula, Jenna Gavula

Gavula Design
Melrose, MA

2

ORGANIZATION
Children's Cancer Fund
CREATED BY
John Swieter, Garrett Owen

Range Design, Inc.
Dallas, TX

3

ORGANIZATION
Matan
CREATED BY
Martin Kace, Masood Bukhari

Empax, Inc.
New York, NY

4

ORGANIZATION
Sadler Vaden Foundation
CREATED BY
Bryan Ledbetter

Airtype Studio
Winston-Salem, NC

5

ORGANIZATION
Riverside Health System
CREATED BY
Dale Campbell

The Greater Good Design
Saint Cloud, FL

1

2

3

4

5

1
ORGANIZATION
Alzheimer's Association
CREATED BY
Michael Osborne, Sheri Kuniyuki
Joey's Corner
San Francisco, CA

1

ORGANIZATION
Second Chance
CREATED BY
Mike Nelson, Tracy Sabin
Sabingrafik, Inc.
Carlsbad, CA

1

1 • 2

ORGANIZATION
IDEA Magazine

CREATED BY
Joshua Berger, Niko Courtelis,
Enrique Mosqueda, Dan Forbes

Plazm
Portland, OR

2

1

ORGANIZATION
Care for Elders

CREATED BY
Scott Ketchum, Sayaka Ito
BBMG
New York, NY

Life Takes Planning. *Get Ready for Life.*

A guide to living with independence,
health and well-being.

1

Welcome to
your future.

You've successfully raised a family and helped
a business grow. Now's a time for passion,
purpose and new possibilities.

This guide is designed to help you *Get Ready for Life.*

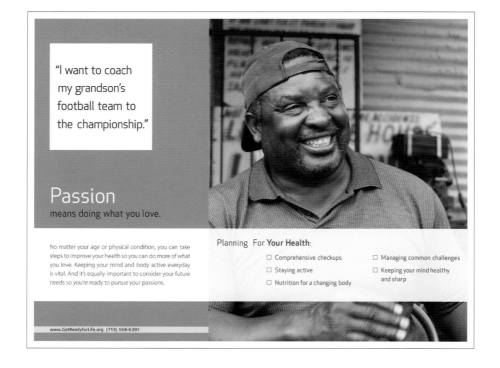

"I want to coach
my grandson's
football team to
the championship."

Passion
means doing what you love.

No matter your age or physical condition, you can take
steps to improve your health so you can do more of what
you love. Keeping your mind and body active everyday
is vital. And it's equally important to consider your future
needs so you're ready to pursue your passions.

Planning For **Your Health:**

☐ Comprehensive checkups
☐ Staying active
☐ Nutrition for a changing body

☐ Managing common challenges
☐ Keeping your mind healthy
 and sharp

www.GetReadyforLife.org (713) 558-6391

1 • 2

ORGANIZATION
Hope Clinic for Women

CREATED BY
Rebecca Carroll

Student
Nashville, TN

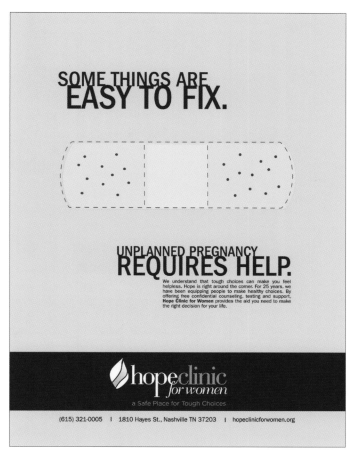

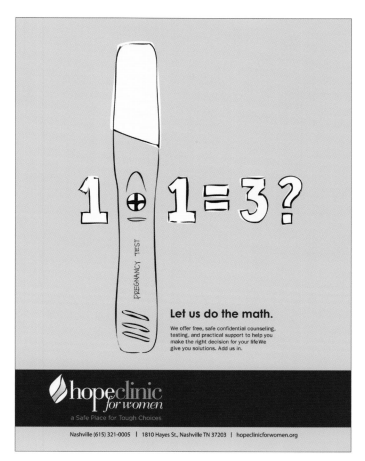

1

2

SPOTLIGHT ON
THE AVON WALK
FOR BREAST CANCER

GABRIELLE RAUMBERGER
EPOS, INC.
HERMOSA BEACH, CALIFORNIA

For many women, breasts represent, alternately, femininity, nurturing, life, identity—and when disease strikes, it cuts at the very notion of how women see themselves. "Most [breast cancer] fundraisers show the people on the walk," says Gabrielle Raumberger of design firm Epos, Inc., in Hermosa Beach, California. "Those campaigns all look the same. Why not show these people as the individuals that they are by shooting intimate, beautiful portraits?"

In creating an identity for a very different kind of event—in this case, the Avon Walk for Breast Cancer—Raumberger and copywriter Rex Wilder of JNR8 Advertising enlisted the help of fashion photographer Isabel Snyder to capture the essence of those whose lives have been touched by the disease. "We treated the people like fashion stars," Raumberger says. "Other campaigns show them walking, celebrating, cheering. Ours is more contemplative. We wanted people to connect to what the person was going through, and feel how this disease affected them. Each photo was accompanied by their story, either as a survivor or as a loved one who lost someone to breast cancer. The result was truly moving."

Some of the slogans—"Great Breasts, Saved by a Mammogram!" and "I'm a Breast Man"—are rather cheeky, but Raumberger thought it fit the cause. "This is about your breasts, a disease that affects your breasts!"

On the first day of the campaign, Raumberger says, two hundred people wrote in to the Web site and said, "'Thank you for talking about our breasts! We love it!'" However, two offended writers precipitated a change in Avon's strategy. "We were asked to be more traditional in our message, so we printed new T-shirts about 'Great Hope' and 'Great Courage,' making the first ones great collector's items that sold out immediately."

• • •

CREATED BY
Gabrielle Raumberger, Chad M. Goodson, Cliff Singontiko, Eric Martinez

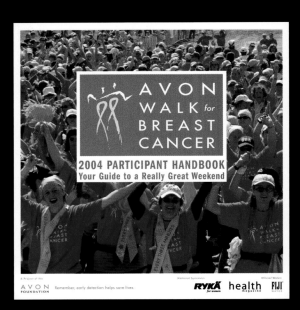

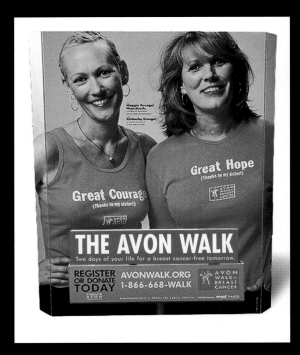

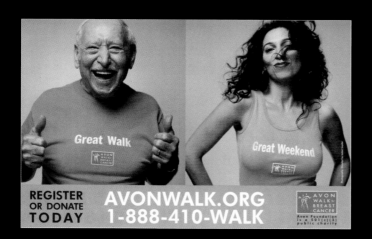

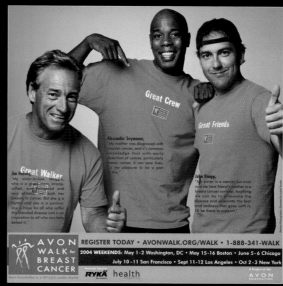

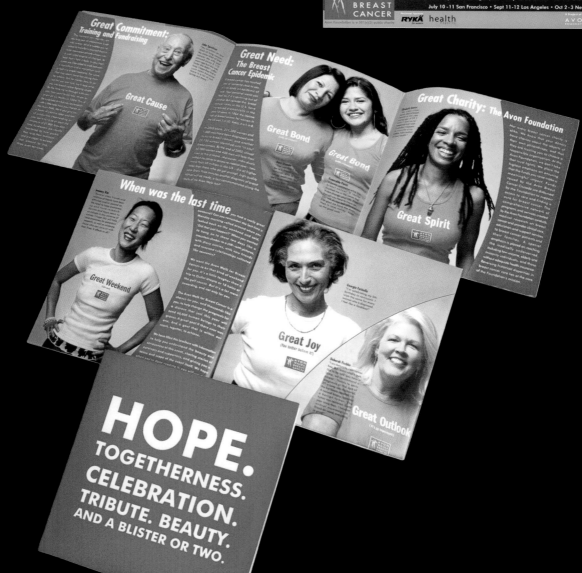

1

ORGANIZATION
Barefoot Baroque benefitting AIDS
Action Baltimore

CREATED BY
Kimberly Hopkins, Jesse Hellman

khopdesign, llc
Nottingham, MD

2

ORGANIZATION
Stopthespray.org

CREATED BY
Jess Sand

Roughstock Studios
San Francisco, CA

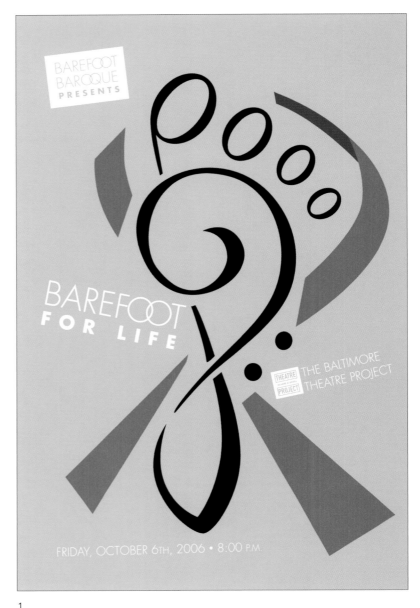

1

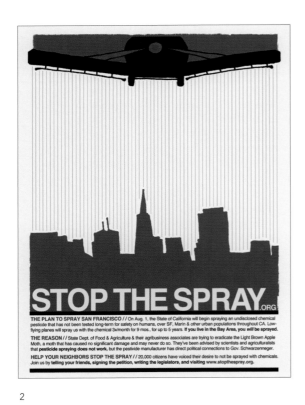

2

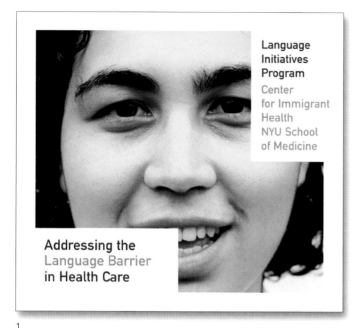

Language
Initiatives
Program
Center
for Immigrant
Health
NYU School
of Medicine

Addressing the Language Barrier **in Health Care**

1

1
ORGANIZATION
Center for Immigrant Health,
NYU School of Medicine
CREATED BY
NICI von Alvensleben
Spell
New York, NY

Addressing the Language Barrier **in Health Care**
More than 10 million Americans speak little or no
English. For those with Limited English Proficiency (LEP),
language barriers often result in reduced access to
health care services, misdiagnoses, poor quality of care,
and compromised medical treatment.

*LEP (the limited ability that a patient may have to effectively speak,
understand, read, or write in English) seriously impedes the practice
of medicine*

Language Initiatives Services and Training Programs
Since 1989 the Center for Immigrant Health (CIH) has
offered an array of language services to meet the specific
needs of LEP patients and their providers.

The Language Initiatives Program provides leading edge
programs in medical interpreting.

Our Training Programs utilize a multi-lingual methodology
that encourages active participation. CIH's innovative
training courses are scheduled to accommodate the needs
of students and facilities. Courses can be held on-site at
the provider facilities or at CIH.

*Trained medical interpreters enable providers to truly communicate with
the patient, enabling more effective medical encounters*

1 · 2

ORGANIZATION
24 Hours of Booty

CREATED BY
Gage Mitchell, Chris Bradle,
Rhonda Sergeant, Jason Robinson

Eye Design Studio
Charlotte, NC

1

2

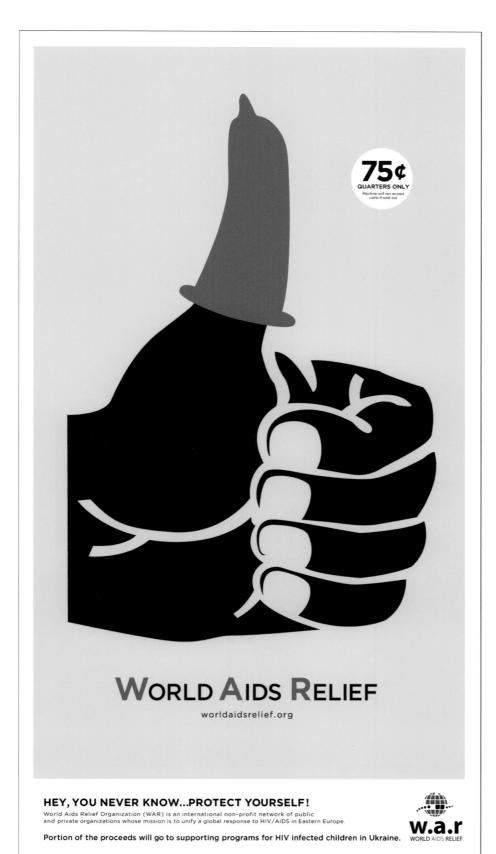

WORLD AIDS RELIEF

worldaidsrelief.org

HEY, YOU NEVER KNOW...PROTECT YOURSELF!

World Aids Relief Organization (WAR) is an international non-profit network of public
and private organizations whose mission is to unify a global response to HIV/AIDS in Eastern Europe.

Portion of the proceeds will go to supporting programs for HIV infected children in Ukraine.

w.a.r
WORLD AIDS RELIEF

75¢
QUARTERS ONLY
Machine will not accept
coins if sold out

1

ORGANIZATION
W.A.R. (World Aids Relief)

CREATED BY
Shogo Ota

Modern Dog Design Co.
Seattle, WA

1

ORGANIZATION
Good Design Cultural Association,
Milan, Italy
CREATED BY
Joe Scorsone, Alice Drueding
Scorsone/Drueding
Jenkintown, PA

2

ORGANIZATION
Emory Winship Cancer Institute
CREATED BY
Citizen Studio
Atlanta, GA

3

ORGANIZATION
Susan G. Komen for the Cure
CREATED BY
Amanda Altman, Alan Altman,
Reachal Giralico
A3 Design
Charlotte, NC

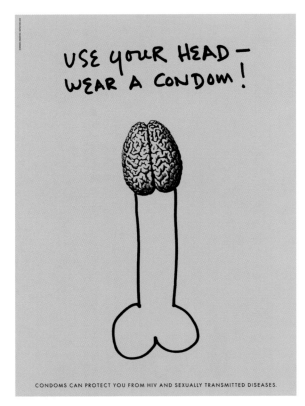

1

2

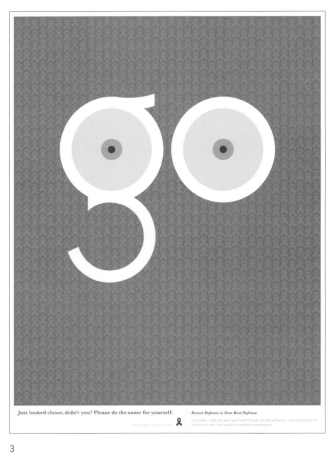

3

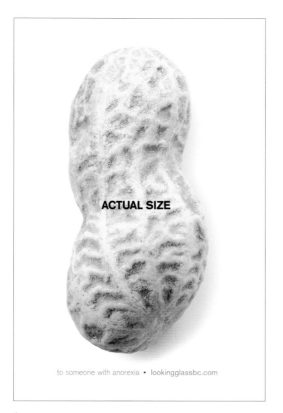

to someone with anorexia • lookingglassbc.com

1

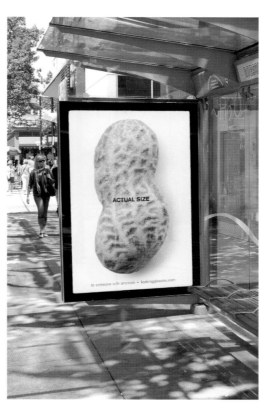

2

1 • 2 • 3

ORGANIZATION
The Looking Glass Foundation

CREATED BY
Alan Russell, Dean Lee, Daryl Gardiner, Jeff Galbraith

DDB Canada / Vancouver
Vancouver, Canada

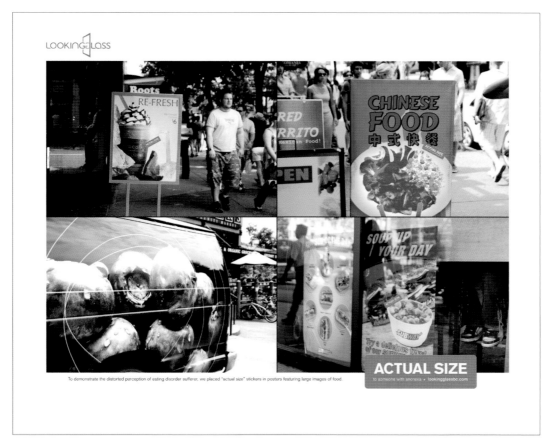

3

1

ORGANIZATION
Pathfinder International

CREATED BY
Alice Hecht, Laura Weiler,
Anne Dauchy, Linda Suttenfield,
Libretto Inc., Pathfinder International

Hecht Design
Arlington, MA

1

reach

Pathfinder has brought reproductive health care to tens of millions of people in more than 120 countries in Africa, Asia, the Near East, and Latin America. Today, our 600-plus employees work alongside more than 300 local partner organizations, helping to implement 60 regional and multi-national programs in more than 25 countries.

MOBILIZING COMMUNITIES IN ETHIOPIA

Pathfinder's reproductive health and family planning projects in Ethiopia are reaching people who often lack information about contraception or access to services. In one year, Pathfinder trained more than 10,000 community-based reproductive health agents—trusted members of their communities—to reach out to those who have been cut off from care due to culture, tradition, or geography. By working through community-based agents, Pathfinder had more than five million contacts with clients who received reproductive health services.

SAVING MOTHERS' LIVES IN NIGERIA

In Nigeria, which has the second highest maternal mortality rate in the world and a long tradition of home births, 55,000 women die annually as a result of pregnancy or childbirth. Through the *Continuum of Care Project*, Pathfinder is helping improve survival rates for one of the deadliest causes of maternal mortality—postpartum hemorrhage. We are training providers to recognize the symptoms of hemorrhage and make speedy medical referrals; introducing a new technology that slows bleeding; and assisting communities in improving emergency transportation to health facilities.

PROVIDING NEW OPTIONS FOR YOUNG COUPLES IN INDIA

The PRACHAR project in India works to improve the welfare of young couples and their children by promoting changes in traditional practices. In three years, the project reached 90,000 adolescents and young couples with information about the risks of early childbearing and the benefits of healthy birth spacing. In a short time, acceptance of contraception improved dramatically. For example, contraceptive use among young married couples increased from below five percent to over 20.

BRINGING SERVICES TO 800,000 WOMEN, MEN AND CHILDREN IN KENYA

In Kenya, Pathfinder works with government and local partners to expand access and integrate services for HIV/AIDS, tuberculosis, and reproductive, maternal, and child health. In one year, outreach workers trained through the program reached more than 800,000 clients. More than 57,000 HIV testing visits were conducted, and 26,000 women were educated about preventing mother-to-child transmission. As a result, by learning their HIV status, pregnant women could act to protect their health and that of their unborn children.

The Power of Pathfinder's Community-Based Model

Throughout our history, Pathfinder has pioneered the use of a community-based approach to reproductive health services that is now a standard the world over. There are three key elements to this model:

- We work though local organizations, which understand the local culture, are well positioned to earn the trust of clients, and can sustain programs after our involvement has ended.
- We seek out community and religious leaders, educating and engaging them in efforts to change attitudes and behaviors that are harmful to women and girls. When local leaders support the need for change, it's easier for individuals to make those changes in their own lives.
- Our programs rely heavily on community health workers, who are often volunteers, to deliver information and services to local neighborhoods and homes. This makes it possible to reach a far larger population at far lower cost than traditional clinical-based service models.

The success of this approach enables Pathfinder to work in a variety of cultural, economic, and geographic settings throughout the world including Ethiopia, Nigeria, India, and Kenya.

"Pathfinder International has brought so much to my community. It has worked at all levels in Ethiopia, going all the way to the village level to significantly reduce maternal and infant mortality. The challenge used to be all about building awareness and convincing people to use services, but since Pathfinder trained all of these community-based reproductive health agents, people are now aware and want services. The increase in contraceptive use in the district has grown from 4 percent to 44 percent."

Hailegebrael Akelu
Community-Based Reproductive Health Agent, Debebrahan, Ethiopia

EXPANDING ACCESS

Blue Cross Blue Shield of Massachusetts Foundation ✳ *2007 Annual Report*

1

ORGANIZATION
Blue Cross Blue Shield of
Massachusetts Foundation

CREATED BY
Alice Hecht, Laura Weiler,
Marylin Humphries, Scott Kearnan

Hecht Design
Arlington, MA

CARING ACROSS
CULTURES

Lowell Community Health Center builds across cultural barriers

YOLANDA
MAURICIO →

MID-IOWA HEALTH FOUNDATION

JOHN SAYLES
SAYLES GRAPHIC DESIGN
DES MOINES, IOWA

The Mid-Iowa Health Foundation understands that annual reports can be rather dry, so they chose Des Moines' Sayles Graphic Design to create something their readers would want to pick up and really get into.

"All these organizations give money to groups, and there's really not much you can show," says co-owner John Sayles, who also designed the reports and created the free, stylized illustrations. "There are no photos, really. Usually you see pictures of people and kids, but it doesn't really show anything." The Foundation, he says, wanted the reports to be "warm, earthy and whimsical" in order to create interest, or as Sayles explains, "get people to read it, take note of it, even just remember it! It's a keepable piece. People hold onto it."

The reports, which have featured drawings of owls, squirrels and fruit, offset the otherwise dull content. "It's the same message every year," Sayles says. When you read it, it's pretty boring copy—that's why I did these short pages. There's always something to look at.'

Despite his iconoclastic approach to annual report design, Sayles prefers traditional media for the end product, whose run averages up to five hundred copies. "What I'd really like to do is have it screen printed," he says of the small-run offset piece. "I just like ink on paper, and for this report you just couldn't get the feel of it digitally."

Sayles knows that an annual report can be difficult to read, and doesn't mind if people just look at it for the pictures—and, it seems, neither does the Foundation. "They pretty much let me do whatever I feel. They're a pretty nice client to have," he says. And even if people gloss over the statistics inside, "Someone can look at it and say, 'Now that was a good annual report!'"

Mid-Iowa Health Foundation '06

ANNUAL REPORT

1

ORGANIZATION
Medtronic Foundation

CREATED BY
Brian Danaher, Michael Hendrickson,
Jeffrey Salter, Joseph Sywenkyj

Peggy Lauritsen Design Group
Minneapolis, MN

1

1

ORGANIZATION
The David H. Koch Institute for
Integrative Cancer Research at MIT

CREATED BY
Alice Hecht, Anne Dauchy,
Libretto, Inc., Kent Dayton,
Sarah Putnam

Hecht Design
Arlington,MA

2

ORGANIZATION
BrainTrust Canada

CREATED BY
Alan Russell, Dean Lee,
Daryl Gardiner,
Paul Little, Frank Hoedl

DDB Canada / Vancouver
Vancouver, Canada

1 • 2 • 3 • 4
ORGANIZATION
Brush. Brush. Smile!
CREATED BY
Craig Welsh, Ford Haegele
Go Welsh
Lancaster, PA

1

2

3

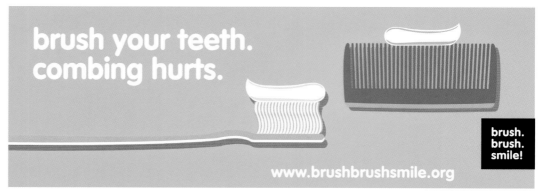

4

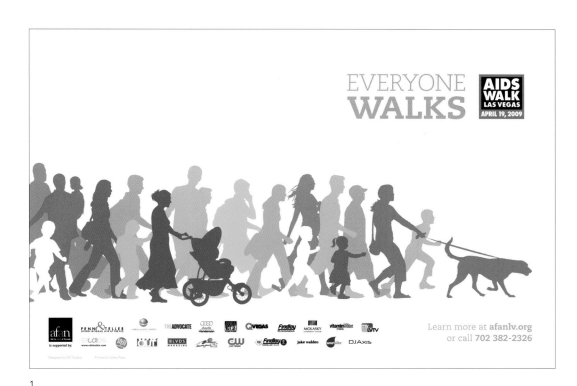

1

1 • 2

ORGANIZATION
AFAN Las Vegas

CREATED BY
Aaron Moses, Brian Felgar

CDI Studios
Las Vegas, NV

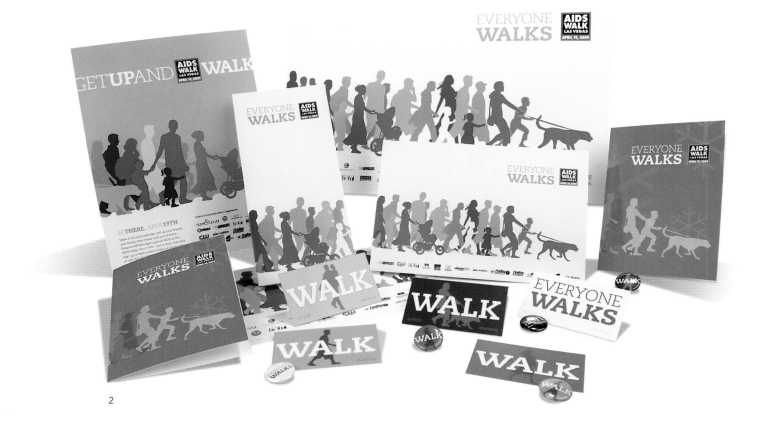

2

1

ORGANIZATION
Chronic Disease Fund

CREATED BY
Jon Sandruck

ohTwentyone
Euless, TX

2

ORGANIZATION
Making Strides

CREATED BY
Scott Mires, Tracy Sabin

Sabingrafik, Inc.
Carlsbad, CA

3

ORGANIZATION
Give Back Global

CREATED BY
Deborah Huelsbergen, Ric Wilson

Type-a-licious
Columbia, MO

4

ORGANIZATION
Broadway Youth Center

CREATED BY
Dawn Hancock, Nako Okubo,
Antonio Garcia

Firebelly Design
Chicago, IL

1

2

3

4

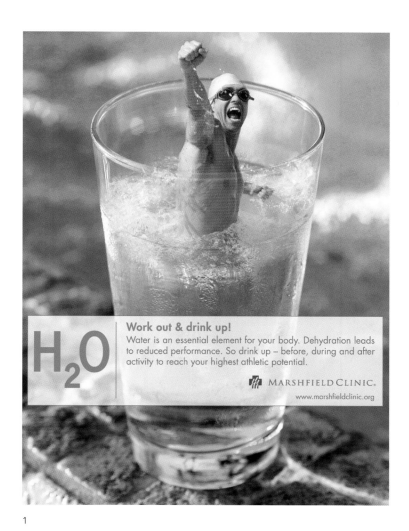

1

ORGANIZATION
Marshfield Clinic
CREATED BY
Erik Borreson, Liquid Library
Marshfield Clinic
Marshfield, WI

2
ORGANIZATION
Commune Wednesdays
CREATED BY
Sarah Sculley, Eric DuBois

Sculley Design
Coorparoo, Australia

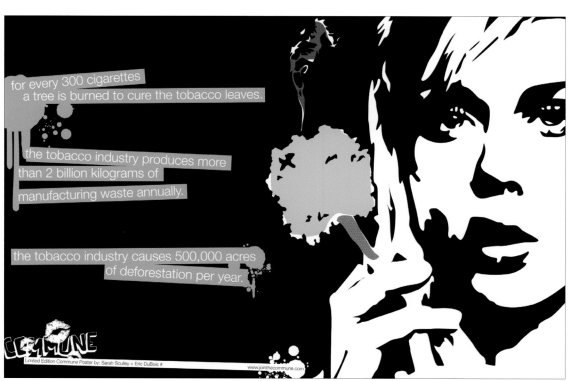

2

SPOTLIGHT ON
THE ART OF YOGA PROJECT

MICHAEL OSBORNE
JOEY'S CORNER
SAN FRANCISCO, CALIFORNIA

Yoga is all about balance and harmony and auspicious beginnings, and so when Michael Osborne started his San Francisco agency, Michael Osborne Design, a mutual friend recommended a woman who was starting her own enterprise. "Mary Lynn was one of our very first clients," he says of her new nonprofit, Art of Yoga.

The organization, which combines yoga and art therapy for at-risk young women in California jails and detention centers, includes a lengthy curriculum creatively laid out by Osborne. He also created the logo, business stationery and brochure. "We showed [the client] three or four design directions and she liked all of them, and they symbolized what she was doing." Osborne let the art program speak for itself, incorporating artwork by the young women themselves into the designs, while keeping a consistent type treatment for the logo and an "official" color scheme of magenta and green.

Understanding the identity is its own exercise in harmony. "The direction is what the organization is doing," Osborne says. "We try to ask questions to find out what's appropriate for who [the client] is and what she's doing: working with teenage women in trouble. It's a fine line we have to address. We want to capture the personality of the organization and yet be businesslike, because the materials are used for fundraising and can't look too lightweight or trendy or whimsical. On the other hand, it's the 'Art of Yoga'—it's a very uplifting, positive organization. So that's the balancing act."

Osborne has taken a couple of his client's yoga classes and enjoys it along with her mission with Art of Yoga. "I think it brings these women to the surface start learning their importance and what the world's about," he says. "Words can be too hard, so they're expressing it through art."

• • •

CREATED BY
Michael Osborne, Jeff Ho

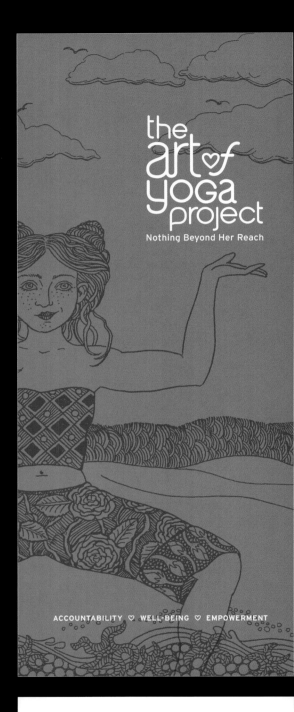

the art of yoga project

Nothing Beyond Her Reach.

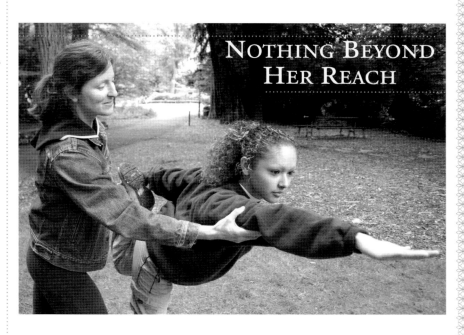

Our Mission

The mission of The Art of Yoga Project is to guide young women to use yoga and creative expression as tools for well-being, accountability and empowerment.

"When I practice yoga I feel whole,
I feel nothing is beyond my reach.
I feel beautiful, strong and perfect,
and fortunate that I am me"

MAKENDRA, AGE 17

NOTHING BEYOND HER REACH

ENTER

840 Kipling Street ♡ Palo Alto, CA 94301 ♡ T 650.322.7520 ♡ E theartofyoga@opendoor.com

WINTER

FOCUS: The six-week winter session is dedicated to a guided journey of self-reflection. Using yoga's "guidelines for living," called *yamas* and *niyamas*, the young women are led through an introspective exploration of important topics such as non-violence, truthfulness, personal ethics and contentment.

WEEK THREE
Focus, Balance, and Intention

FALL

ART PROJECT: BEADED POWER BRACELETS

GOALS
Students will:
- Understand how to set intentions for achieving short and long-term goals.
- Experience more fully the centering and grounding effects of a yoga practice.
- Learn several techniques for focus and balance, anger management and impulse control.
- Experience the effects of deep breathing for stress reduction, and relaxation.

OBJECTIVES
Students will:
- Be able to define "drishti" as a technique for focus and grounding.
- Be able to demonstrate "take five breathing" for anger management and impulse control.
- Create a beaded power bracelet as a reminder to keep their intentions strong and individual goals alive.

MATERIALS
- Yoga equipment: mats, blocks, straps, eye pillows
- Setting the space: flowers, Buddha, candles, scarves for centerpiece, posters of yoga's guidelines.
- Art activity materials:
 A wide variety of fun beads—larger are a little easier
 Stretch nylon, specific for beading, works best because it's flexible and knots hold
 Beads with letters on them (craft stores often have them, they look like dice with letters)
 Cheryl Richardson's Self-Care cards or any other "inspiration" cards with positive guidance and affirmations (e.g., angel cards, goddess cards, animal totems, etc.)
 Journals and pens

SET-UP
The instructor asks the girls to sit in a circle, with the instructor and support staff spread throughout. The instructor then welcomes the group and asks everyone to check-in.

CHECK-IN (5 MINUTES)
The instructor asks the girls to:
Say your name and name one goal you're working on in the short-term and one goal you're working on in the long-term.

READING (1 MINUTE)
"Yoga practice transforms us. We become more beautiful, our faces change and our walk gains in elasticity. Our way of standing is sturdy and poised, our legs are firmer, and our toes and feet spread out, giving us more stability. Our chests expand, the muscles of the abdomen start to work, the head is lighter on the neck (like the corolla of a flower on its stem moving easily with flexibility while the wind blows). To watch these enchanting changes is amazing. A different life begins and the body expresses a happiness never felt before. These are not words, it actually happens."

-Vanda Scaravelli

YOGA AS A TOOL FOR CENTERING AND SETTING INTENTIONS (5 MINUTES)
The instructor begins a discussion of yoga as a tool for grounding and balancing, both physically and emotionally. Introduce the practice of setting intention as a way to ground oneself and reach individual goals. Prompts could include:

How many of you have found it hard to concentrate in school?
How many have had trouble sticking to a goal?
What about controlling your emotions? For instance, when you feel angry?
What is "intention?"

EXPLANATION OF DRISHTI (1 MINUTE)
Instructor introduces the concept of "drishti" as a tool for centering and balancing. In Sanskrit, "dri" means to hold. Drishti means to fix your eyes softly on a spot. Instructor asks the students to find an object and focus on it. The gaze is steady but not hard. The face stays soft and everything around the object becomes a bit hazy. If practiced during the yoga postures, drishti can help with one's balance.

PHOTO BY JANE OSMO SMITH

• FALL • WEEK THREE | 27

1

ORGANIZATION
Fenway Community Health

CREATED BY
Dawn Hancock, Katie Yates,
Kara Brugman

Firebelly Design
Chicago, IL

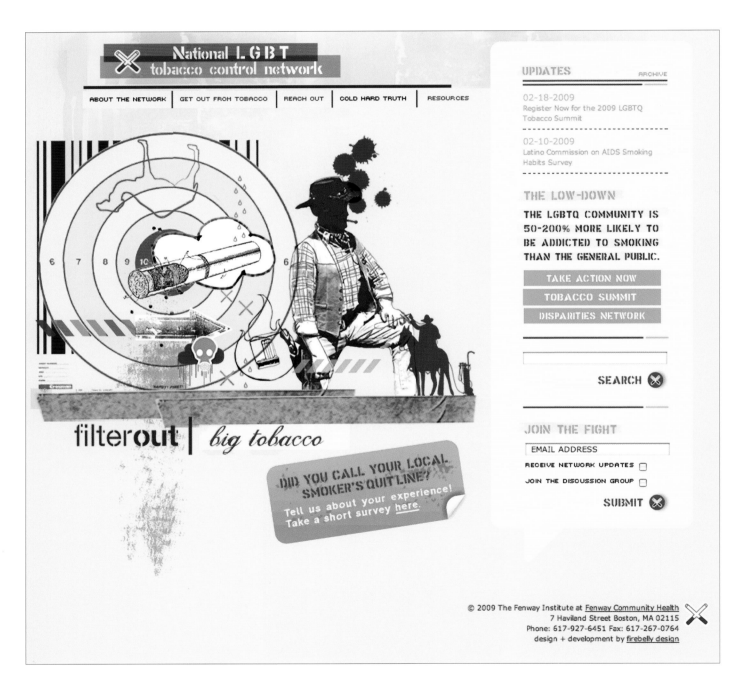

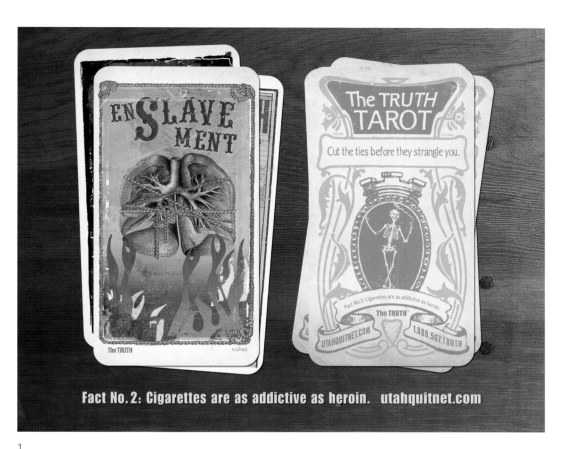

Fact No. 2: Cigarettes are as addictive as heroin. utahquitnet.com

1

1 • 2

ORGANIZATION
Utah Department of Health

CREATED BY
Preston Wood, Dung Hoang,
Kevin Peaslee

Love Communications
Salt Lake City, UT

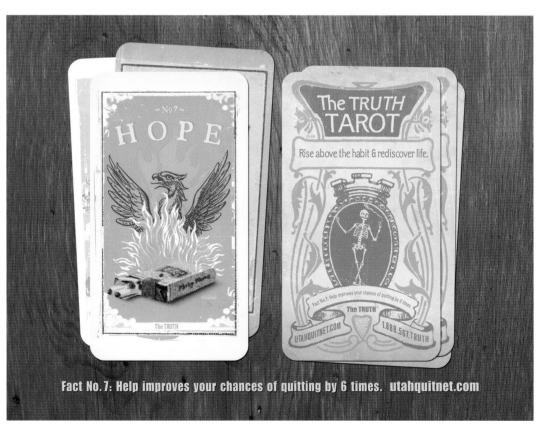

Fact No. 7: Help improves your chances of quitting by 6 times. utahquitnet.com

2

1

ORGANIZATION
Prostate Cancer Foundation

CREATED BY
Kim Baer, Allison Bloss

KBDA
Santa Monica, CA

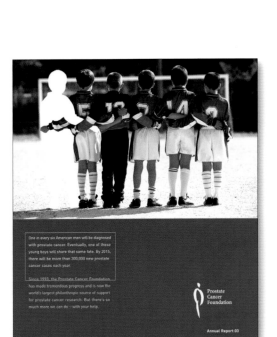

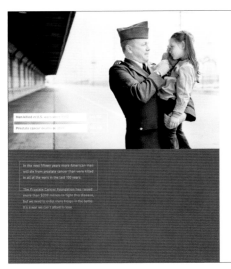

01

THE FACTS ABOUT PROSTATE CANCER

Cancer of the prostate is the most common non-skin cancer in America. A nonsmoking male is more likely to get prostate cancer than the seven next most prevalent cancers combined. In 2003, 230,000 men were diagnosed with prostate cancer, and nearly 30,000 men died from it. It may surprise you to learn that an American man is actually 33% more likely to develop prostate cancer than an American woman is to get breast cancer.

Scientists and researchers have not yet determined why the prostate — a walnut-sized reproductive gland located between a man's bladder and penis — is unusually prone to cancer. Yet one in six American men will develop prostate cancer in their lifetimes, an unacceptably high rate that the Prostate Cancer Foundation is dedicated to sharply reducing.

American men are particularly susceptible to prostate cancer compared with men in other countries, especially those living in Japan and China, where the prostate cancer rate is markedly lower. Scientists theorize that the high-fat American diet and other lifestyle issues may be the culprits — which is why the Prostate Cancer Foundation has made research grants to study the American diet's role in prostate cancer.

Heredity may play a role: Prostate cancer has the strongest familial link of any of the major cancers. One in every four men with prostate cancer has a family history of it. Some men actually inherit a mutated gene that makes it more likely that they will develop prostate cancer. In many

PCF 05

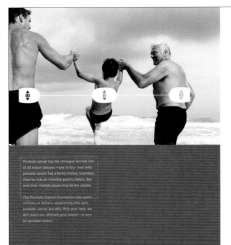

02

PROSTATE CANCER RESEARCH: THE PCF'S PIVOTAL ROLE

Over the past 11 years, the Prostate Cancer Foundation has played a vital and unique role in advancing prostate cancer research. The PCF has raised more than $208 million in private contributions for prostate cancer research and has successfully advocated for significant increases in government research spending.

The PCF has pioneered a "fast-track" awards process that minimizes the time spent filling out applications and maximizes the time spent working on research. It has followed a venture capital model of philanthropic investing, providing initial funding for high-impact, early-stage research projects that offer great hope for new treatments or better understanding of the disease.

When the PCF entered the field, there was virtually no private funding for prostate cancer research and federal government funding totaled just $25 million per year. Scientists avoided prostate cancer research because there was so little money available. Because there was so little research interest, the government and philanthropies did not earmark much funding for it. The PCF was determined to change this vicious cycle, and it has.

Since 1993, the Prostate Cancer Foundation has awarded more than 1,100 grants to researchers at 100 institutions worldwide. The PCF is now the largest philanthropic source of support for prostate cancer research in the world.

PCF 09

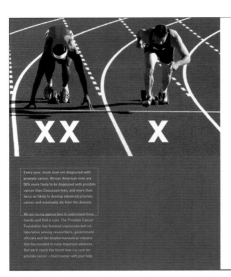

03

THE COLLABORATIVE EFFORT

The Prostate Cancer Foundation believes that the fastest way to significantly reduce prostate cancer deaths is to foster collaborative efforts within the medical and scientific communities. The PCF staff and board members spend a great deal of time forging ties among disparate players in the prostate cancer field, including researchers in the lab, government officials who oversee research funding and pharmaceutical executives who develop and market treatments.

The centerpiece of the PCF's efforts is the annual Scientific Retreat, a unique gathering of research scientists, physicians, government officials, industry executives and others. For three days, these leaders engage in intensive discussions and presentations designed to break down the barriers that impede progress toward a cure for prostate cancer. Over the years, the Retreat has been a catalyst for numerous advances in prostate cancer research. One such instance involved Velcade, a promising investigational drug that was presented at the 5th Annual Scientific Retreat in 1998, when funding for its further development was endangered. Following the retreat, the PCF provided crucial funding to keep the project alive, and in 2003 Velcade was approved for multiple myeloma (bone marrow cancer) and is being tested for treatment of advanced prostate cancer.

In November 2003, the PCF held its 10th Annual Scientific Retreat in New York City, bringing together 400 attendees from around the world. The retreat covered a wide range of topics in prostate cancer research, including the latest research into androgen receptors, tyrosine kinases (growth factor regulation) and new drug development; updates on advances in clinical trial design;

PCF 15

1

ORGANIZATION
Florida Atlantic University

CREATED BY
Heather Bellino

Bellino Graphics
Henderson, NV

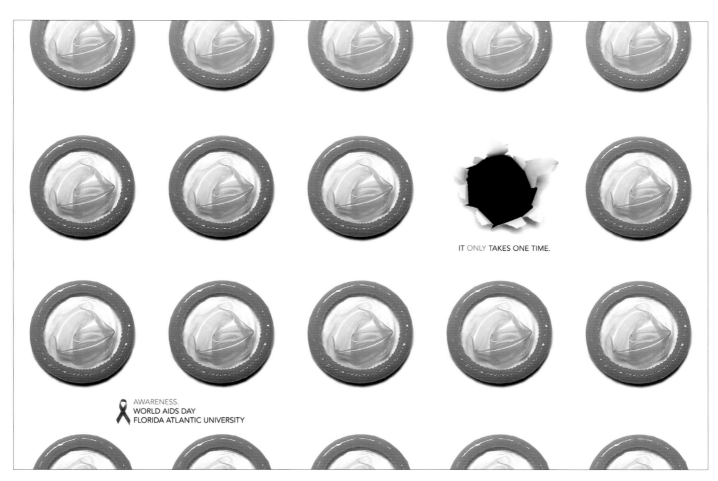

1

1 • 2 • 3

ORGANIZATION
The Looking Glass Foundation

CREATED BY
Alan Russell, Dean Lee, Daryl Gardiner,
Jeff Galbraith, Frank Hoedl

DDB Canada / Vancouver
Vancouver, Canada

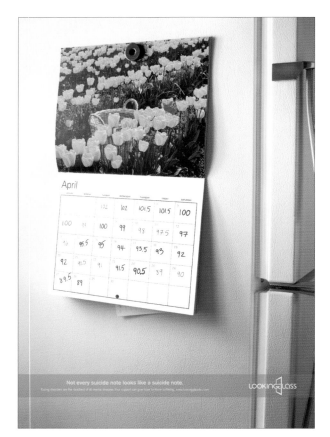

2

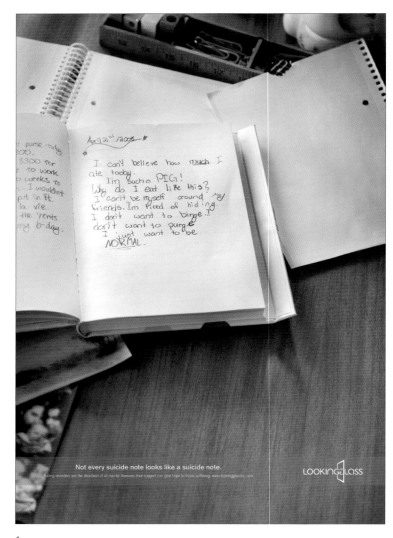

1

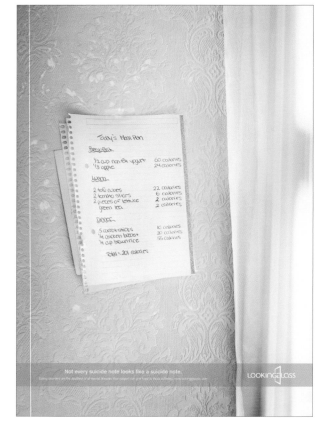

3

PREVENT HIV/AIDS IN AFRICA
THE CAUSE OF OVER 2 MILLION DEATHS

1

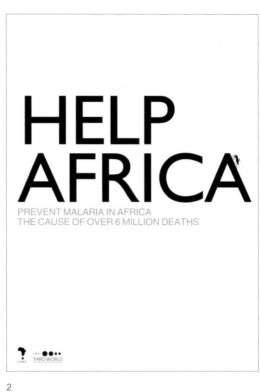

PREVENT MALARIA IN AFRICA
THE CAUSE OF OVER 6 MILLION DEATHS

2

1 • 2

ORGANIZATION
C.A.R.E. and THIRD WORLD

CREATED BY
Nenad Dickov
Novi Sad, Serbia

3

ORGANIZATION
Chicago Abortion Fund

CREATED BY
Dawn Hancock, Aaron Shimer,
Alexdrina Chong, Kara Brugman

Firebelly Design
Chicago, IL

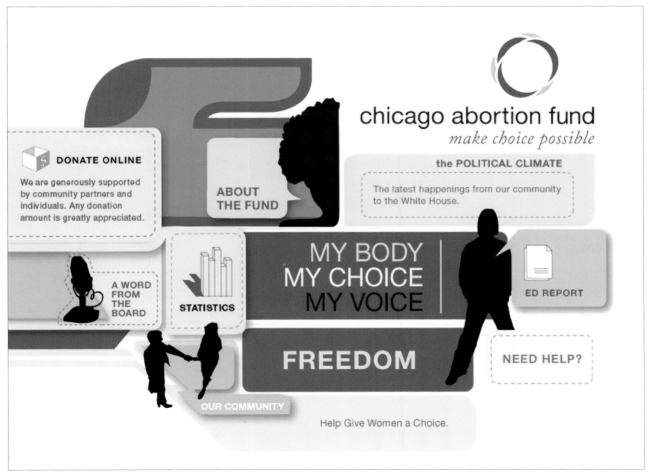

3

SPOTLIGHT ON
UTAH DEPARTMENT OF HEALTH CLUB AND BAR POSTERS

PRESTON WOOD
LOVE COMMUNICATIONS
SALT LAKE CITY, UTAH

Any health worker dealing with tobacco-related illnesses can tell you that smoking and smokeless aren't glamorous—but getting that message across to Middle America's young and invincible twentysomethings takes finesse. "It's a very, very difficult category to connect to, so you do things that aren't traditional marketing," says Preston Wood of Salt Lake's Love Communications.

To this end, Wood coordinated a series of collectible posters for the Utah Department of Health for distribution in clubs and bars frequented by a demographic most at risk for new tobacco addiction. He says, "It started at the college level—health centers, concert series—and it was met with such [a positive] response, we realized we'd use the same tactics to get into bars and clubs."

The posters themselves, which depict shocking graphics steeped in tar-black humor, became unexpected objects of desire. "It's art with also a message," Wood explains. "Suddenly people said they saw them in college dorms." The posters, created by artists with a background in creating posters for rock shows, took off—T-shirts and signed, limited-edition prints followed. "They're fun and stylish," Wood says, "and we did art in a very progressive way, like the way bands are marketed nowadays. You can be anti-tobacco but not dissing on your friends for smoking. It's great social marketing."

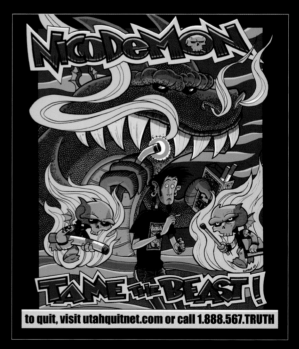

Of course, given the demographic, a bit of backlash was to be expected; irony is the natural currency of the 18-to-25 crowd. "There was a little bit of that," Wood admits. "I'm sure some smokers took the posters. They're edgy, and they make a statement by people using them as art." Overall, though, the state considers the campaign a success. "They understand that 'even if I don't like it, it doesn't mean our client won't like it.' They see the high-risk people and they're very supportive."

• • •
CREATED BY
Preston Wood, Bret Ivory, Katie Bradley

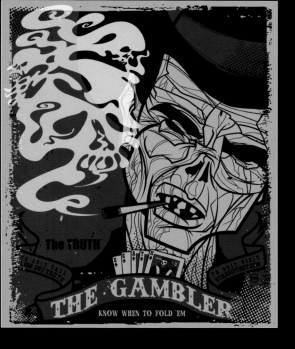

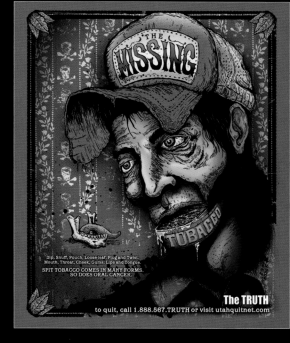

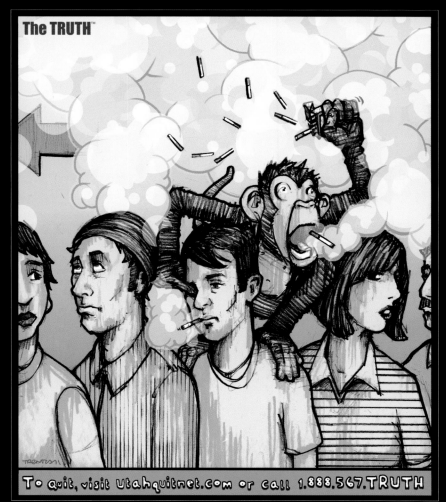

1 · 2

ORGANIZATION
Utah Cancer Action Network

CREATED BY
Preston Wood, Adam Fox,
Katie Bradley, Chad Hurst

Love Communications
Salt Lake City, UT

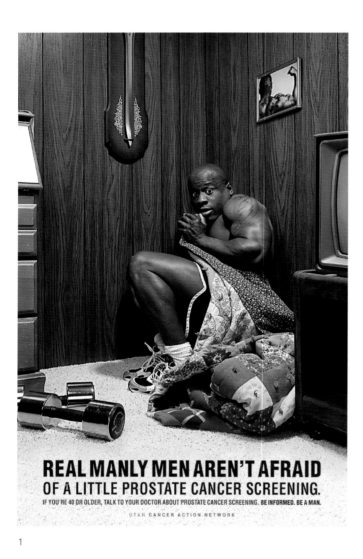

1

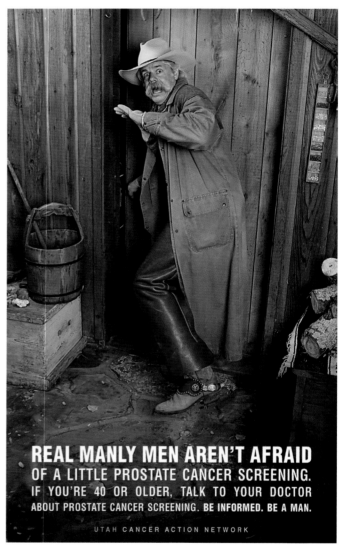

2

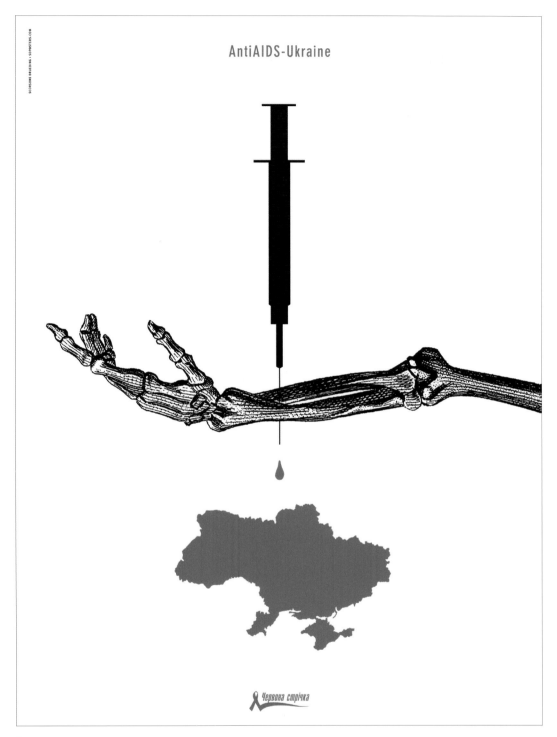

AntiAIDS-Ukraine

1
ORGANIZATION
The Kharkov Regional Center for AIDS
Prevention and Control
CREATED BY
Joe Scorsone, Alice Drueding
Scorsone/Drueding
Jenkintown, PA

1

ORGANIZATION
The Exceptional Outreach
Organization
CREATED BY
Kevin Smith
CreateTWO
Auburn, AL

1

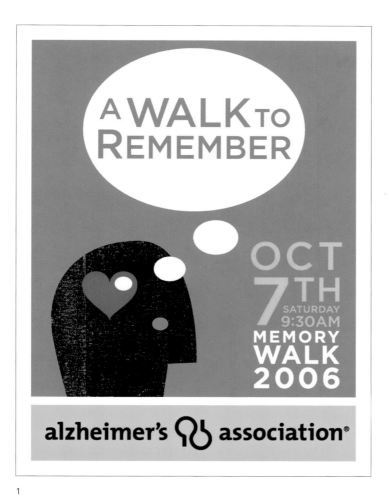

1

ORGANIZATION
Alzheimer's Association
CREATED BY
Michael Osborne, Jeff Ho
Joey's Corner
San Francisco, CA

2
ORGANIZATION
Prostate Cancer Foundation
CREATED BY
Kim Baer, Allison Bloss
KBDA
Santa Monica, CA

2

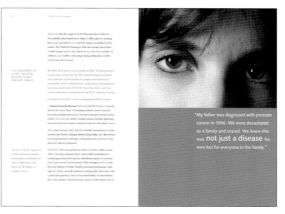

1

ORGANIZATION
Mid-Iowa Health Foundation
CREATED BY
John Sayles
Sayles Graphic Design
Des Moines, IA

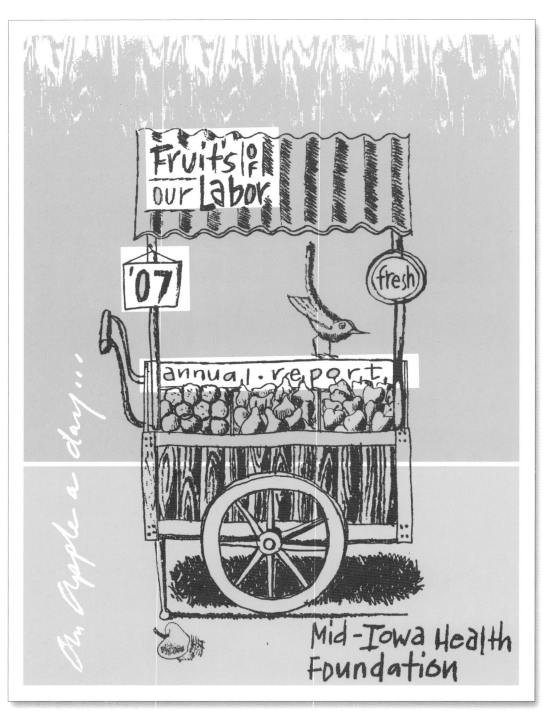

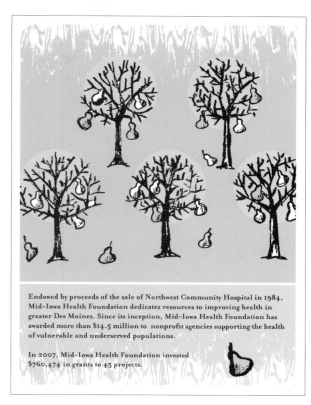

Endowed by proceeds of the sale of Northwest Community Hospital in 1984, Mid-Iowa Health Foundation dedicates resources to improving health in greater Des Moines. Since its inception, Mid-Iowa Health Foundation has awarded more than $14.5 million to nonprofit agencies supporting the health of vulnerable and underserved populations.

In 2007, Mid-Iowa Health Foundation invested $760,474 in grants to 45 projects.

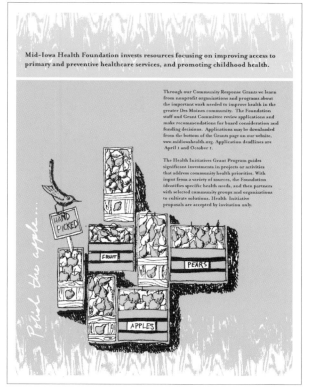

Mid-Iowa Health Foundation invests resources focusing on improving access to primary and preventive healthcare services, and promoting childhood health.

Through our Community Response Grants we learn from nonprofit organizations and programs about the important work needed to improve health in the greater Des Moines community. The Foundation staff and Grant Committee review applications and make recommendations for board consideration and funding decisions. Applications may be downloaded from the bottom of the Grants page on our website, www.midiowahealth.org. Application deadlines are April 1 and October 1.

The Health Initiatives Grant Program guides significant investments in projects or activities that address community health priorities. With input from a variety of sources, the Foundation identifies specific health needs, and then partners with selected community groups and organizations to cultivate solutions. Health Initiative proposals are accepted by invitation only.

1

ORGANIZATION
ORBIS International

CREATED BY
Frankie Gonzalez, Nick Schmitz

3rd Edge Communications
Jersey City, NJ

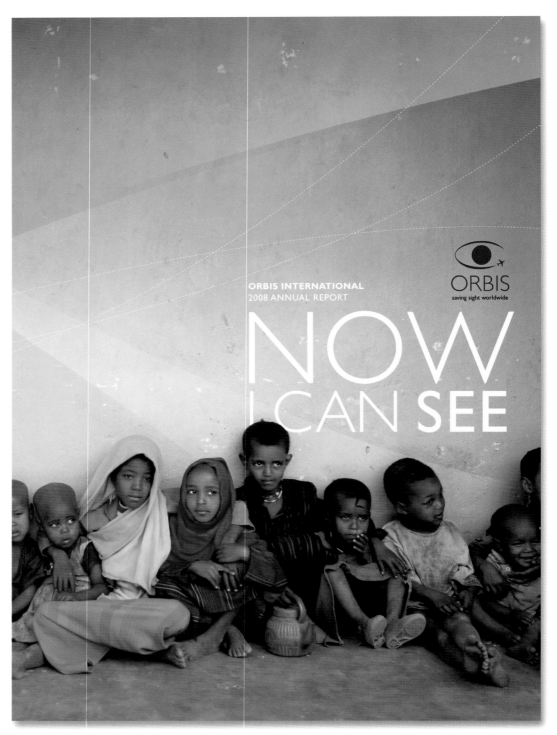

CAPACITY BUILDING

ASSEMBLING CRUCIAL COMPONENTS FOR IMPROVED EYE CARE SERVICES

Since 1982, ORBIS has carried out more than 1,000 programs in 86 countries, delivering the resources and inspiration for people of diverse backgrounds to work together to prevent, manage and cure avoidable blindness.

CAPACITY BUILDING
- Training eye care professionals and other health workers
- Introducing ophthalmic technology and related management systems
- Improving the quality and accessibility of eye care

PUBLIC AWARENESS
- Increasing awareness that blindness can be prevented or treated

ADVOCACY
- Promoting improved eye care services at the national level

ORBIS's integrated approach consists of:

COUNTRY PROGRAMS
In five priority countries—Bangladesh, China, Ethiopia, India and Vietnam—ORBIS develops and implements comprehensive eye care and blindness prevention efforts. Long-term regional projects are also underway in parts of Latin America and the Caribbean.

THE FLYING EYE HOSPITAL
The world's only airborne ophthalmic training facility serves as a focal point for educational programs and advocacy efforts. On board, eye care professionals from developing nations work side-by-side with the ORBIS medical team and volunteer teaching faculty to perform surgery, learn new skills and restore sight.

HOSPITAL-BASED TRAINING PROGRAMS AND FELLOWSHIPS
Year round, ORBIS conducts intensive specialized training at local hospitals and supports fellowships for talented eye care professionals to undertake advanced study with mentors at some of the world's leading eye care institutions.

CYBER-SIGHT®
This cutting edge telemedicine program uses the Internet to connect doctors throughout the world with ORBIS volunteer ophthalmologists for professional mentoring, patient consultation and online continuing medical education.

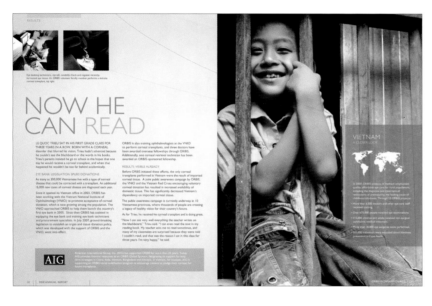

Eye banking technicians, top: cell, candida check and register recently harvested eye tissue. An ORBIS volunteer faculty member performs a delicate corneal transplant, top right.

NOW HE CAN READ

LE QUOC TRIEU SAT IN HIS FIRST GRADE CLASS FOR THREE YEARS IN A ROW, BORN WITH A CORNEAL disorder that blurred his vision, Trieu hadn't advanced because he couldn't see the blackboard or the words in his books. Trieu's parents insisted he go to school in the hopes that one day he would receive a corneal transplant, and when that happened he wouldn't be too far behind academically.

EYE BANK LEGISLATION SPURS DONATIONS

As many as 300,000 Vietnamese live with a type of corneal disease that could be corrected with a transplant. An additional 15,000 new cases of corneal disease are diagnosed each year.

Since it opened its Vietnam office in 2003, ORBIS has been working with the Vietnam National Institute of Ophthalmology (VNIO) to promote acceptance of corneal donation, which is now growing among the population. The VNIO approached ORBIS to help them launch the country's first eye bank in 2005. Since then ORBIS has assisted in equipping the eye bank and training eye bank technicians and procurement specialists. In July 2007, ground-breaking legislation to establish an organ and tissue donation policy, which was developed with the support of ORBIS and the VNIO, went into effect.

ORBIS is also training ophthalmologists at the VNIO to perform corneal transplants, and three doctors have been awarded overseas fellowships through ORBIS. Additionally, one corneal retrieval technician has been awarded an ORBIS-sponsored fellowship.

RESULTS VISIBLE ALREADY

Before ORBIS initiated these efforts, the only corneal transplants performed in Vietnam were the result of imported corneal tissue. A joint public awareness campaign by ORBIS, the VNIO and the Vietnam Red Cross encouraging voluntary corneal donation has resulted in increased availability of domestic tissue. This has significantly decreased Vietnam's dependency on imported corneal tissue.

The public awareness campaign is currently underway in 10 Vietnamese provinces, where thousands of people are creating a legacy of healthy vision for their country's future.

As for Trieu, he received his corneal transplant and is doing great.

"Now I can see very well everything the teacher writes on the blackboard," Trieu said. "I can even read the text in my reading book. My teacher asks me to read sometimes, and many of my classmates are surprised because they were told I couldn't read, and that was the reason I sat in this class for three years. I'm very happy," he said.

VIETNAM
A CLOSER LOOK

In 2003, ORBIS protects in Vietnam emphasized quality, affordable eye care for rural populations, including the diagnosis and treatment of retinopathy of prematurity, the leading cause of childhood blindness. Through 12 ORBIS projects:

- More than 6,000 theaters and other eye care staff received training.
- Over 675,000 people received eye examinations.
- 215,000 children and adults received non-surgical ophthalmic medical treatment.
- More than 18,000 eye surgeries were performed.
- 365,000 individuals were educated about blindness prevention and eye health.

AIG American International Group, Inc. (AIG) has supported ORBIS for more than 20 years. Today, AIG provides financial resources as an ORBIS Global Sponsor, designated to support for long term investments in China, India, Vietnam, Bangladesh and Ethiopia. For example, AIG is supporting an ORBIS corneal transplantation program to encourage cornea re-stocking in Vietnam for future transplants.

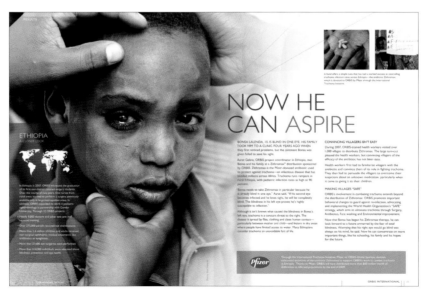

NOW HE CAN ASPIRE

BONSA LALENDA, 10, IS BLIND IN ONE EYE. HIS FAMILY TOOK HIM TO A CLINIC FOUR YEARS AGO WHEN they first noticed problems, but the ointment Bonsa was given failed to save his sight.

Aaron Gebre, ORBIS project coordinator in Ethiopia, met Bonsa and his family at a Zithromax® distribution sponsored by ORBIS. Zithromax is the Pfizer-donated antibiotic used to protect against trachoma—an infectious disease that has plagued millions across Africa. Trachoma runs rampant in rural Ethiopia, with pediatric infection rates as high as 90 percent.

"Bonsa needs to take Zithromax in particular because he is already blind in one eye," Aaron said. "If his second eye becomes infected and he loses sight, he will be completely blind. The blindness in his left eye proves he's highly susceptible to infection."

Although it isn't known what caused the blindness in Bonsa's left eye, trachoma is a constant threat to the right. The disease is spread by flies, clothing and close human contact—particularly between mother and child—and flourish in dry areas where people have limited access to water. Many Ethiopians consider trachoma an unavoidable fact of life.

CONVINCING VILLAGERS ISN'T EASY

During 2007, ORBIS-trained health workers visited over 1,000 villages to distribute Zithromax. The large turnout pleased the health workers, but convincing villagers of the efficacy of the antibiotic has not been easy.

Health workers first had to familiarize villagers with the antibiotic and convince them of its role in fighting trachoma. They then had to persuade the villagers to overcome their suspicions about an unknown medication, particularly when it came to giving it to their children.

MAKING VILLAGES "SAFE"

ORBIS's involvement in combating trachoma extends beyond the distribution of Zithromax. ORBIS promotes important behavioral changes to guard against re-infection, advocating and implementing the World Health Organization's "SAFE" strategy, which aims to eliminate trachoma through Surgery, Antibiotics, Face washing and Environmental improvements.

Now that Bonsa has begun his Zithromax therapy, he can look forward to a future unmarred by the fear of total blindness. Worrying that his right eye would go blind was always on his mind, he said. Now he can concentrate on more important things, like his schooling, his family and his hopes for the future.

ETHIOPIA
A CLOSER LOOK

In Ethiopia in 2007, ORBIS witnessed the graduation of its first non-doctor cataract surgery students. Over the course of two years, nine nurses from rural areas received specialized training previously available only to ophthalmologists. Through 12 ORBIS projects:

- Nearly 5,000 doctors and other eye care staff received training.
- Over 375,000 people received eye examinations.
- More than 1.6 million children and adults received non-surgical ophthalmic medical treatment for blindness or amblyopia.
- More than 27,000 eye surgeries were performed.
- More than 414,000 individuals were educated about blindness prevention and eye health.

A hand offers a single cure that has had a marked success in controlling trachoma infection rates across Ethiopia—the antibiotic Zithromax, which is donated to ORBIS by Pfizer through the International Trachoma Initiative.

Pfizer Through the International Trachoma Initiative, Pfizer, an ORBIS Global Sponsor, donates substantial quantities of the antibiotic Zithromax to support ORBIS's work to combat trachoma in Ethiopia. Thanks to Pfizer, ORBIS will have distributed more than $40 million worth of Zithromax to infected populations by the end of 2009.

CALGARY SOCIETY FOR PEOPLE WITH DISABILITIES

JOE HOSPODAREC
WAX
CALGARY, ALBERTA, CANADA

Most of us think nothing of jumping into our cars and running to the store—and that's exactly what the Calgary Society for People with Disabilities (CSPD) wanted to demonstrate with its annual report, produced by local agency WAX. "Typically donations go into a general revenue fund and they send you a thank you note," says executive creative director Joe Hospodarec. "They showed us what they *bought*." According to designer Jonathan Herman, "[CSPD] had a very successful year with a number of cash and services donations, and they wanted to highlight where the money went, things we take for granted, things that make a big difference."

These everyday objects—photographed on location in clients' homes—became not only the stars of the annual report but the medium as well, with stories and figures written right on them with dry-erase markers. "The van gave [clients] mobility, so they could go places without waiting for the bus," explains Hospodarec. "The bidet isn't the most glamorous thing but it gave them dignity in cleaning themselves. By showing these things that made a difference in their lives, [we showed] things that gave them personal freedom, dignity, happiness—and showed donors where their dollars went." Adds Herman: "There's someone behind every object."

More than six hundred annual reports went out to donors, families of clients and government agencies. The unconventional reports "created a really engaging book," says Herman. "People read it again and again. They feel challenged and engaged to read it." Says Hospodarec. "The reports communicated the story of the CSPD in a really strong way."

One challenge became an opportunity for creativity, says Hospodarec. "The accountant wouldn't sign off on the auditor's report being handwritten on a dishwasher, so we had it coming out of a fax machine. So we found that way around it."

• • •
CREATED BY
Monique Gamache, Joe Hospodarec, Jonathan Herman, Saro Ghazarian, Justen Lacoursiere

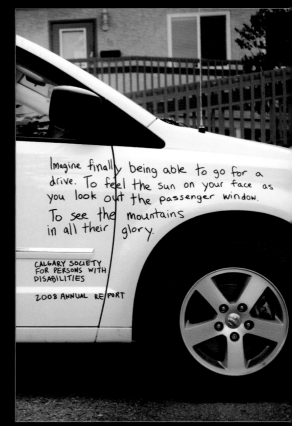

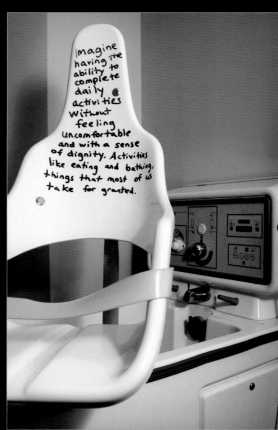

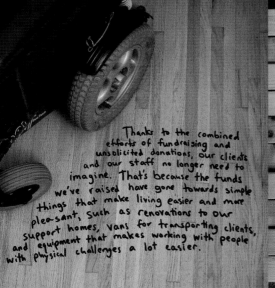

Thanks to the combined efforts of fundraising and unsolicited donations, our clients and our staff no longer need to imagine. That's because the funds we've raised have gone towards simple things that make living easier and more pleasant, such as renovations to our support homes, vans for transporting clients, and equipment that makes working with people with physical challenges a lot easier.

Another year of service and support has gone by, but the concern for obtaining sufficient funding for our day-to-day operations continues to be a growing concern. This year, the CSPD received a one-time grant from the PDD for recruitment and retention, which was used for one-time bonuses and recruitment for our valued employees. But we still need help. Since our doors first opened, it's been our mission to support adults with developmental disabilities to reach their greatest potential through quality community living. Through proper funding, we look forward to another year and hope to continue to make a difference in the quality of life of everyone we touch.

Mickey Greiner
Executive Director

Liza Mulholland
Fund Development Chairperson

RESIDENTIAL SUPPORT

We provide three types of residential supports: Community Homes, Independent Living, and Community Support. Since our first home opened over 30 years ago, we've placed great importance on the compatibility between roommates, support workers, and service providers. Because of our dedicated staff, our 45 clients have been able to reach personal bests that have gone beyond expectations.

team recognition award

1 • 2 • 3

ORGANIZATION
Utah Department of Health

CREATED BY
Preston Wood, Trent Wall,
Alison Faulkner

Love Communications
Salt Lake City, UT

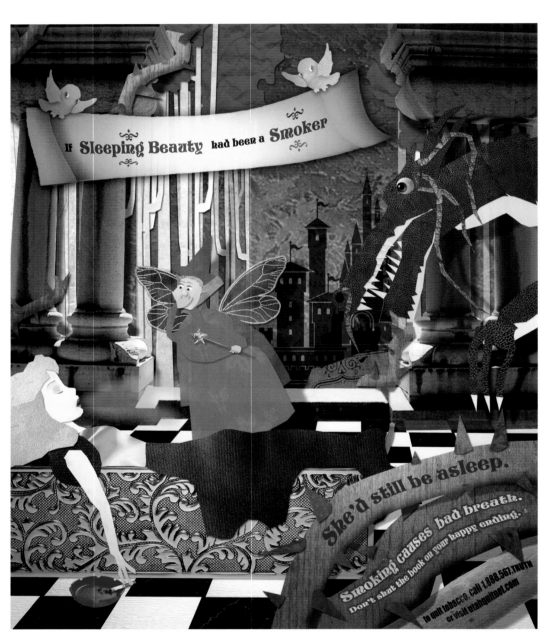

1

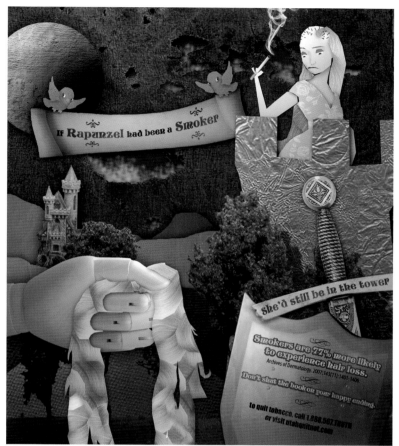

2

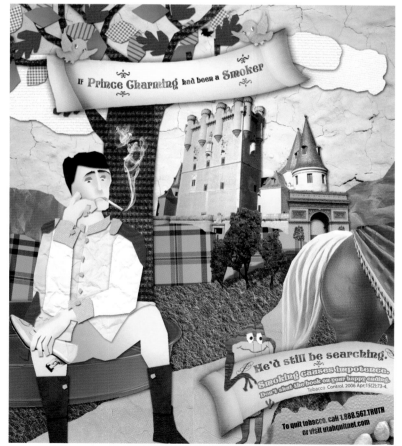

3

1 • 2 • 3
ORGANIZATION
Hope Clinic for Women
CREATED BY
Lydia Light
whatislight
Knoxville, TN

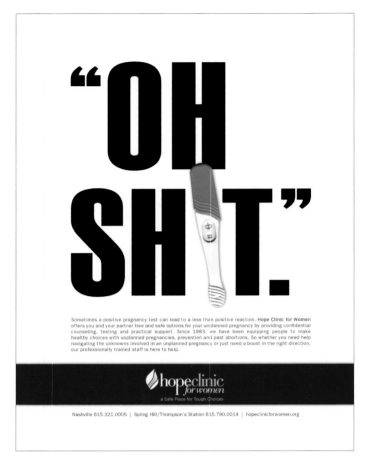

1

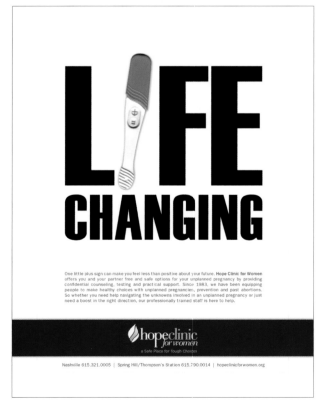

2

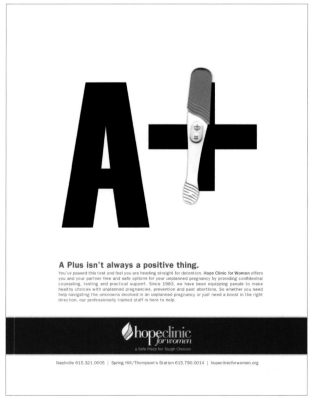

3

1

ORGANIZATION
Liv International and ONJ Productions

CREATED BY
Gabrielle Raumberger, Kimiyo Nishio,
Brandon Fall, Mariko Ostboe

Epos, Inc.
Hermosa Beach, CA

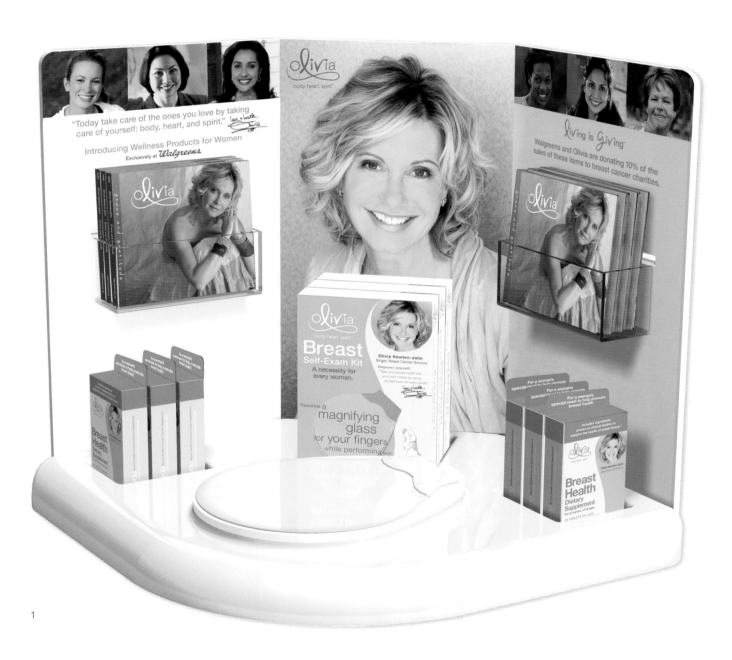

1

1

ORGANIZATION
The Simons Foundation

CREATED BY
Dwayne Flinchum, Yi Son Ko,
June Kim, Ferdinand Alfonso

IridiumGroup
New York, NY

1

Simons Foundation
Annual Report 2007

President's Letter
Math & Science
• SFARI
Financials

Simons Staff
Simons Grants
Contact Us

Explore

SFARI: Simons Foundation Autism Research Initiative

Autism is a developmental disorder that was first described more than 70 years ago. Clinical descriptions have become more precise with time, and new diagnostic instruments have quantified cardinal clinical features across the entire spectrum of autism disorders.

Due in part to these improvements in diagnosis, the number of children identified as having autism has steadily risen over the past two decades. Despite the increasing awareness of autism, however, the disorder's causes remain mysterious.

However, we have good reasons to hope that, in the near future, we will understand much more about what causes autism. Recent advances in genetics and neuroscience have led to new hypotheses, and to the discovery of molecular, anatomical and functional 'biomarkers' that will facilitate research.

• The rapid development of genetic technologies, including high-resolution comparative genome hybridization and high-throughput DNA sequencing, has intensified the search for risk genes. It is clear that no single gene causes all manifestations of autism, but the identification of genetic risk factors will turn attention to relevant biochemical pathways, regions of the brain and critical times during development.

• New methods for characterizing neural circuits and for manipulating genes that alter circuit function can help understand learning, memory and the 'social brain'. They also offer the exciting possibility of preventing or even reversing errors in development that predispose to autism.

• High-resolution brain imaging and new methods for recording electromagnetic signals from populations of nerve cells have led to testable hypotheses about social cognition, language delay and repetitive behaviors.

SFARI, the Simons Foundation Autism Research Initiative, is funding research in each of these areas. We have also initiated an unprecedented effort to characterize 2,000 'simplex' families (see page 20).

There is a growing excitement in the autism research community. New, talented investigators have been attracted to the field, and hopes are high that major advances are on the horizon.

Gerald D. Fischbach
SFARI Director

Simons Foundation
Annual Report 2007

President's Letter
Math & Science
SFARI
• Financials

Simons Staff
Simons Grants
Contact Us

Sustain

1

ORGANIZATION
Nebraska AIDS Project
CREATED BY
Drew Davies, Ted Schlaebitz
Oxide Design Co.
Omaha, NE

2

ORGANIZATION
Calagraphic Design
CREATED BY
Ronald J. Cala II
Calagraphic Design
Elkins Park, PA

3

ORGANIZATION
Good 50 x 70
CREATED BY
Ronald J. Cala II
Calagraphic Design
Elkins Park, PA

1

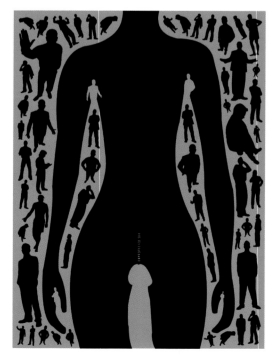

2

3

1 · 2 · 3

ORGANIZATION
City of Hope

CREATED BY
Howie Cohen, Mike Cunningham,
Armand Kerechuk

The Phelps Group
Santa Monica, CA

1

How can you remove
a brain tumor without
harming the brain?

Brain canswer.

City of Hope is a leader in minimally invasive surgery, and our skilled surgeons are at the forefront in targeting and removing brain tumors. Computerized mapping, used during an operation, provides a clear image of key brain regions, including those for speech, movement and sensation. This minimizes the risk of neurological damage while maximizing tumor removal. In addition, City of Hope is a pioneer in TomoTherapy, a non-surgical radiation technique that precisely targets the tumor, while sparing the healthy tissue around it. And we're conducting a number of promising clinical trials, such as immunotherapy, which uses the body's own immune system to fight cancer. For an appointment, call 800-826-HOPE. Or ask your doctor for a referral. We accept most insurance. At City of Hope, we have answers to cancer.

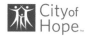

City of
Hope™

Science saving lives.
cityofhope.org/brain

2

Can a robot
named da Vinci help you
recover faster?

Colon canswer.

At City of Hope we're leading the way with robotic laparoscopic surgery for colon cancer patients, using the most advanced da Vinci® robotic system. In fact, last year we performed more robotic procedures than any other hospital in the area. Guided by our skilled surgeons, da Vinci goes beyond the reach of humans and performs with greater dexterity and precision. This enables us to remove cancerous tumors without disturbing the healthy tissue around them. The result is less discomfort, fewer side effects and a faster recovery. Most of our colon cancer patients return home within days, instead of a week or more. For an appointment, call 800-826-HOPE or ask your doctor for a referral. We accept most insurance. At City of Hope, we have answers to cancer.

City of
Hope™

Science saving lives.
cityofhope.org/colon

3

How can a symbol
help save your life?

canswer.

 For the 19th year, U.S.News & World Report has awarded this symbol to the top hospitals in America. We're proud to say that City of Hope is ranked among the best cancer hospitals, with an equally impressive ranking for urology. In fact, we have the largest prostate cancer program in California and our surgeons have more experience performing robotic procedures than anyone else in the country. This advanced form of surgery is minimally invasive so our patients experience less discomfort and a faster recovery. If you or someone you love has cancer, call **800-826-HOPE** or visit **cityofhope.org**. We have answers to cancer.

City of
Hope™

Science saving lives.

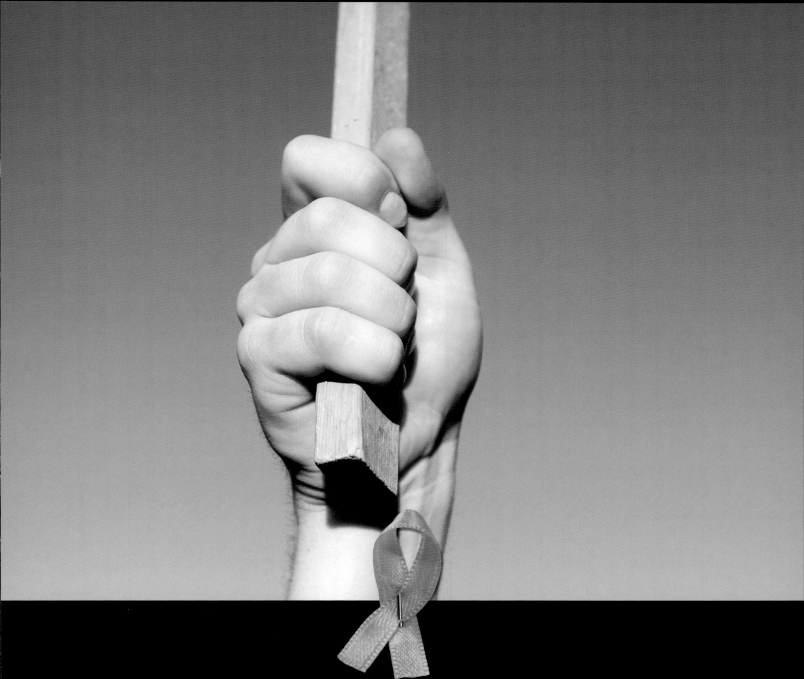

STREET REACH CAMPAIGN

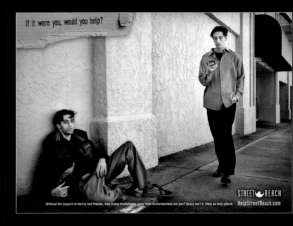

JEFF THOMPSON
T2H ADVERTISING
MYRTLE BEACH, SOUTH CAROLINA

Most people have witnessed the phenomenon of homelessness—but relatively few have pondered the possibility of finding themselves in a similar situation. "We started chatting about just how close nearly everyone has been at one time or another in their lives to homelessness," says Jeff Thompson of T2H Advertising in Myrtle Beach, South Carolina. "In many cases, just a paycheck or two away."

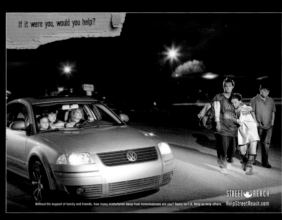

T2H Advertising designed the campaign to build awareness of homelessness and drive philanthropic residents to the one local organization's Web site. Nonprofit organization Street Reach Mission, a ninety-bed facility for emergency shelter and supportive services in the Myrtle Beach area, benefited from the effort. The ads—which appeared on billboards, in magazines and newspapers—featured both professional talent as well as area homeless individuals. The amateur models told of their life experiences and brought the reality home to the T2H creative team: principal Thompson, associate creative director Tim Parry, copywriter Daniel Stevenson and photographer Matt Silk.

"There was one man we talked to," Thompson recalls. "Smart guy, dressed well. He said he could talk to his family, but had too much pride to ask them for help." He adds that the issue of homeless families often flies under the radar. "Here in Myrtle Beach, there was a published story about the many area kids who would go without food during the holidays since the school cafeteria would be closed. "It pulled on people's heartstrings that these kids had to spend Christmas without enough food to eat."

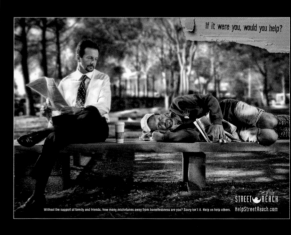

Thompson, who was acquainted with the organization prior to starting the campaign, feels strongly about it's mission and his agency's role. "Street Reach helps people get their lives back, because once you've slid that far, it becomes too monumental to turn your life around without support," he says.

• • •

CREATED BY
Jeff Thompson, Daniel Stevenson, Tim Parry, Matt Silk

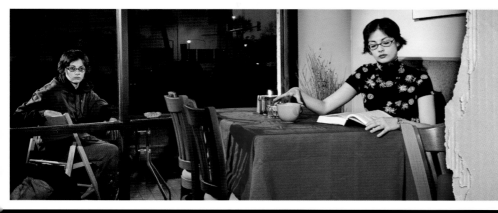

If it were you,
would you help?

HelpStreetReach.com

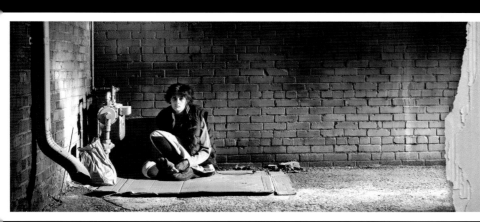

If it were you,
would you help?

HelpStreetReach.com

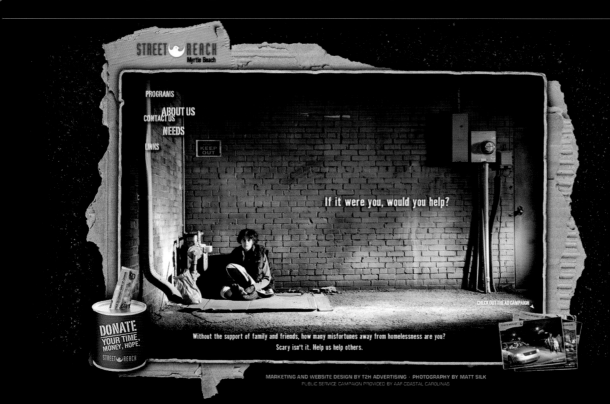

STREET REACH
Myrtle Beach

PROGRAMS
ABOUT US
CONTACT US
NEEDS
LINKS

KEEP OUT

If it were you, would you help?

CHECK OUT THE AD CAMPAIGN

DONATE
YOUR TIME,
MONEY, HOPE.
STREET REACH

Without the support of family and friends, how many misfortunes away from homelessness are you?
Scary isn't it. Help us help others.

MARKETING AND WEBSITE DESIGN BY T2H ADVERTISING · PHOTOGRAPHY BY MATT SILK
PUBLIC SERVICE CAMPAIGN PROVIDED BY AAF-COASTAL CAROLINAS

1

ORGANIZATION
World of Hope Foundation

CREATED BY
Eric Theriot, Susanne Bynum

Legacy Design Group
Tomball, TX

2

ORGANIZATION
Vital

CREATED BY
Rian Hughes

Device
London, United Kingdom

3

ORGANIZATION
Sexual Minority Youth Assistance
League

CREATED BY
Sharon Ogburn, Christopher Dyer

Black Marker Creative
North Vancouver, Canada

4

ORGANIZATION
Los Angeles Metro Task Force

CREATED BY
Fabian Geyrhalter,
Katherine Feshchenko

Geyrhalter Design
Santa Monica, CA

5

ORGANIZATION
Tribal Law Enhancement Project

CREATED BY
Delphine Keim-Campbell,
Matt Williamson, Aimee Graham,
Todd Goehner

Delphine Keim-Campbell
Moscow, ID

6

ORGANIZATION
Smile Africa

CREATED BY
Phred Martin

Splash:Design
Kelowna, Canada

1

2

3

4

5

6

1

1

ORGANIZATION
AIGA Center for Cross Cultural
Design (AIGA XCD) and the
Centro Torriente de la Brau

CREATED BY
Todd Childers

Todd Childers Graphic Design
Bowling Green, OH

2

ORGANIZATION
UNESCO

CREATED BY
Nelida Nassar

Nassar Design
Brookline, MA

3

ORGANIZATION
Travis County Green party

CREATED BY
Kelly Blanscet

Graphic Granola
Austin, TX

3

2

1

ORGANIZATION
Amnesty International

CREATED BY
Hannah Stubblefield, Clayton Crocker,
Aaron Shapiro
HUGE
Brooklyn, NY

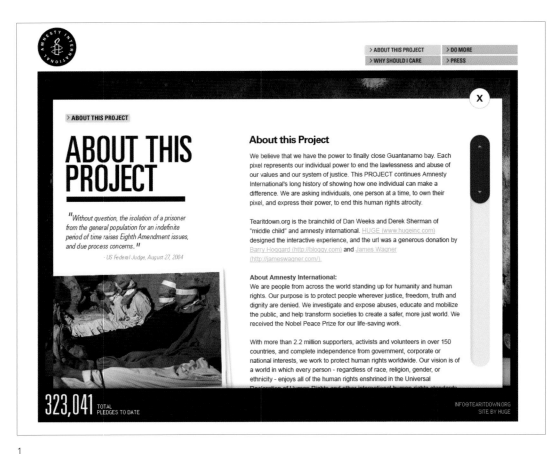

1

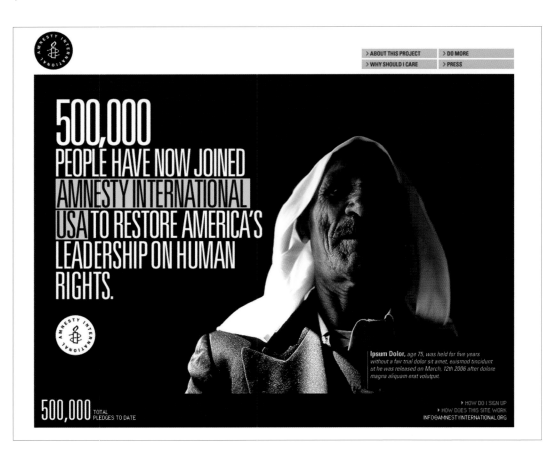

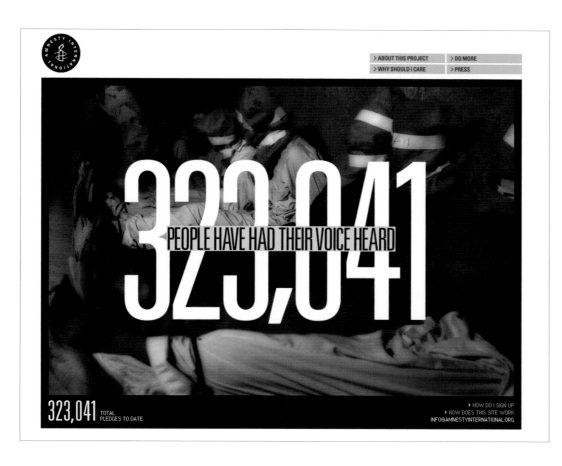

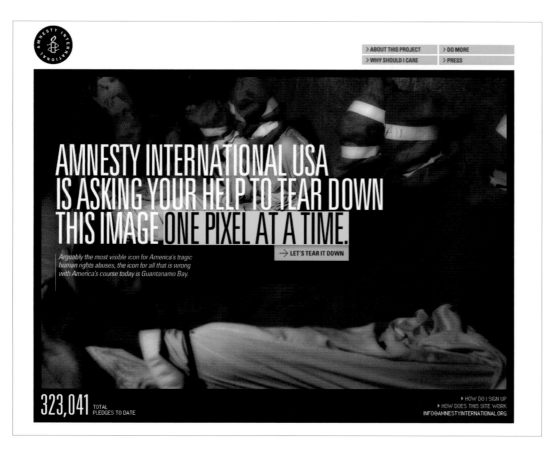

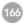

1 • 2

ORGANIZATION
Life In Abundance International

CREATED BY
Justin Ahrens, Kerri Liu

Rule29
Geneva, IL

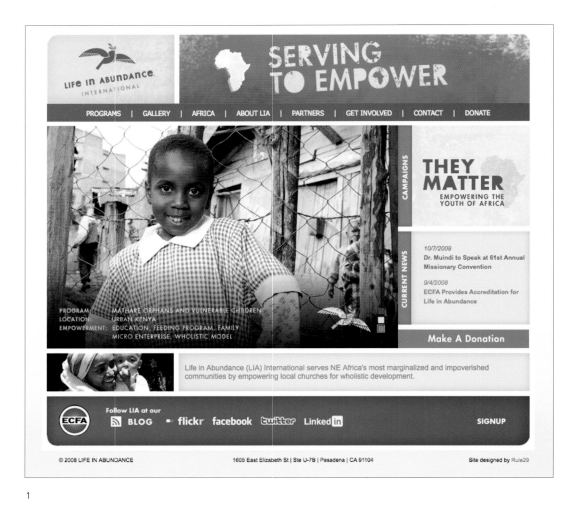

1

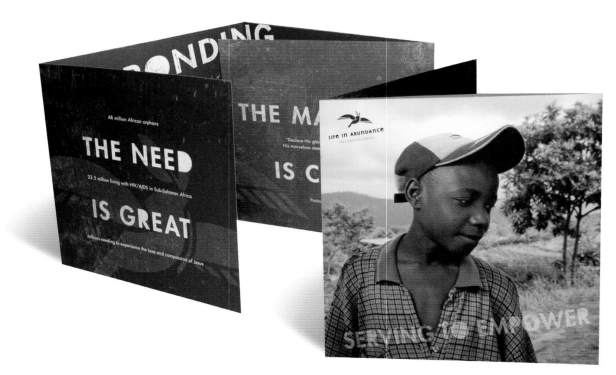

2

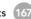

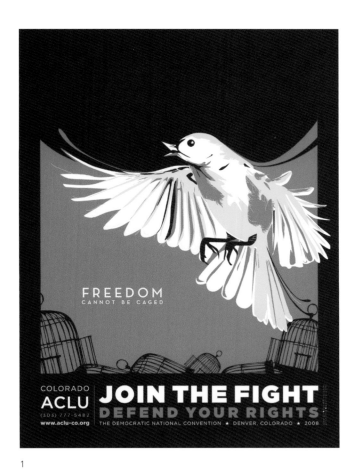

1

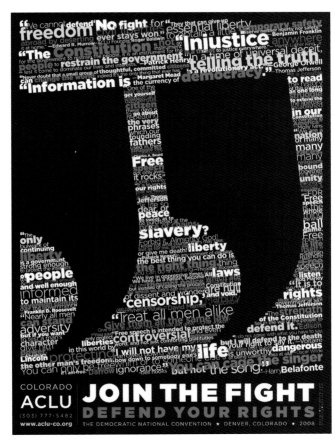

2

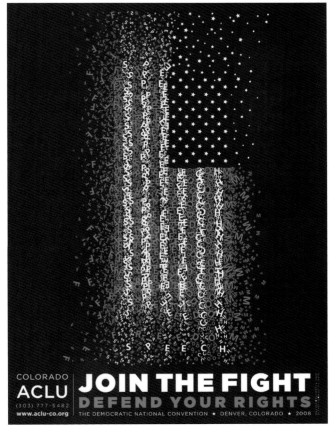

3

1 • 2 • 3

ORGANIZATION
American Civil Liberties Union,
Colorado

CREATED BY
Sacha Halenda, Amanda Lenz,
Liz Fox

FormFive
Boulder, CO

1 • 2 • 3

ORGANIZATION
Verein NeunerHAUS

CREATED BY
Robert Wohlgemuth, Florian
Nussbaumer, Phil Hewson,
Robert Staudinger

Euro RSCG Vienna
Vienna, Austria

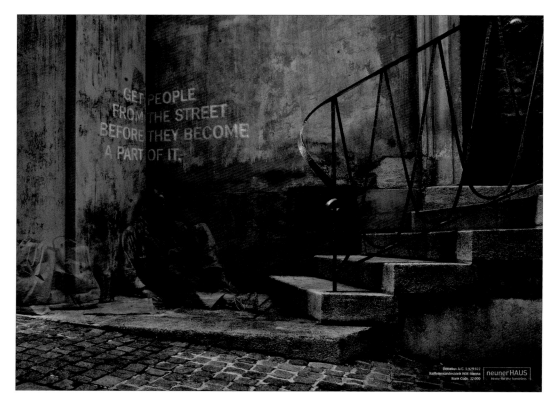

1

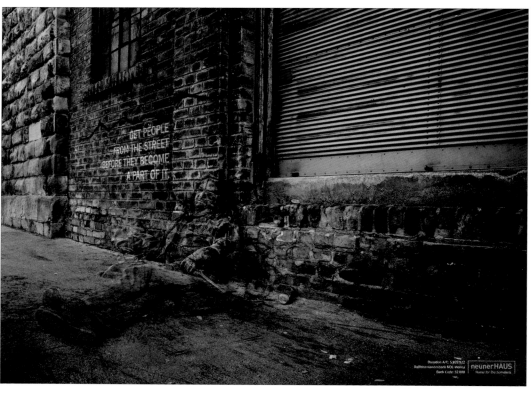

2

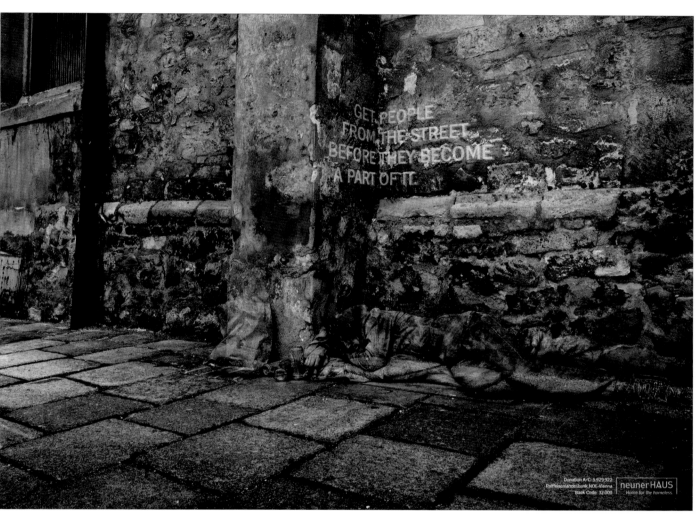

3

1

ORGANIZATION
V-Day

CREATED BY
Claudio Luis Vera, Alisha Haydn Vera,
Richard Roth, Felix Arteaga

studio:module
Miami, FL

1

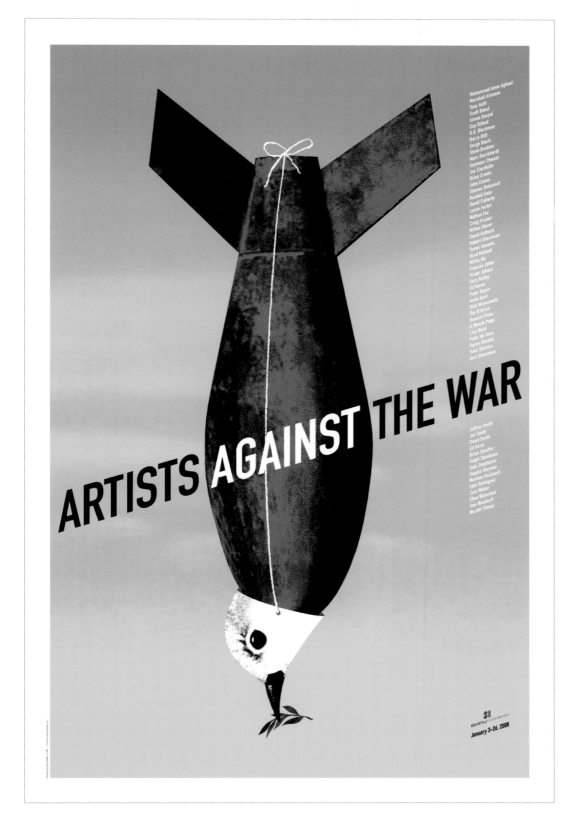

1

ORGANIZATION
Society of Illustrators NYC

CREATED BY
Brian Stauffer, Steve Brodner,
Anelle Miller

Log Cabin Studio
Miami, FL

1

1

ORGANIZATION
The Innocence Project

CREATED BY
Masood Bukhari

Masood Bukhari, LLC
Bronx, NY

2

ORGANIZATION
REACT

CREATED BY
Stuart Tolley

Transmission
Brighton, England

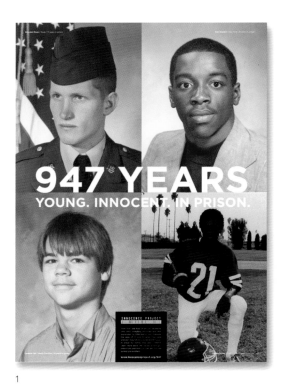

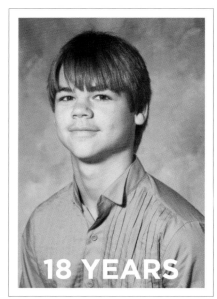

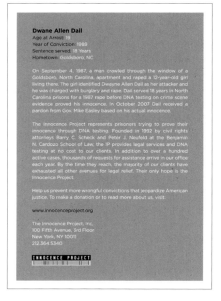

1

2

1

ORGANIZATION
TechnoServe

CREATED BY
Lena Markley

Levine & Associates, Inc.
Washington, DC

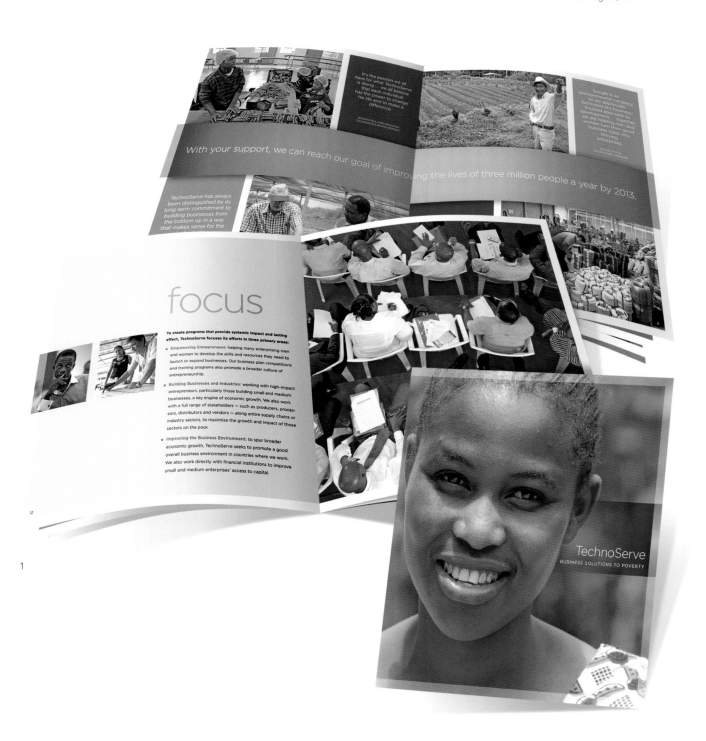

1

1 • 2
ORGANIZATION
ACDI/VOCA
CREATED BY
Scott Miller, John Vance
Levine & Associates, Inc.
Washington, DC

3
ORGANIZATION
International Youth Foundation
CREATED BY
Greg Sitmann
Levine & Associates, Inc.
Washington, DC

1

2

3

1
ORGANIZATION
Alberta Rockies Gay Rodeo
Association
CREATED BY
David Biggar, Rick Sealock

Rick Sealock
Kitchener, Canada

1

SPOTLIGHT ON
RED FLAG CAMPAIGN

NOAH SCALIN
ALR DESIGN
RICHMOND, VIRGINIA

When a lot of people—college students in particular—think of domestic violence, they think of older or married people. The Virginia Sexual and Domestic Violence Action Alliance, however, recognizes that people age 18-21 are at particularly high risk for experiencing or perpetrating dating violence, and that anyone can stop dating violence by recognizing red flags for emotional, physical and sexual violence.

Noah Scalin of Richmond's Another Limited Rebellion took this charge literally, creating a series of posters featuring college students holding actual red flags. "This campaign talks to bystanders, not survivors of abuse," he says. "We wanted to cultivate an environment in which students recognize warning signs and feel compelled to speak up." The campaign, which depicts students of both sexes, various ethnicities and sexual orientations, strives to speak to everyone so everyone could speak to those who need help the most. "That's the reality of it. It's not just heterosexual white people… everyone is affected by this. It's calling on your network of friends to help: 'If you see this happening in your friends' lives, step up and say something!'"

The posters, which went from a handful of Virginia colleges and universities to a nationwide campaign in one year, evolved into a kit that included other educational materials, including red flags that organizers could plant around campus. "We want to draw attention and facilitate conversations about healthy relationships, especially at the beginning of the school year," Scalin says.

In order to make sure the dialogue got off on the right foot, the organization conducted a series of focus groups with college students. "Efficacy was of prime importance, especially when appealing to young people and making sure it resonated," he says. "The posters show realistic scenarios and what to say in a language that is appropriate for the students."

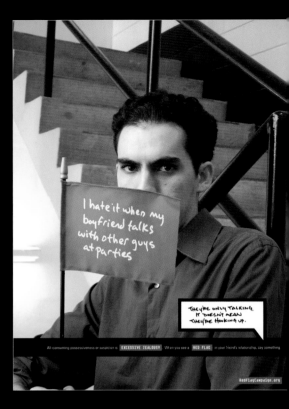

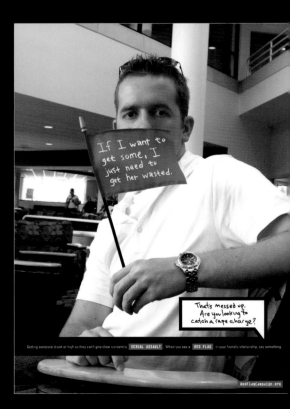

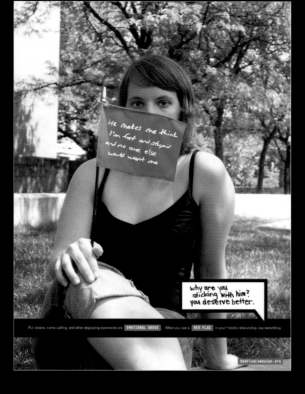

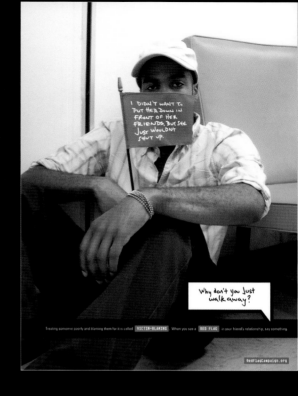

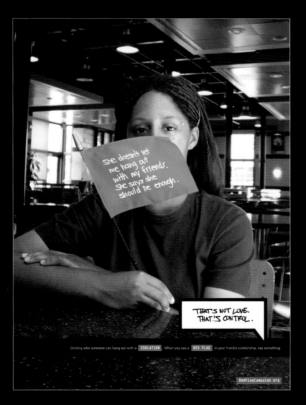

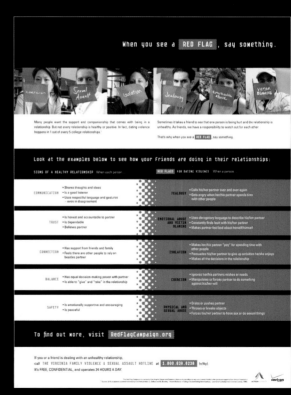

1

ORGANIZATION
Gay Men's Health Crisis, Inc.

CREATED BY
Norman Cherubino, Jim Keller,
Samantha Taylor, Krishna Stone

Langton Cherubino Group
New York, NY

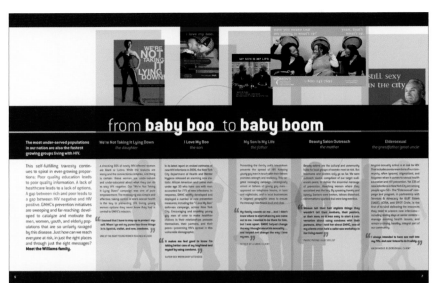

1

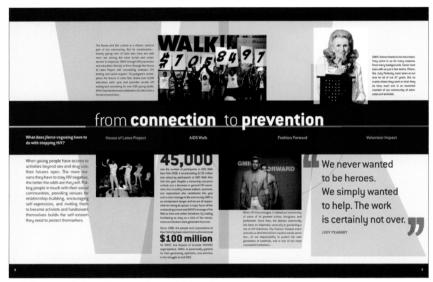

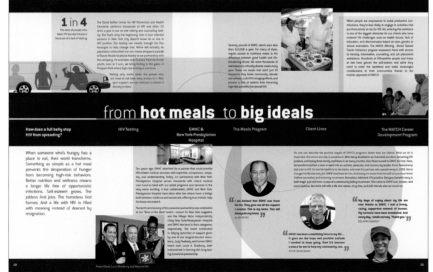

1

1
ORGANIZATION
Travis County Green Party
CREATED BY
Kelly Blanscet
Graphic Granola
Austin, TX

2
ORGANIZATION
stoph8te.org
CREATED BY
Robynne Raye
Modern Dog Design Co.
Seattle, WA

3
ORGANIZATION
Qwien
CREATED BY
Wade Lough
Red Shoes Studio
Farmville, VA

2

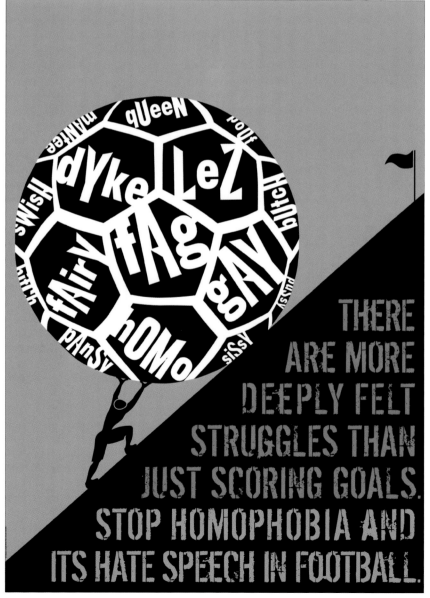

3

1

ORGANIZATION
Pan American Health Organization
CREATED BY
Jana Frieling
Vrontikis Design Office
Los Angeles, CA

2

ORGANIZATION
United Nations Department of
Information
CREATED BY
Anya Farquhar, Josh Tetreault
Vrontikis Design Office
Los Angeles, CA

3

ORGANIZATION
I Have A Dream Foundation
CREATED BY
Pash
Digital Soup
Culver City, CA

2

1

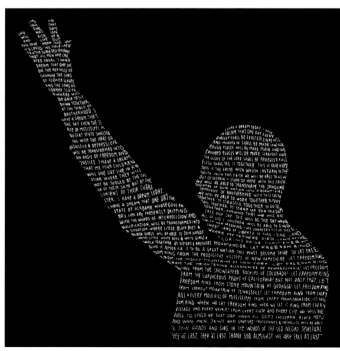

3

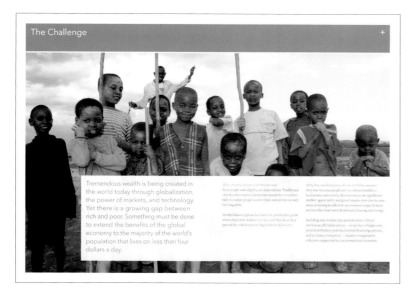

The Challenge +

Tremendous wealth is being created in the world today through globalization, the power of markets, and technology. Yet there is a growing gap between rich and poor. Something must be done to extend the benefits of the global economy to the majority of the world's population that lives on less than four dollars a day.

1
ORGANIZATION
Acumen Fund
CREATED BY
Matthew Schwartz
MSDS
New York, NY

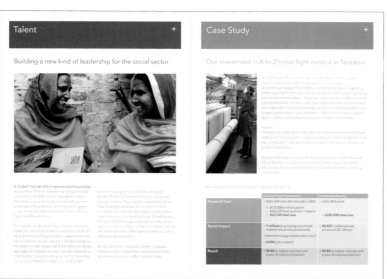

Talent +

Building a new kind of leadership for the social sector

Case Study +

Our investment in A to Z helps fight malaria in Tanzania

We've taken a different approach to solving the problem of global poverty…

It's market-driven, and it works.

acumen FUND

1

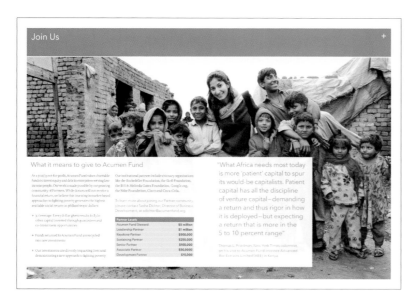

Join Us +

What it means to give to Acumen Fund

"What Africa needs most today is more 'patient' capital to spur its would-be capitalists. Patient capital has all the discipline of venture capital – demanding a return and thus rigor in how it is deployed – but expecting a return that is more in the 5 to 10 percent range"

1

ORGANIZATION
AIGA World Day of Design

CREATED BY
Elizabeth Maplesden

EMdash Design
Yardley, PA

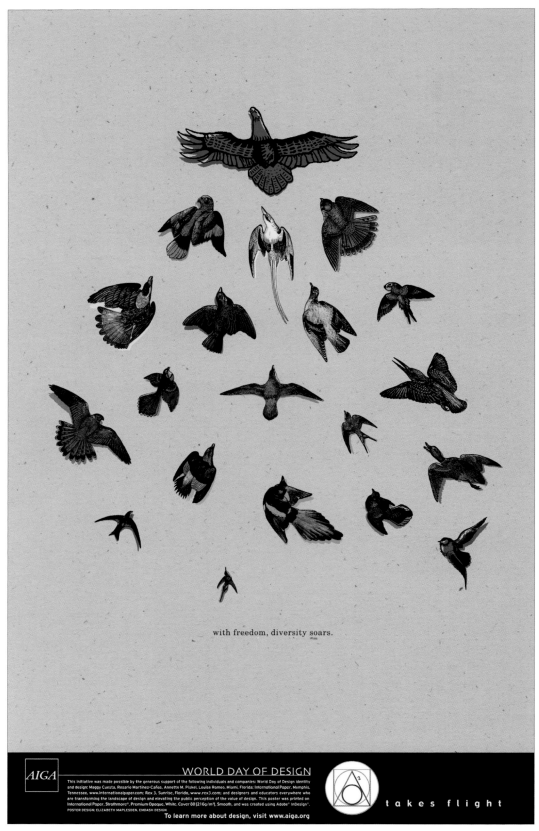

1

2

5

4

6

1
ORGANIZATION
Grameen Creative Lab
CREATED BY
Iris Wieder, Thomas Hitthaler
Strukt
Vienna, Austria

2
ORGANIZATION
The Art of Peace Foundation
CREATED BY
Tomas Snoreck, Maryam Seifi,
Ian Hamilton
Ripe
Washington, DC

3
ORGANIZATION
TYPros
CREATED BY
Kathy Piersall
A Blue Moon Arts LLC
Tulsa, OK

4
ORGANIZATION
The Uganda Rural Fund
CREATED BY
Kevin Flores
The Flores Shop
Ashland, VA

5
ORGANIZATION
Open Square
CREATED BY
Christopher Simmons, Tim Belonax
MINE™
San Francisco, CA

6
ORGANIZATION
Gay Men's Chorus of Washington
CREATED BY
Brent M. Almond
Design Nut, LLC
Kensington, MD

1

ORGANIZATION
AIGA

CREATED BY
Greg Bennett, David Griffiths,
Brion McCarthy

WORKtoDATE
York, PA

The 2008 Presidential Election

VOTE NOV 4th
LET YOURS OUT

Good design makes choices clear.

AIGA's get-out-the-vote initiative was made possible by the generous support of more than 22,000 AIGA members in 59 chapters
and 225 student groups nationwide along with designers everywhere who believe in the power of design for the public good.
This poster was designed by Greg Bennett : WORKtoDATE : Baltimore, Maryland : WORKtoDATE.com : VISUALSOLDIER.com

AIGA

A public service initiative of
AIGA Design for Democracy.
For more information visit
www.aiga.org/getoutthevote.

1

2

3

1
ORGANIZATION
Harry Kaplowitz, Carolina Performing
Arts, The University of North Carolina
CREATED BY
Alison Duncan, Harry Kaplowitz

Duncan Design
Beaverton, OR

2
ORGANIZATION
Calagraphic Design
CREATED BY
Ronald J. Cala II

Calagraphic Design
Elkins Park, PA

3
ORGANIZATION
Mladina Magazine
CREATED BY
Sladan Srdić, Vladan Srdić

Studio 360 d.o.o.
Ljubljana, Slovenia

ENVIRONMENTAL
AWARENESS

SPOTLIGHT ON
CLEAN PACIFIC BEACH CAMPAIGN

JEFF HUNTER
JEFF HUNTER DESIGN
SAN DIEGO, CALIFORNIA

Jeff Hunter was a student at the Art Institute of California San Diego in the summer of 2006 when he partook in a student project that would change the landscape of his hometown—literally. "There were ten students and one instructor," says the owner and principal of Hunter Design in San Diego. "We wanted to focus on a specific area, and we created this campaign with the recommendations with which to solve the litter problems in Pacific Beach."

The final book sat on the shelf for a long time. Then, a member of an organization named I Love a Clean San Diego—to whom Hunter's group had presented the original idea—gave a member of the Pacific Beach town council a copy of the resulting book. "This chance meeting transformed the project from mere concepts to a real world anti-litter campaign featuring bar coasters, brochures and garbage can signs," says Hunter. Suddenly, the students weren't just college kids looking for a grade but, he says, "a bunch of energized young people" involved with the council from then on.

Like with most civic undertakings, of course, Hunter and his team found nothing to be simple. "A lot of the copy we created had to be toned down for families," he says. "Not that it was bad, but a lot of people had their opinions… It was an eye-opening experience dealing with a committee voting on everything. But it was a lot of fun, actually."

Another potentially political difficulty stemmed from the challenge of selling the idea of paper brochures to a town council attempting to address the problem of litter. "We wanted to limit how they were distributed, like at events and to businesses and residences with a substantial litter problem," says Hunter. "You have to give up a bit to get the message out."

• • •
CREATED BY
Jeff Hunter, Mayra Moreno, David Gonsalves, Jeff Silva

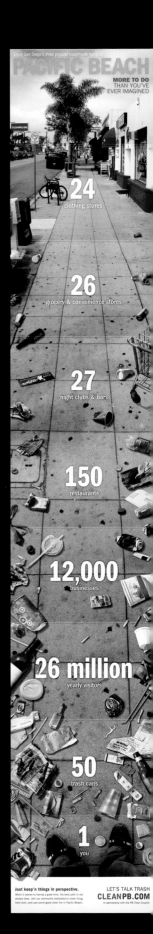

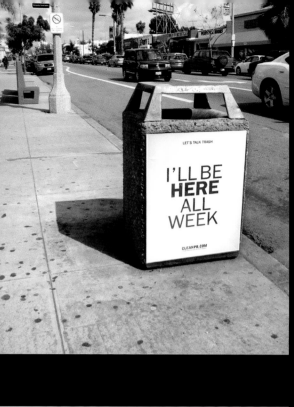

LET'S TALK TRASH

I'LL BE **HERE** ALL WEEK

CLEANPB.COM

1. DON'T **WASTE** YOUR LIFE
2. GOOD **CLEAN** FUN
3. I'LL BE **HERE** ALL WEEK
4. I WAS **MADE** FOR YOU
5. THINK **CLEAN** THOUGHTS
6. I'M **HERE** FOR YOU
7. **USE ME**
8. YOUR **WASTE** IS EXPANDING
9. YOU GOTTA **HAND IT** TO ME
10. BACK THAT **TRASH** UP
11. I CAN **HANDLE** IT
12. LET'S GET OUR TRASH **TOGETHER**
13. KEEP IT **CLEAN**
14. I DON'T MIND BEING **USED**
15. I'M HAVING YOUR **LITTER**
16. WE **NEED** EACHOTHER

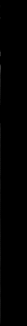

BACK THAT **TRASH** UP

KEEP IT **CLEAN**

DRINKS ARE ON ME

YOU CAN DO **BETTER**

GOOD **CLEAN** FUN

WHERE IS THE **CAN?**

DO YOU WANT TO **START** SOMETHING?

COME **CLEAN**

TALK **DIRTY** TO ME

FOUND CRUSH-PROOF BOX
CLEANPB.COM

FOUND PLASTIC CUP
CLEANPB.COM

FOUND METAL CAN
CLEANPB.COM

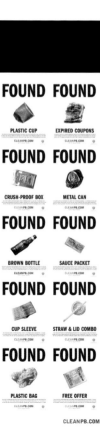

FOUND PLASTIC CUP

FOUND EXPIRED COUPONS

FOUND CRUSH-PROOF BOX

FOUND METAL CAN

FOUND BROWN BOTTLE

FOUND SAUCE PACKET

FOUND CUP SLEEVE

FOUND STRAW & LID COMBO

FOUND PLASTIC BAG

FOUND FREE OFFER

CLEANPB.COM

1

2

3

4

5

1

2

3

4

5

1

1

ORGANIZATION
Islington Council

CREATED BY
Christine Fent

Beam
London, United Kingdom

1 • **2** • 3 • 4

ORGANIZATION
The Northwest Passage

CREATED BY
Matt Dutra, Molly McGuirk,
Kathy Beck, Sprague Theobald

Rubic Design Inc.
Middletown, RI

1

2

3

4

Securing America's
Future Energy

1

2

3

1

ORGANIZATION
Securing America's Future Energy (SAFE)

CREATED BY
Matthew Schwartz

MSDS
New York, NY

2 • 3

ORGANIZATION
Global Coral Reef Alliance

CREATED BY
Lea Barozzi

Red Room Graphics
Los Angeles, CA

4 • 5 • 6 • 7

ORGANIZATION
Post Carbon Institute

CREATED BY
Christopher Simmons, Tim Belonax

MINE™
San Francisco, CA

POST CARBON
INSTITUTE

4

RELOCALIZATION
NETWORK

5

ENERGY FARMS
NETWORK

6

OIL DEPLETION
PROTOCOL

7

1

ORGANIZATION
Ocean Conservancy

CREATED BY
Scott Ketchum, Miriam Kriegel,
Russell Feldman

BBMG
New York, NY

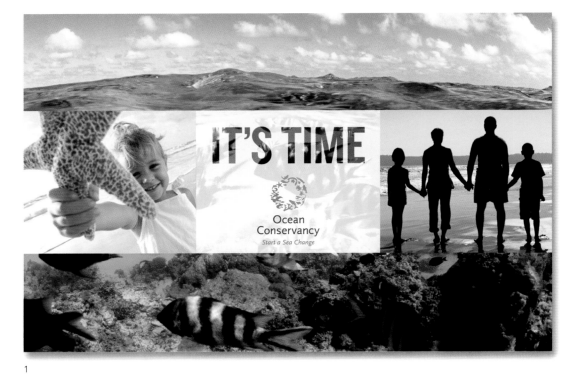

IT'S TIME

Ocean
Conservancy
Start a Sea Change

1

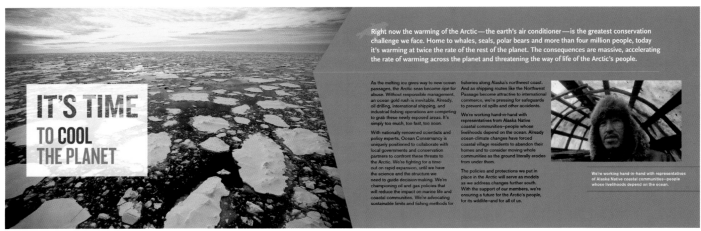

IT'S TIME
TO COOL
THE PLANET

Right now the warming of the Arctic—the earth's air conditioner—is the greatest conservation challenge we face. Home to whales, seals, polar bears and more than four million people, today it's warming at twice the rate of the rest of the planet. The consequences are massive, accelerating the rate of warming across the planet and threatening the way of life of the Arctic's people.

As the melting ice gives way to new ocean passages, the Arctic seas become ripe for abuse. Without responsible management, an ocean gold rush is inevitable. Already, oil drilling, international shipping, and industrial fishing operations are competing to grab these newly exposed areas. It's simply too much, too fast, too soon.

With nationally renowned scientists and policy experts, Ocean Conservancy is uniquely positioned to collaborate with local governments and conservation partners to confront these threats to the Arctic. We're fighting for a time-out on rapid expansion, until we have the science and the structure we need to guide decision-making. We're championing oil and gas policies that will reduce the impact on marine life and coastal communities. We're advocating sustainable limits and fishing methods for

fisheries along Alaska's northwest coast. And as shipping routes like the Northwest Passage become attractive to international commerce, we're pressing for safeguards to prevent oil spills and other accidents.

We're working hand-in-hand with representatives from Alaska Native coastal communities—people whose livelihoods depend on the ocean. Already ocean-climate changes have forced coastal village residents to abandon their homes and to consider moving whole communities as the ground literally erodes from under them.

The policies and protections we put in place in the Arctic will serve as models as we address changes further south. With the support of our members, we're ensuring a future for the Arctic's people, for its wildlife—and for all of us.

We're working hand-in-hand with representatives of Alaska Native coastal communities—people whose livelihoods depend on the ocean.

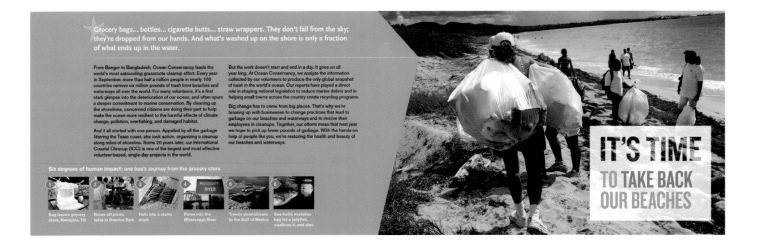

Grocery bags... bottles... cigarette butts... straw wrappers. They don't fall from the sky; they're dropped from our hands. And what's washed up on the shore is only a fraction of what ends up in the water.

From Bangor to Bangladesh, Ocean Conservancy leads the world's most astounding grassroots cleanup effort. Every year in September, more than half a million people in nearly 100 countries remove six million pounds of trash from beaches and waterways all over the world. For many volunteers, it's a first stark glimpse into the deterioration of our ocean, and often spurs a deeper commitment to marine conservation. By cleaning up the shorelines, concerned citizens are doing their part to help make the ocean more resilient to the harmful effects of climate change, pollution, overfishing, and damaged habitat.

And it all started with one person. Appalled by all the garbage littering the Texas coast, she took action, organizing a cleanup along miles of shoreline. Some 20 years later, our International Coastal Cleanup (ICC) is one of the largest and most effective volunteer-based, single-day projects in the world.

But the work doesn't start and end in a day. It goes on all year long. At Ocean Conservancy, we analyze the information collected by our volunteers to produce the only global snapshot of trash in the world's ocean. Our reports have played a direct role in shaping national legislation to reduce marine debris and in helping small towns across the country create recycling programs.

Big change has to come from big places. That's why we're teaming up with businesses to change practices that lead to garbage on our beaches and waterways and to involve their employees in cleanups. Together, our efforts mean that next year we hope to pick up fewer pounds of garbage. With the hands-on help of people like you, we're restoring the health and beauty of our beaches and waterways.

Six degrees of human impact: one bag's journey from the grocery store

1 Bag leaves grocery store, Memphis, TN
2 Blows off picnic table in Overton Park
3 Falls into a storm drain
4 Flows into the Mississippi River
5 Travels downstream, to the Gulf of Mexico
6 Sea turtle mistakes bag for a jellyfish, swallows it, and dies

IT'S TIME
TO TAKE BACK
OUR BEACHES

1

National Environmental
Education Foundation

Knowledge to live by

2

National Environmental
Education Week

A National Environmental Education Foundation Program

3

National Public Lands Day

A National Environmental Education Foundation Program

4

Earth Gauge

A National Environmental Education Foundation Program

1 · 2 · 3 · 4

ORGANIZATION
National Environmental Education
Foundation

CREATED BY
Scott Ketchum

BBMG
New York, NY

5

ORGANIZATION
The Big Wild

CREATED BY
Alan Russell, Dean Lee,
Cosmo Campbell, Chris Moore,
Jarrod Banadyga

DDB Canada / Vancouver
Vancouver, Canada

CANADA IS HOME TO ONE OF THE WORLD'S LAST GREAT FORESTS.

SADLY, THE PROTECTED AREA FITS UNDER THIS PERIOD.

Less than 10% of Canada's wilderness is protected.
If that doesn't sit right with you, add your voice at thebigwild.org **the big wild**.org

5

1 • 2 • 3

ORGANIZATION
Hudson Bay Company

CREATED BY
Brian Lovell, Michael D. Johnson,
Rebecca Stillpass

Anthem
San Francisco, CA

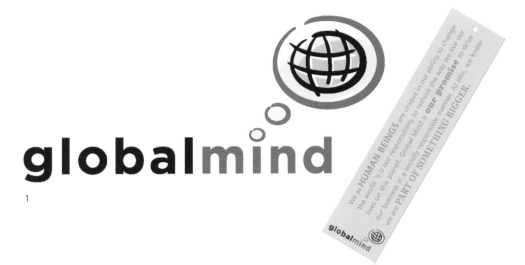

1

2

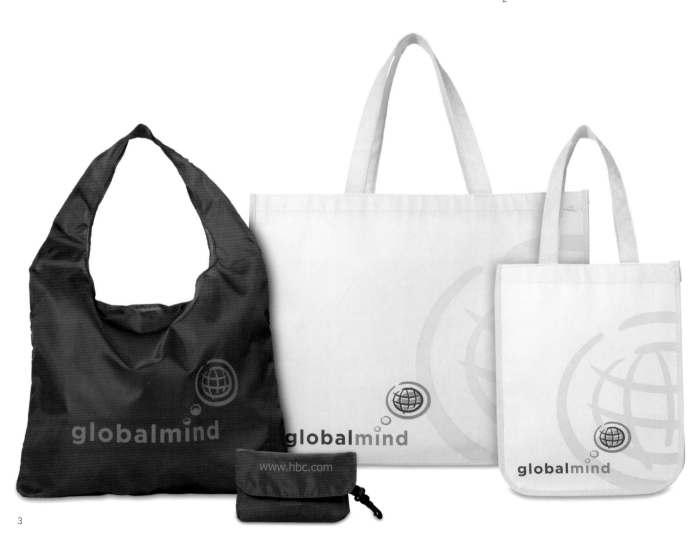

3

1

ORGANIZATION
iLuvTrees.org

CREATED BY
Angela Hill, Dave Smith, Randy Fraser
Incitrio
San Diego, CA

1

1

ORGANIZATION
Tyler School of Art, Temple University

CREATED BY
Joe Scorsone, Ronald J. Cala II

Calagraphic Design
Elkins Park, PA

2

ORGANIZATION
The Nature Conservancy

CREATED BY
Greg Kihlstrom, Andrew Jarvis,
Brandon Prudent

Carousel30
Alexandria, VA

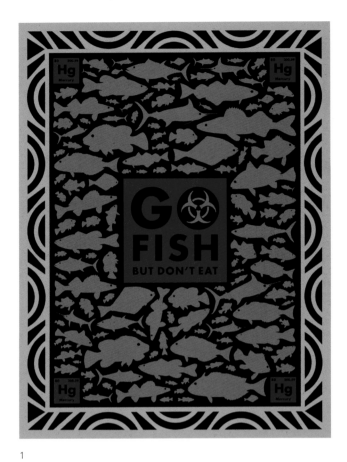

1

2

1

ORGANIZATION
Emily Carr Institute Grad Project
CREATED BY
Tanya Duffy

Tanya Duffy Design
Montreal, Canada

1

1

ORGANIZATION
The Sierra Club Foundation

CREATED BY
Zach Hochstadt, Clint Delapaz,
Felicia Mello, Carrie Hudiburgh

Mission Minded
San Franscisco, CA

1

With the help of its generous donors, The Sierra Club Foundation provides the Sierra Club and other grassroots organizations with the tools and resources they need to create dramatic, lasting change on the most pressing environmental issues of our time.

> "We stand poised to enter an era of environmental leadership, where we tackle the challenges facing the country and turn them into opportunities for growth."
>
> *–Peter Martin, Executive Director*

Peter Martin

Dear Friends,

Every so often in history, a moment arrives when the efforts of committed citizens over a long period of time begin to bear fruit in important and pivotal ways.

This past year brought exciting transformations to our country and to The Sierra Club Foundation. The election of a new president provides a chance for the nation to chart a different course on environmental policy, one that can safeguard our planet's future. Because of the work of the Sierra Club and the financial support of donors like you, we stand poised to enter an era of environmental leadership, where we tackle our greatest challenges and turn them into opportunities for growth.

At the Foundation, we have met the unprecedented threat of global warming with new strategies, focus and determination. In 2008, the Sierra Club and The Sierra Club Foundation launched the Climate Recovery Partnership, an ambitious program to cut greenhouse gas emissions by 80 percent by 2050 and prepare our communities and ecosystems to survive a changing climate.

The Climate Recovery Partnership has already scored important successes: This year alone, with your help, we stopped 24 coal-burning power plants from being built, took important steps toward stricter federal fuel economy standards, and protected California's largest continuous land parcel from development, providing habitats for species threatened by climate change. In the coming pages you'll learn about these and other victories. I hope you'll stop for a moment and revel in what we achieved together.

While prioritizing global climate change, the Foundation continues its historic support of a variety of grassroots environmental projects, from wildlife and habitat protection in the Rockies to encouraging sustainable fisheries along the Gulf Coast. We are also helping our nation's military families in their time of great need. Because of the generosity of our donors, we are making it possible for children of active-duty service personnel to experience the healing effects of nature and we are providing funding for custom green homes for disabled veterans returning from Iraq and Afghanistan.

Change, while essential, is not always easy. The special-interest groups in Washington, D.C. and their backers, will resist proposals for change, no matter how well considered or scientifically justified those proposals may be. That's why The Sierra Club Foundation's role is more important now than ever. By providing a solid base of support for strategic, grassroots environmental campaigns, we ensure that those advocating for our planet wield as much influence in our national policy debates as the oil and coal companies.

In the coming year, The Sierra Club Foundation will take the Climate Recovery Partnership to scale. We are deeply grateful to you, our donors, for embarking with us on this exciting phase of our organization's growth. We look forward to walking side by side with you as our country turns down the path of environmental leadership.

Yours in transformation,

Peter Martin
Executive Director

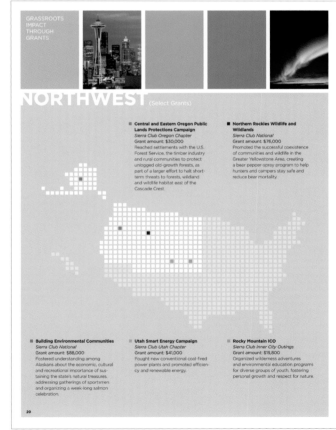

NORTHWEST (Select Grants)

■ **Central and Eastern Oregon Public Lands Protections Campaign**
Sierra Club Oregon Chapter
Grant amount: $30,000
Reached settlements with the U.S. Forest Service, the timber industry and rural communities to protect unlogged old-growth forests, as part of a larger effort to halt short-term threats to forests, wildland and wildlife habitat east of the Cascade Crest.

■ **Northern Rockies Wildlife and Wildlands**
Sierra Club National
Grant amount: $76,000
Promoted the successful coexistence of communities and wildlife in the Greater Yellowstone Area, creating a bear pepper-spray program to help hunters and campers stay safe and reduce bear mortality.

■ **Building Environmental Communities**
Sierra Club National
Grant amount: $88,000
Fostered understanding among Alaskans about the economic, cultural and recreational importance of sustaining the state's natural treasures, addressing gatherings of sportsmen and organizing a week-long salmon celebration.

■ **Utah Smart Energy Campaign**
Sierra Club Utah Chapter
Grant amount: $41,000
Fought new conventional coal-fired power plants and promoted efficiency and renewable energy.

■ **Rocky Mountain ICO**
Sierra Club Inner City Outings
Grant amount: $15,800
Organized wilderness adventures and environmental education programs for diverse groups of youth, fostering personal growth and respect for nature.

SOUTHWEST (Select Grants)

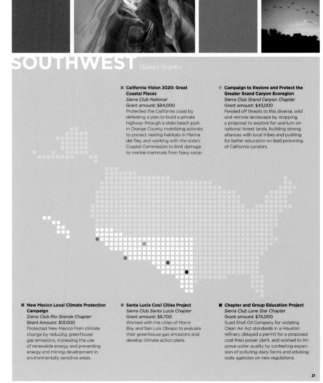

■ **California Vision 2020: Great Coastal Places**
Sierra Club National
Grant amount: $84,000
Protected the California coast by defeating a plan to build a private highway through a state beach park in Orange County, mobilizing activists to protect nesting habitats in Marina del Rey, and working with the state's Coastal Commission to limit damage to marine mammals from Navy sonar.

■ **Campaign to Restore and Protect the Greater Grand Canyon Ecoregion**
Sierra Club Grand Canyon Chapter
Grant amount: $43,000
Fended off threats to this diverse, wild and remote landscape by stopping a proposal to explore for uranium on national forest lands, building strong alliances with local tribes and pushing for better education on lead poisoning of California condors.

■ **New Mexico Local Climate Protection Campaign**
Sierra Club Rio Grande Chapter
Grant Amount: $13,000
Protected New Mexico from climate change by reducing greenhouse gas emissions, increasing the use of renewable energy and preventing energy and mining development in environmentally sensitive areas.

■ **Santa Lucia Cool Cities Project**
Sierra Club Santa Lucia Chapter
Grant Amount: $6,700
Worked with the cities of Morro Bay and San Luis Obispo to evaluate their greenhouse gas emissions and develop climate action plans.

■ **Chapter and Group Education Project**
Sierra Club Lone Star Chapter
Grant amount: $74,000
Sued Shell Oil Company for violating Clean Air Act standards in a Houston refinery, delayed a permit for a proposed coal-fired power plant, and worked to improve water quality by contesting expansion of polluting dairy farms and advising state agencies on new regulations.

1

ORGANIZATION
American Wind Energy Association
CREATED BY
Matt Davidson

Matt Davidson
Manhattan, KS

{Q:} {A:}

Why should I care?

Wind energy is a free, renewable resource, so no matter how much is used today, there will still be the same supply in the future. Wind energy is also a source of clean, non-polluting, electricity. Unlike conventional power plants, wind plants emit no air pollutants or greenhouse gases.

In one year alone, California's wind power plants offset the emission of more than 2.5 billion pounds of carbon dioxide, and 15 million pounds of other pollutants that would have otherwise been produced.

It would take a forest of 90 million to 175 million trees to provide the same air quality.

{Q:} {A:}

What can I do?

• Spread the word!
People need to be aware of the opportunity of wind energy

• Take a stand!
Call your senators and tell them how important wind energy is to their citizens.

• Get active!
Become an advocate for American Wind Energy Association (AWEA). They promote wind energy as a clean source of electricity for consumers around the world.

To learn more or to become an advocate visit http://www.awea.org/

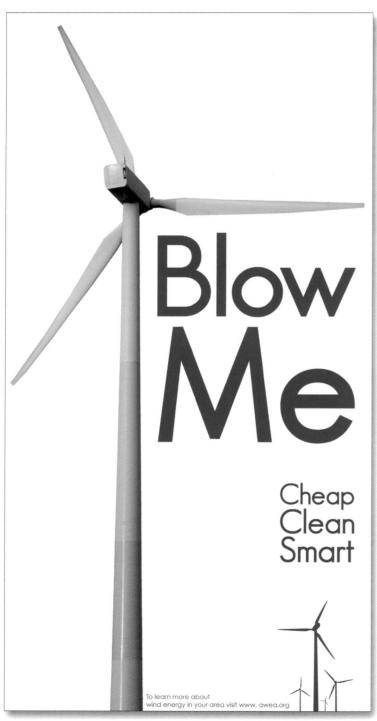

Blow Me

Cheap
Clean
Smart

To learn more about
wind energy in your area visit www.awea.org

1

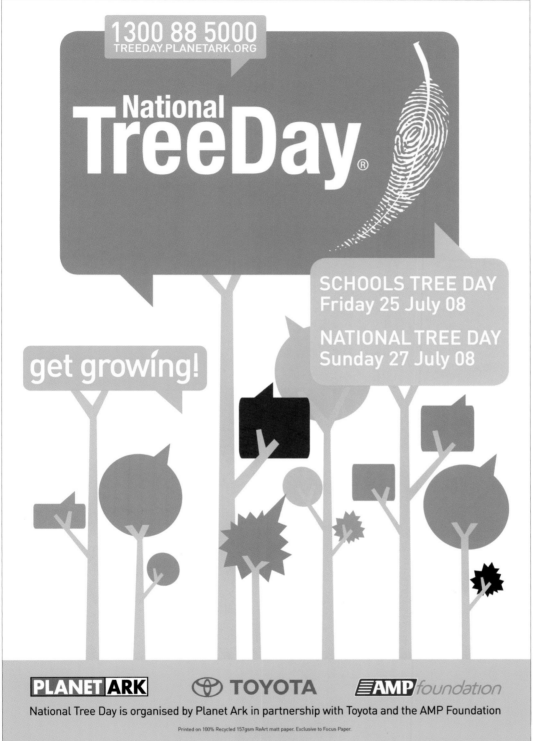

1

ORGANIZATION
Planet Ark

CREATED BY
Steven Joseph, Leah Procko

Spatchurst
Broadway, Australia

1

ORGANIZATION
Agriculture, Fisheries and
Conservation Department,
Hong Kong

CREATED BY
NG Lung Wai, Ben POON Ho Sing,
Jasmine HO Sze Man

Executive Strategy Limited
Hong Kong

2

ORGANIZATION
Thrive Design

CREATED BY
Kelly Salchow

Thrive Design
East Lansing, MI

1

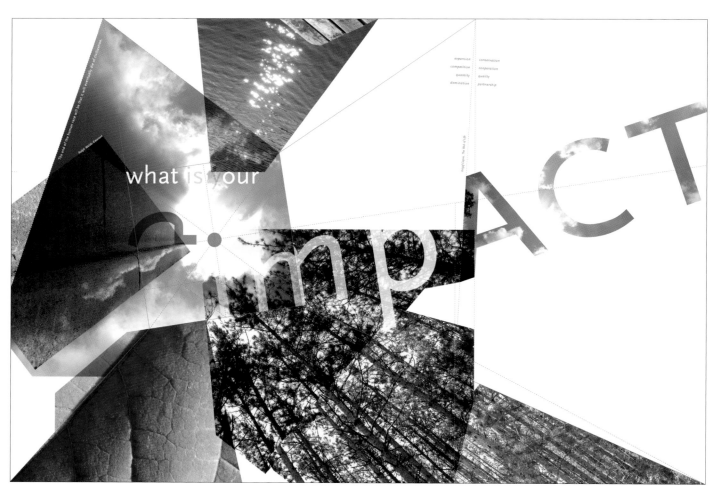

2

renu.net®
the future is green

1

renufuel®
better than diesel

2

renusolar®
clean energy

3

renupower®
electrisurety

4

5

GoLoco

6

1 · 2 · 3 · 4

ORGANIZATION
Renu.net

CREATED BY
Gabrielle Raumberger, Kimiyo Nishio

Epos, Inc.
Hermosa Beach, CA

5

ORGANIZATION
The Sustainable Bean

CREATED BY
Rob Mesarchik

Mez Design
Sausalito, CA

6

ORGANIZATION
GoLoCo

CREATED BY
Alice Hecht

Hecht Design
Arlington, VA

SPOTLIGHT ON
THE CYCLE CAMPAIGN

CHRIS ERICKSON
PARLIAMENT
PORTLAND, OREGON

Most people remember the concept of saving aluminum cans for pennies. But what if you could get free merchandise for your cans, papers and bottles—without ever having to tote your trash to a recycling center? That's what Parliament, a Portland, Oregon design studio, tried to illustrate and encourage for their client RecycleBank, a company that rewards people simply for sorting their garbage and recycling the rest. "They wanted to communicate what happens when recyclables leave somebody's curb," says Chris Erickson, who led the promotional effort for RecycleBank's The Cycle campaign.

"We toured facilities and took pictures," he says of the creative process. "The [recycling facilities] use really dangerous machines that the public doesn't see. It's pretty boring. So we created these stylized machines to make the process interesting, so people could stay tuned and learn what happens to paper, plastic, metal and glass."

The ensuing Web site takes viewers through the life cycle of recyclables in eight chapters, says Erickson: "Picking up, organizing, sending them to various places. It explains the process." Parliament wrote the script, created the storyboards and programmed the animation for the site, which provides an educational, rewarding experience for anyone who happens upon it while allowing actual participants to earn "RecycleBank points" redeemable for free products from such sponsors as Target and Sears. "It saves money over putting things in landfills, people have incentive to recycle and the environment benefits because there's less things going into the ground," Erickson explains. "The only people left out on the curb are the people who own the landfills!"

Even for those who don't reduce, reuse and recycle, the site has become a hit and interest as RecycleBank gains currency through word of mouth, awards, Facebook and YouTube. "People e-mailed it to their friends," Erickson says. "It worked out well.

• • •

CREATED BY
Chris Erickson, Aaron Noah, Jono Stark • Chris Erickson Photo by Matthew Brush

INTRO MRF PAPER METAL PLASTIC GLASS OVERSEAS RECYCLEBANK

MATERIAL RECOVERY FACILITY

00:35

Arrival Paper Metal Plastic Glass

EMBED LARGE VIDEO EMBED SMALL VIDEO **DOWNLOAD SCENE** DOWNLOAD FULL VIDEO

`<object width="640" height="360"><param name=` COPY iPOD PSP PC/MAC

1

ORGANIZATION
Cala/Krill Design

CREATED BY
Alyssa Lang, Ronald J. Cala II

Little Utopia, Inc.
Los Angeles, CA

2

ORGANIZATION
Green Zone Home

CREATED BY
David Clark

Graphic Granola
Austin, TX

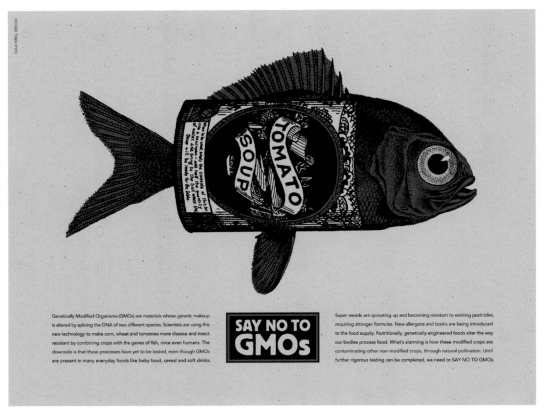

1

2

1

2

3

4

5

1

ORGANIZATION
AIGA Philadelphia

CREATED BY
Kelly Holohan, Alexander Zahradnik

Holohan Design
Philadephia, PA

2

ORGANIZATION
The Salvation Army

CREATED BY
Greg Bennett, David Griffiths

WORKtoDATE
York, PA

3

ORGANIZATION
Urban Paradise Guild

CREATED BY
Claudio Luis Vera, Felix Arteaga

studio:module
Miami, FL

1

2

3

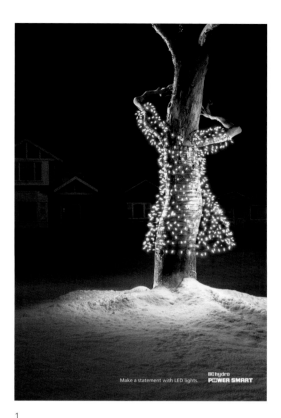

1

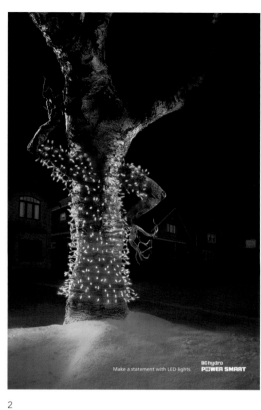

2

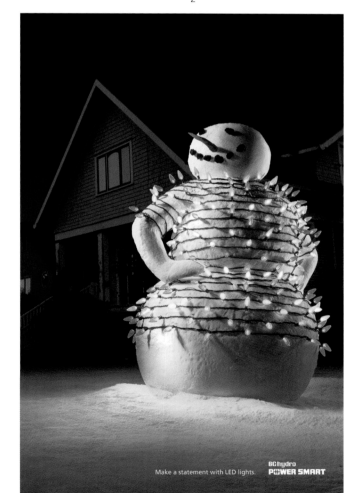

3

1 • 2 • 3
ORGANIZATION
BC Hydro

CREATED BY
Alan Russell, Dean Lee, Dan Strasser,
Kevin Rathgeber, Scott Morgan

DDB Canada / Vancouver
Vancouver, Canada

1

ORGANIZATION
The Alliance for Climate Protection
CREATED BY
Jamie Mahoney
VCU
Richmond, VA

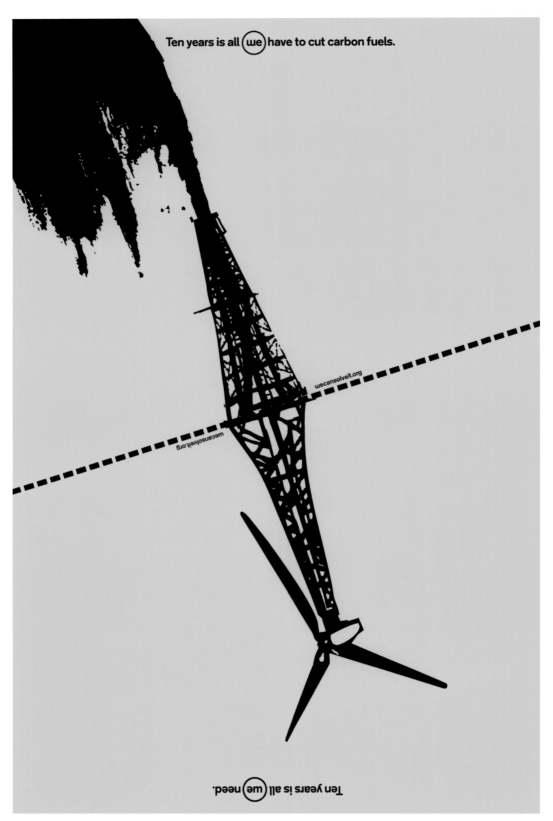

1

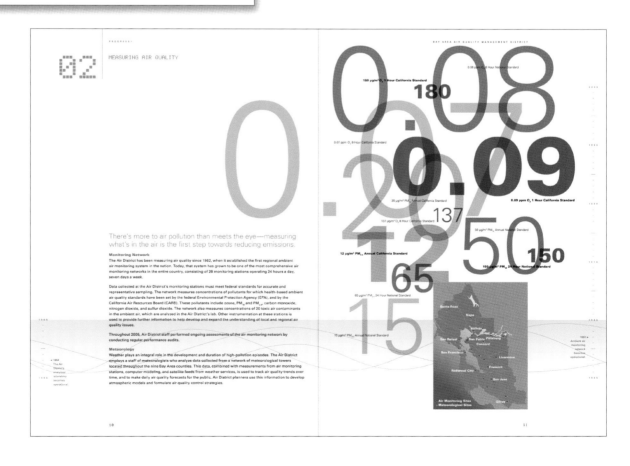

1

ORGANIZATION
Bay Area Air Quality
Management District

CREATED BY
Earl Gee, Fani Chung, Sharon Beals

Gee + Chung Design
San Francisco, CA

1

ORGANIZATION
Islington Council

CREATED BY
Christine Fent

Beam
London, United Kingdom

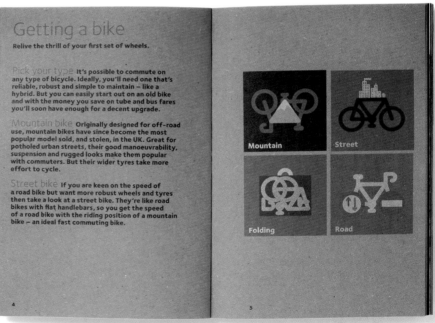

1

1 • 2

ORGANIZATION
Islington Council

CREATED BY
Christine Fent, Marek Gwiazda
Beam
London, United Kingdom

1

2

Gibson Square

church on this site since the Norman conquest, though it has seen its share of rebuilds – the most recent in 1956 after it was mostly destroyed by a bomb in WWII – and its share of controversies. Refusing to attend mass here turned out to be a fatal error for 40 Islington residents who were consequently burned to death by Queen Mary. Continue along Upper Street and turn right down Cross Street. Halfway down Cross Street, turn right into the archway beside the knitting shop – this is Dagmar Passage.

46

Islington Green

which allows you to enter the gardens of St Mary's Church. Walk through the gardens and exit the other side onto Gaskin Street. Straight ahead of you is a housing development with large gates – enter here into Anderson's Square, follow the path around onto Collins Yard. You'll see ahead of you Islington Green. Often filled with lunching office workers, the green was once a piece of common land on which wealthy landlords would let farmers graze their herd. It was largely built over in the 19th century. Take the path through the green and as you leave,

47

1

ORGANIZATION
Keep America Beautiful

CREATED BY
Daniel Taylor, Steve Habersang,
Erin Cummings, Steve Dildarian

Taylor Design
Stamford, CT

1

1

1

ORGANIZATION
Global Environment Facility

CREATED BY
Brent M. Almond, Polina Pinchevsky,
Susan Chenoweth

Design Nut, LLC
Kensington, MD

49

Looking Ahead:
What is Next for GEF

A New GEF: Seeking Biodiversity Impacts Commensurate with the Scale of the Threats
THE FOURTH PHASE of the GEF is becoming, in many ways, a turning point for the facility, and for revisiting its role as the largest funding mechanism dedicated to the protection of global biodiversity. In order to continue to fulfill its function as the financial mechanism of the CBD, the GEF must evolve and be strengthened. The emphasis on biodiversity as an individual focal area should remain at GEF, not only to highlight the specificities of dealing with an irreplaceable global good whose value to society remains to be fully assessed, but also to address the ways to deal with existing and emerging threats, as well as identify rapidly expanding opportunities to act strategically. GEF needs to move from solely dealing with individual projects designed to achieve specific biodiversity goals to larger programs composed of many complementary projects, which themselves could include resources from different focal areas, adding to the biodiversity-specific investments. »

38 SECTION 5 » THE GEF BIODIVERSITY STRATEGY IN ACTION FINANCING THE STEWARDSHIP OF GLOBAL BIODIVERSITY 39

CASE STUDY › Protected Areas of the Amazon: The ARPA Program

Brazil has established the Protected Areas of the Amazon Program (ARPA) to expand its protected area network in the Amazon, to improve capacity for management, and secure financing for long-term management needs. Implementation of the first phase of the program began in 2003, supported by a GEF grant of $30 million, which leveraged initial co-financing of $59 million. The project includes support from the Brazilian government, the Brazilian Biodiversity Fund (FUNBIO), the World Bank, the German Development Bank (KfW), and the World Wildlife Fund (WWF).

During the first phase, ARPA sought to create 18 million hectares in new protected areas (9 million hectares of strict protection PAs and 9 million hectares of sustainable use). The sustainable use protected areas have the goal of conserving biodiversity while at the same time supporting the communities living in them. ARPA will also develop long-term sustainable management tools and mechanisms for effective protection within all Amazonian strict protected areas. As this first phase of the program enters its last year of implementation, the original targets have been exceeded: more than 31 million hectares of protected areas have been created, and an additional 25 areas are being studied for future protected area creation and an endowment fund has been established and capitalized with $17.9 million. A second phase is currently under design.

1

ORGANIZATION
AIGA Detroit and The Ann Arbor
Ecology Center

CREATED BY
Kelly Salchow

thrive design
East Lansing, MI

1

1 • 2 • 3 • 4

ORGANIZATION
Michigan State University

CREATED BY
Kelly Salchow, Caitlin Gallagher,
Kate Hunt, Liz Levosinski

thrive design
East Lansing, MI

1

2

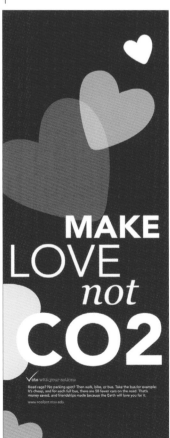

3

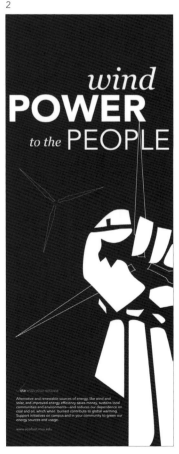

4

1

ORGANIZATION
AIGA

CREATED BY
Gaby Brink, Nicole Flores,
Sarah Labieniec, Monica Hernandez,
Scott Hickman

Tomorrow Partners
Berkeley, CA

Compostmodern 09
Convergence

1

In the five years since Compostmodern
began, sustainability has grown from a niche
conversation to a global mass movement.

As activists, industry, and government
take simultaneous steps toward change,
sustainable solutions are finding new and
unexpected applications. Join us as we
explore this world of converging ideas
and examine the role of design thinking in
creating them.

Registration

Compostmodern 09 is presented
by AIGA San Francisco and the
AIGA Center for Sustainable Design

February 21_ 2009
Herbst Theatre
401 Van Ness Avenue
San Francisco_ California

To reserve your space,
please register online at
www.compostmodern.org

On or before Feb 6, 2009_

$50 AIGA student members
$60 AIGA members
$70 Students (with valid ID)
$80 Non-members

After Feb 6, 2009_

$60 AIGA student members
$70 AIGA members
$80 Students (with valid ID)
$90 Non-members

Admission will also be available at the
door, space permitting.

Compostmodern 09 will also be webcast live
and will be available for viewing 90 days
following the event. For more information on
webcast opportunities and locations, please
visit www.compostmodern.org.

1

ORGANIZATION
Santa Monica Summer Project

CREATED BY
Bryan Ledbetter

Airtype Studio
Winston-Salem, NC

2

ORGANIZATION
North Branch Wesleyan Church

CREATED BY
Brock Henderson, Brenden Jones

Paper Tower
Elgin, IL

3

ORGANIZATION
Grace Fellowship Church

CREATED BY
Steve Allen

Allen Creative
Snellville, GA

4

ORGANIZATION
Cityline Church

CREATED BY
Frankie Gonzalez, Michelle Wang

3rd Edge Communications
Jersey City, NJ

5

ORGANIZATION
Warehouse 242

CREATED BY
Gage Mitchell, Chris Bradle

Eye Design Studio
Charlotte, NC

1

2

3

4

5

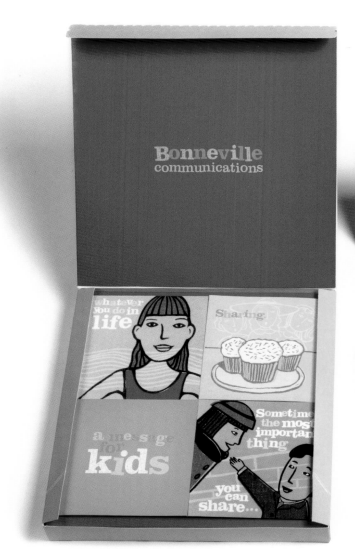

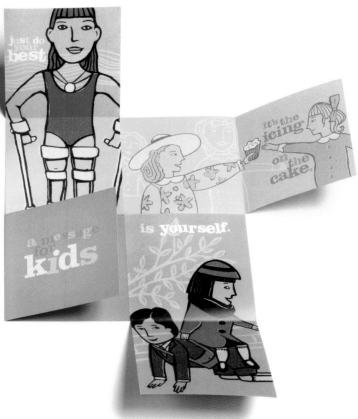

1

ORGANIZATION
The Church of Jesus Christ
of Latter Day Saints

CREATED BY
Shawn Hansen, Chris Shill,
Joe Esquibel

Fluid Studio
Bountiful, UT

1

1

ORGANIZATION
Mladina Magazine
CREATED BY
Vladan Srdić
Studio 360 d.o.o.
Ljubljana, Slovenia

2

ORGANIZATION
The Church of Jesus Christ
of Latter Day Saints
CREATED BY
Chris Shill
Fluid Studio
Bountiful, UT

1

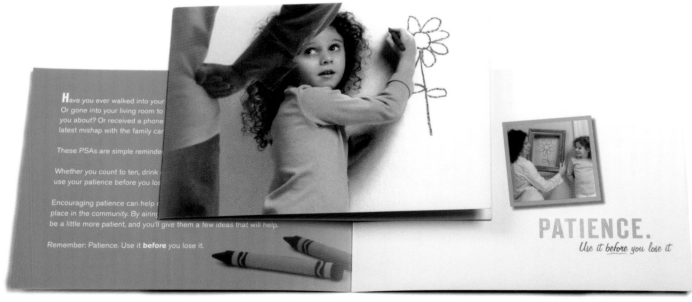

2

luceo

1

INTERFAITH
ALLIANCE

2

3

4

1

ORGANIZATION
Luceo

CREATED BY
Tyler Sticka

Tyler Sticka Interactive Design
& Illustration
Newberg, OR

2

ORGANIZATION
The Interfaith Alliance

CREATED BY
Scott Ketchum, Molly Conley

BBMG
New York, NY

3

ORGANIZATION
Buckhead Church

CREATED BY
Bryan Ledbetter

Airtype Studio
Winston-Salem, NC

4

ORGANIZATION
Koinonia / Martin Luther
Camp Association

CREATED BY
David Langton, Roland Dubois

Langton Cherubino Group
New York, NY

1 • 2

ORGANIZATION
Christ Episcopal Church
of Needham, MA

CREATED BY
Lauren Capers

Capers Design
Middleboro, MA

1

2

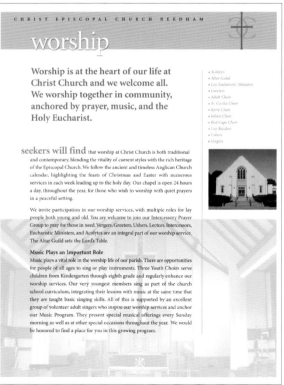

1

1
ORGANIZATION
Mayapur Institute for Higher
Education and Training
CREATED BY
Pancharatna dasa, Tracy Sabin
Sabingrafik, Inc.
Carlsbad, CA

2
ORGANIZATION
St. Mary Church
CREATED BY
Michael Bartello
Seesponge
Washington Township, MI

2

1

ORGANIZATION
Supreme Task Ministries

CREATED BY
Mark Combs

DzinDNA.com
Sapulpa, OK

2

ORGANIZATION
Ohev Yisrael Messianic
Jewish Congregation

CREATED BY
Jason Linas

J.LinasDesign
Richmond, VA

3

ORGANIZATION
Grace Fellowship Church

CREATED BY
Steve Allen

Allen Creative
Snellville, GA

4

ORGANIZATION
New Life Church

CREATED BY
Jeff Kern, Brent Robison

Robison Creative Studios
Ozark, MO

1

2

3

4

CENTER FOR
FAITH AND
ENTERPRISE

1

1 • 2
ORGANIZATION
Center for Faith and Enterprise, Inc.,
Sierra Madre, CA
CREATED BY
Marc Posch
Marc Posch Design, Inc
Long Beach, CA

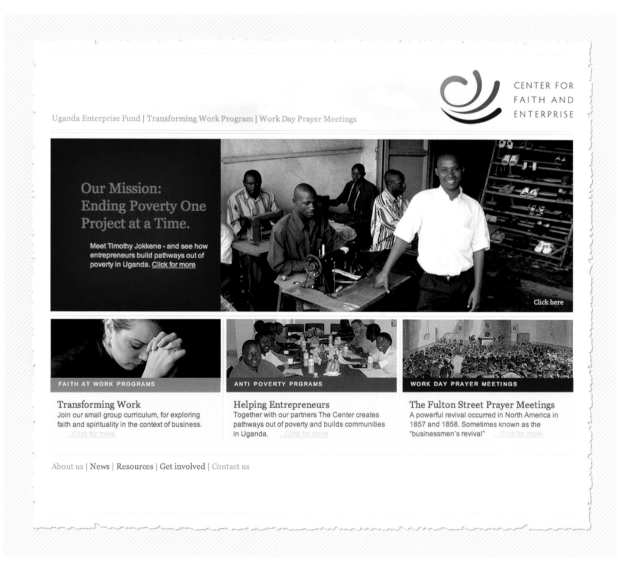

2

1

ORGANIZATION
The Salvation Army
CREATED BY
Cindy King
King Design Group, LLC
Conshohocken, PA

BECAUSE OF *you*... WE BRING REAL, POSITIVE CHANGES TO PEOPLE'S LIVES.

Dear Friends of The Salvation Army,

This year, The Salvation Army of Greater Philadelphia continued to do the most good with the resources entrusted to us for those in the most need.

Lynn Wilson found her inner strength through Salvation Army programs as she fought and won her battle against drug and alcohol addiction. Luke Barney found a sustaining faith at The Salvation Army's Pioneer Corps Community Center that guided him through a difficult childhood and inspires his ministry today. In The Salvation Army's compassionate response to the daily disaster of substandard housing, our neighbors in North Philadelphia found answered prayers and the beginnings of community revitalization.

We are committed to doing the most good for any needy individual, in any given situation. Our mission statement – meeting human needs in Jesus' name without discrimination – binds us to addressing a person's immediate needs. Yet at the same time, it allows us to look ahead to the longer term social, emotional, educational, and spiritual needs that must be addressed before a happy, healthy, productive life is possible. We meet people wherever they are and offer the services and support that allow them to see where they can be. Each and every person who crosses our path is recognized as one of God's children, and with your support, we are able to help them bring about real, positive changes in their lives.

Of course, change is impossible without hope. The future Salvation Army Ray and Joan Kroc Corps Community Center promises to greatly expand our ability to reach people like Lynn, Luke, and countless others. This state-of-the-art facility—with programs for children, teens, adults, seniors, and families—has the potential to transform lives throughout the region.

As our Doing the Most Good manifesto reads, The Salvation Army is "a humble steward of other people's generosity." We want to express our deepest gratitude to our donors and volunteers. Your continuing support allows us to meet our community's evolving needs. We look to next year with excitement and confidence, forging ahead in our mission to do the most good day after day, one person at a time.

Sincerely,

William R. & Marcella Carlson

Lt. Colonels William R. & Marcella Carlson
Divisional Leaders

COMPASSION

BECAUSE OF *World Changers*... ANOTHER NEIGHBORHOOD'S SPIRIT IS RESTORED.

World Changers' mission fits perfectly with The Salvation Army's longstanding tradition of caring for the "whole person"— responding with compassion to the spiritual, emotional, and physical needs of hurting people.

The homes on Deacon Street and Roberts Avenue in North Philadelphia were badly in need of repair. Lacking the ability or the resources to make improvements, residents lived with peeling paint and dilapidated fencing. Many of the porches in the neighborhood's row homes rotted and sagged dangerously. Families lived next to trash-strewn empty lots.

"It was a beautiful street when I moved here fifty years ago," said neighborhood resident Jesse Holloway. Since then, he added, "I've seen a lot of changes."

Our neighbors were hurting, and The Salvation Army of Greater Philadelphia knew a way to offer help. Our partner ship with World Changers, a volunteer youth initiative affiliated with the North American Mission Board of the Southern Baptist Convention, just celebrated its fifth successful year. The Salvation Army and World Changers share a common goal: to meet human needs in Jesus' name without discrimination. World Changers aim to eliminate substandard housing for elderly, low-income, and disabled residents in communities all over the world.

For one week each year, hundreds of students from around the country perform construction and cleanup alongside community volunteers. Spending hours under the hot summer sun, volunteers work to complete projects that revitalize several blocks in Philadelphia's inner city. "It's awesome," said a seventeen-year-old World Changer from North Carolina. "Just by putting a roof on we can show people we love them and so does God."

The Salvation Army's Bonnie Camarda and Dottie Wells, who worked to coordinate the projects, feel that World Changers' mission fits perfectly with The Salvation Army's longstanding tradition of caring for the "whole person" – responding with compassion to the spiritual, emotional, and physical needs of hurting people. Notes Dottie, "It's important that the volunteers finish the clean-up and repair tasks they've been assigned, but it's more important that they connect with people."

Mr. Holloway sat on his son-in-law's porch, surveying the scene. Two doors away, a group of teenagers freshened the facade of his rowhouse with a new coat of bright yellow paint. "I can't wait till they're finished to see how it looks," he said, adding, "I really have enjoyed this week."

During that one week in Philadelphia each year, paint jobs are refreshed. Fences are repaired. Abandoned, debris-strewn lots are cleaned. Weathered roofing and crumbling porches are refurbished. And The Salvation Army and World Changer volunteers embody their missions with a spirit of connection and community fellowship, attending to the residents' immediate physical needs and engaging them in prayer and spiritual discussions.

Looking up and down his block, Mr. Holloway drew his own conclusion. "The Salvation Army and World Changers," he said, "did a very good job."

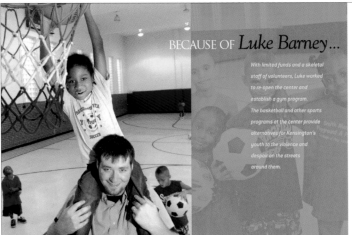

FAITH

BECAUSE OF *Luke Barney*... KENSINGTON YOUTH HAVE A SANCTUARY FROM VIOLENCE.

With limited funds and a skeletal staff of volunteers, Luke worked to re-open the center and establish a gym program. The basketball and other sports programs at the center provide alternatives for Kensington's youth to the violence and despair on the streets around them.

Luke Barney's work is transforming patterns of poverty and violence into stories of learning, progress and development.

In the late 1980s, five-year-old Luke Barney, his mother, and his two sisters were struggling to survive in North Philadelphia's Kensington, a neighborhood rife with deep poverty and youth violence. Destitute and alone, and hoping for something better for her children, Luke's mother turned to The Salvation Army Philadelphia Pioneer Corps Community Center for help with food and bills. The Pioneer Corps staff fulfilled the family's basic needs, making it possible for them to re-establish a sustainable and stable life among a supportive community.

Dr. Harold Burgmayer, The Salvation Army Divisional Musical Director, noticed Luke's potential and shepherded him into the after-school music program. Luke began guitar and trumpet lessons. "He was very enthusiastic," recalls Burgmayer. "Each year we have two recitals and there is a competition for the children. The one who brings the most family members wins a prize. Luke and his sister teamed up and brought 18 people! They won a pizza sized chocolate chip cookie."

Luke's involvement with The Salvation Army, which he characterizes as a "very generous church," re-structured his entire life. He learned to shoulder responsibility by working last year as operations manager at The Salvation Army's Camp Ladore, a summer camp with programs for youth, family and seniors. He has become a first-rate musician, learning how to acquire new skills quickly and effectively.

At just 22 years old, Luke serves not only as a youth pastor, but also as the Pioneer Corps community center director. With limited funds and a skeletal staff of volunteers, Luke worked to re-open the center and establish a gym program. Just like The Salvation Army's music programs did for Luke, the basketball and other sports programs at the center provide alternatives for Kensington's youth to the violence and despair on the streets around them. "He grew up two blocks from the corps. Now 17 years later, he is giving back by teaching the kids," says Burgmayer. "He really, really understands what it is like for the kids to come into the gym."

Using his ability to "get quickly into the swing of things," Luke's been able to run a series of programs to meet the changing needs of "the kids." Earlier this year, with 20 children, a few donated puppets and some online research, Luke began a puppet ministry.

The first term brings to life the story of Jesus through puzzles, art activities, and puppet theater. For all of his students, Luke's class is a chance to learn an expressive art. For many, it is their first experience learning the gospel of Jesus Christ. In the second term, Luke uses the book "I Am Somebody" as a character-building tool, allowing the children to reflect on their own spiritual walks.

While Luke's education and recreation programs offer important opportunities to Kensington residents, he considers them a means to reach participants at a deeper level. "My program is definitely an outreach program. It is about people experiencing the Lord, whether it's through playing a basketball game or laughing at puppets."

1

ORGANIZATION
Sand Springs Assembly of God

CREATED BY
Mark Combs

DzinDNA.com
Sapulpa, OK

2

ORGANIZATION
World Bridge

CREATED BY
Steve Allen

Allen Creative
Snellville, GA

3

ORGANIZATION
Life Center

CREATED BY
Jeff Kern, Brent Robison

Robison Creative Studios
Ozark, M

4

ORGANIZATION
We Care America

CREATED BY
Jeff Kern, Brent Robison

Robison Creative Studios
Ozark, MO

1

2

3

4

1

1

ORGANIZATION
Benedictine Sisters in Cullman, AL

CREATED BY
April Mraz, Alan Whitley, Nik Layman

Open Creative Group
Birmingham, AL

1 • 2 • 3 • 4

ORGANIZATION
Southern Hills Baptist Church
CREATED BY
Chris Lo
Matcha Design
Tulsa, OK

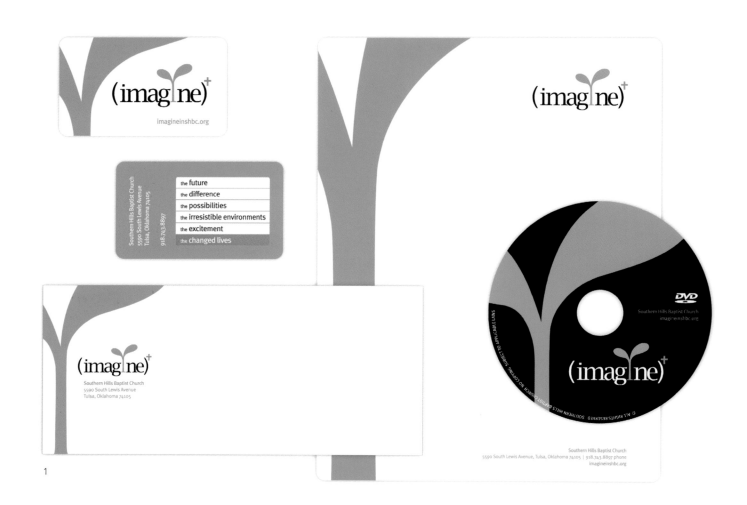

1

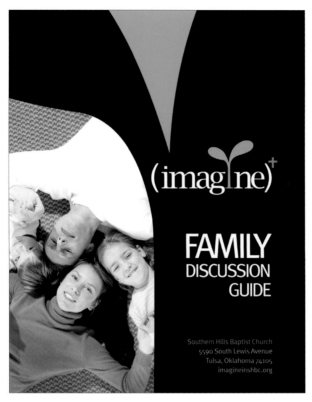

2

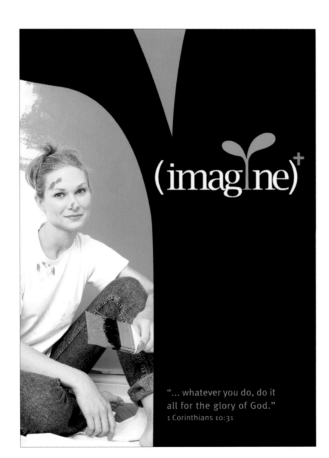

3

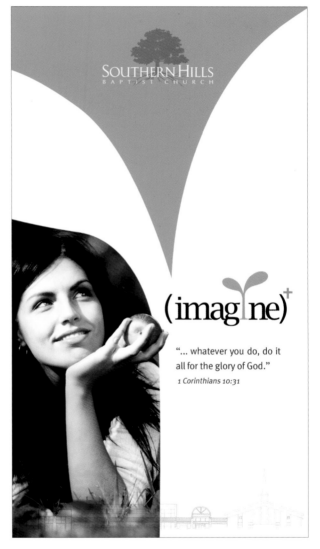

4

1

ORGANIZATION
Harpeth Community Church

CREATED BY
Jon McGrath, Brenden Jones,
Brock Henderson

Paper Tower
Elgin, IL

2

ORGANIZATION
Saint Thomas More Parish

CREATED BY
Fa. Bob Camuso, Dara Turransky

Turransky, LLC
Snohomish, WA

3

ORGANIZATION
High Street Baptist Church

CREATED BY
Jeff Kern, Brent Robison

Robison Creative Studios
Ozark, MO

4

ORGANIZATION
Zion

CREATED BY
Jeff Kern, Brent Robison

Robison Creative Studios
Ozark, MO

5

ORGANIZATION
Foundation "I Hear, I Believe, I See"

CREATED BY
Mario Depicolzuane
Croatia

1

2

3

4

5

1
ORGANIZATION
Crossroads Tabernacle
CREATED BY
Frankie Gonzalez, Nick Schmitz, Eugenia Wong
3rd Edge Communications
Jersey City, NJ

1

ARTS AND CULTURE

SPOTLIGHT ON
FRAMELINE FILM FESTIVAL

GABY BRINK
TOMORROW PARTNERS
BERKELEY, CALIFORNIA

A film festival with a three-decade history catering to seventy-five thousand attendees is as close to mainstream as you can expect—but perhaps surprising when you consider that it's the Frameline Film Festival, "the world's first and still largest celebration of queer cinema." "We really believe that design and communications are a powerful conduit for social change," says Gaby Brink, principal and owner of Tomorrow Partners in Berkeley. "That's why we donate ten to twenty percent of our services to cause-related work."

To promote the San Francisco festival and its two hundred films shown at three theaters over two weeks every spring, Brink took a different tack for the thirty-first annual event. "Every year they use one graphic for banners, posters and the program guide," she says. "I felt it was a shame that they have all these amazing films and that they never show them, so why not show off the breadth of all the films they play and reflect the diverse LGBT community from every angle?" Using provocative stills paired with zingy one-liners, Brink says, "allow[ed] us to give credit to the colorful range of films: a pair of elderly ladies kissing, two guys making out in a bathroom stall, drag queens in a hospital waiting room, a young man holding a baby doll." The stills are striking, chosen with help from the festival producers themselves. "It was the first time they'd ever had a campaign that showed the very thing they celebrate: queer cinema."

The images appeared on Frameline's magazine-style festival guide, schedule, bus shelters, entry posters, smaller tabloid-sized posters, VIP invites for parties, tickets and even a trailer shown that ran on local TV and before the films. The Festival principals and audience were "extremely thrilled," says Brink. "The campaign was more about cinema, and it celebrated what Frameline was about."

• • •
CREATED BY
Gaby Brink, Katie Fishback

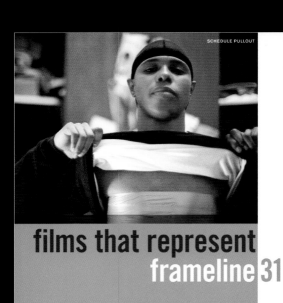

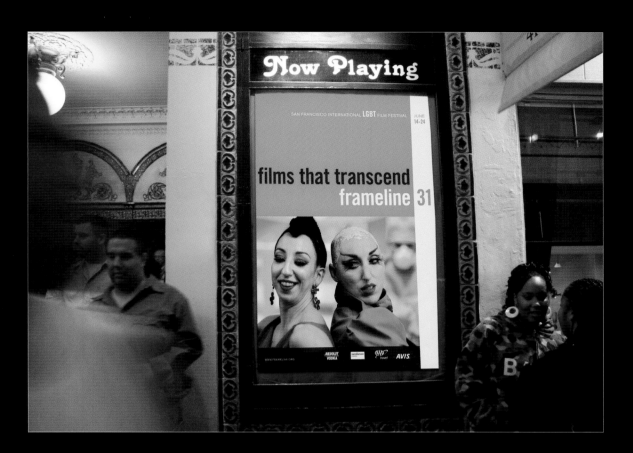

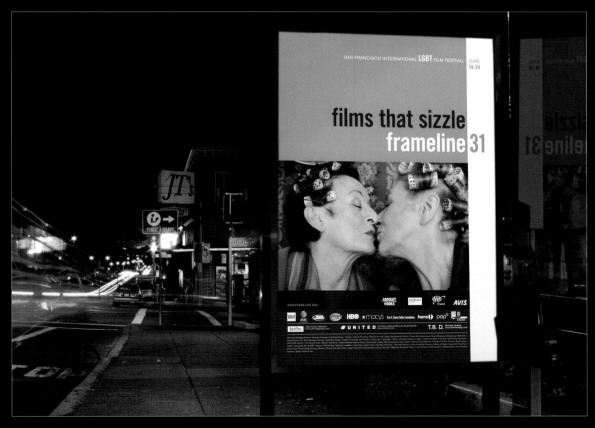

1
ORGANIZATION
Peace it Together
CREATED BY
Blair Pocock, Mike Moraal, Felix Heinen
Fleming Creative Group
St. Petersburg, FL

2
ORGANIZATION
Mill Valley Film Festival
CREATED BY
Christopher Simmons, Tim Belonax
MINE™
San Francisco, CA

3
ORGANIZATION
Art in Public Spaces
CREATED BY
Matthew Marosz
2 Em Design
Portland, OR

4
ORGANIZATION
Green Bay Boy Choir
and Girl Choir, Inc.
CREATED BY
Daniel Green
Eye-D Design
Green Bay, WI

5
ORGANIZATION
Auburn University
CREATED BY
Kevin Smith
CreateTwo
Auburn, AL

6
ORGANIZATION
Disabilities Film Festival
CREATED BY
Martin Kace, Masood Bukhari
Empax Inc.
New York City, NY

Peace it Together

1

2

3

4

5

6

1

ORGANIZATION
Greater New Orleans Youth Orchestra
CREATED BY
Chris Brown, Jacee Brown
Plaine Studios
New Orleans, LA

2
ORGANIZATION
California Music Project
CREATED BY
Michael Osborne, Jeff Ho
Joey's Corner
San Francisco, CA

2

1 • 2 • 3 • 4

ORGANIZATION
National Youth Arts Wales

CREATED BY
Guto Evans, Gwion Prydderch,
Aaron Easterbrook

Elfen
Cardiff, United Kingdom

1

2

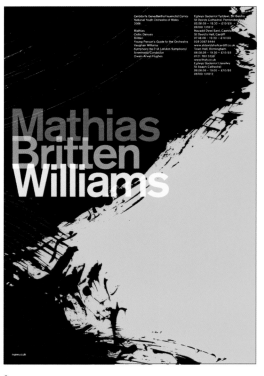

3

4

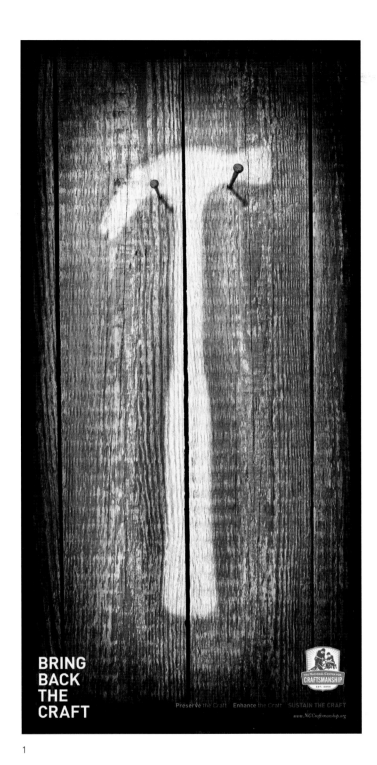

1

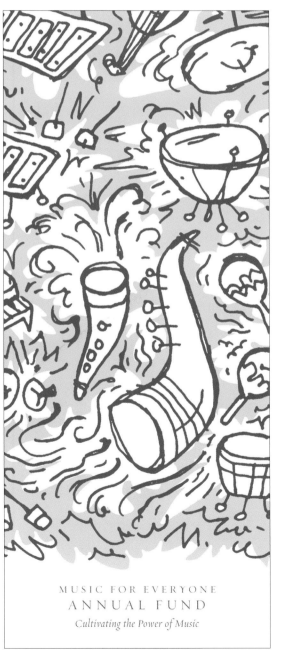

2

1

ORGANIZATION
National Center for Craftsmanship

CREATED BY
Matt Kistler, Tom Campbell

Toolbox Creative
Fort Collins, CO

2

ORGANIZATION
Music for Everyone

CREATED BY
Craig Welsh

Go Welsh
Lancaster, PA

1

ORGANIZATION
Music for Everyone

CREATED BY
Craig Welsh

Go Welsh
Lancaster, PA

2

ORGANIZATION
Maricopa Partnership for Arts
& Culture

CREATED BY
Greg Fisher, GG LeMere,
Andy Mrozinski

Campbell Fisher Design
Phoenix, AZ

3

ORGANIZATION
impulse

CREATED BY
Alexander Egger
Vienna, Austria

4

ORGANIZATION
The Sheldon Concert Hall

CREATED BY
Jenny Anderson

Paradowski Creative
St. Louis, MO

1

2

3

4

1

ORGANIZATION
The SilkRoad Project

CREATED BY
Alice Hecht, Anne Dauchy,
Embolden Design, Heidi Koelz

Hecht Design
Arlington, MA

1

1

ORGANIZATION
Music City Youth Orchestra

CREATED BY
Ron Zisman, Walter Bitner

ricochet:communications design
Pearl River, NY

2

ORGANIZATION
Alabama Museums Association

CREATED BY
April Mraz, Michael Vizzina

Open Creative Group
Birmingham, AL

1

2

1

2

3

4

5

6

1

ORGANIZATION
Cascade Youth Symphony

CREATED BY
Josh Oakley

Weather Control
Seattle, WA

2

ORGANIZATION
The Williamson Museum

CREATED BY
Nick Ramos

Graphismo
Georgetown, TX

3

ORGANIZATION
VH-1 Save the Music Foundation

CREATED BY
Alexander Isley, Aline Hilford,
George Kokkinidis

Alexander Isley, Inc.
Redding, CT

4

ORGANIZATION
Cuisine Canada

CREATED BY
Phred Martin

Splash:Design
Kelowna, Canada

5

ORGANIZATION
Cause TV

CREATED BY
John Fisk, Wyndy Wilder

GraFISK Design
Astoria, NY

6

ORGANIZATION
Artmakers Inc.

CREATED BY
Jacqueline Law, David Frisco,
Michael Kelly

Design Corps, Pratt Institute
Brooklyn, NY

7

ORGANIZATION
Women's Independent Cinema

CREATED BY
Barry Deutsch, Nancy Andre

Deutsch Design Works
San Francisco, CA

WOMEN'S INDEPENDENT CINEMA

7

1

ORGANIZATION
San Francisco Opera

CREATED BY
Zach Hochstadt, Jennie Winton,
Tine Reese, Amy Weiher

Mission Minded
San Francisco, CA

1

1 • 2

ORGANIZATION
Asian Art Museum

CREATED BY
Rod Lemaire, Jennie Winton,
Zach Hochstadt, Tine Reese,
Amy Weiher, Ozzie Thoreson

Mission Minded
San Francisco, CA

1

2

1

ORGANIZATION
Autry National Center of the American
West (formerly the Autry Museum of
Western Heritage)

CREATED BY
Beth Goldfarb

b.g. design
Los Angeles, CA

1

COLLECTIONS: CULTURAL TREASURES IN THE DIGITAL AGE

Collections are the lifeblood of museums. They are the medium through which stories are told, ideas examined, connections made. They are a precious cultural resource, vessels that allow the past to live with us today and encourage us to reflect on how we will live tomorrow. Although protecting collections is the number one duty of any museum, providing broad public access comes very close behind. We provide that access primarily through exhibitions and by accommodating the work of scholars and researchers. Increasingly, though, the public is finding greater access to museum collections in electronic form. At the Autry we are no different, having firmly planted ourselves in the digital age.

Through our Collections Online database, the Autry National Center has made roughly 50,000 searchable records of objects, artwork, and archival holdings available to the public over the Internet—and this number grows every day. Most of these records are accompanied by digital images, allowing lay people, researchers, tribal representatives, and educators around the world to study and enjoy them. Others have taken notice; the Autry was invited by the Institute of Museum and Library Services to demonstrate its Collections Online at the national WebWise Conference on Libraries and Museums in the Digital World held in Washington, D.C., last March. The Autry is currently exploring electronic partnerships with institutions possessing similar digital collections in order to increase public access in a variety of online contexts. It is one of the ways museums will stay relevant in the 21st century, in terms of both content development and stimulating information delivery.

In 2007, a number of important items were added to the Autry's collections that will find their way into Collections Online, as well as into upcoming exhibitions and future long-term galleries. The Gold-level Member Acquisitions Committee—composed of the Autry's highest-level members, and quickly becoming one of its most engaged and dynamic groups—is helping to shape the Autry's future through expansion of its holdings. At the committee's annual meeting, they selected for purchase a lot of rare maps documenting early exploration of

North America and the Pacific. These maps are just as much beautiful works of art as they were navigational tools. Through the generosity of its members, the committee supplemented this prized acquisition with several other important purchases: contemporary dance regalia from Native tribes of northern California; the work of contemporary Native American photographers Dugan Aguilar, Zig Jackson, Victor Masayesva, and Hulleah Tsinhnahjinnie (all featured in *Picturing the People*); and the 2005 painting *Lady Luck* by Michael Scott.

Other important acquisitions of note—through donation or purchase—included 103 modern Native American ceramics; a 1947 Bohlin silver parade saddle and tack; a contemporary Inuit basket made from baleen; the model of a rampant colt dating to 1838 from which the Colt firearms trademark was derived; the paintings *Malibu Canyon* by Hanson Puthuff, *Aspen Draw* by Tucker Smith (Masters of the American West Trustees' Purchase Award), and *Raindrops and Dragonflies* by Clyde Aspevig (winner of the Masters Purchase Award); a Navajo weaving by Rena Begay (winner of the Jackie Autry Best in Show award at the Intertribal Arts Marketplace); and Camilla Chandler Frost's promised gift of her extraordinary basket collection.

"To me the orbs represent spirits of the past, present, and future. All here to help."

– Hulleah Tsinhnahjinnie

Tom Lee
Chairman, Board of Trustees

John Gray
President and CEO

DEAR FRIENDS OF THE AUTRY

Vibrant, active, forward-thinking: these are traits we believe characterize the Autry National Center. For some, this might seem incongruous, for we are an institution focused on history. It's true that much of what we do at the Autry is grounded in an appreciation of the past. It's also true that a portion of what we present appeals to the romantic in all of us and summons a longing for bygone times. We would argue, however, that the study of history is pointless unless it provides insight into how we live today, and unless we use the lessons of the past to build a more respectful and cooperative future—one marked by greater opportunity for all. Romance is wonderful, but empowering people to participate more fully in life, and to see themselves as history makers, is profoundly more important.

No one knew this better than the two figures chiefly responsible for the Autry National Center: Gene Autry, the visionary entertainer and philanthropist from whom our institution derives its name; and Charles Lummis, the tramping journalist, editor, amateur archaeologist, and social crusader who fathered the Southwest Museum of the American Indian. Each, in his own way, had a strong sense of America's roots, a deep respect both for cultural traditions and everyday life, a firm conviction that history matters, and an abiding belief that the present and future belong to all. Although the two men never met, the museums they founded are now inextricably linked as the key public faces of the Autry National Center.

What a lovely twist of fate it was, then, that 2007 marked the 100th anniversaries of the incorporation of the Southwest Museum and Gene Autry's birth. For the Southwest Museum, we organized a variety of programs so that visitors could learn more about the museum's significance as well as the challenges that exist in saving its collections and preserving its historic building. We also presented a unique exhibition pairing rarely seen photographs of Native cultures from the Southwest collection with photographic art of and by contemporary indigenous peoples—a provocative commentary on the reclaiming of Indian identity. At the same time, we celebrated Gene with a major exhibition profiling the many aspects of his life and the overwhelming influence he had on 20th-century popular culture; and we honored him at our annual Gala.

A whole lot more happened in 2007. In this annual report, we invite you to relive—or for those as yet unfamiliar with the Autry, to discover—a year of wide-ranging exhibitions and educational programs, celebrations of the past and present, and intense planning both for the next iteration of our two campuses and for employing our collections and resources to better serve the greater public. The doors of the Autry swing back, allowing us to reflect upon our diverse history, and then swing forward to chart a path to our shared future. As always, we thank you for your friendship and support, and invite you to join us as we commence a new journey of a hundred years.

"Do not go where the path may lead: go instead where there is no path and leave a trail."

– Ralph Waldo Emerson

PS ARTS WEEK

JOHN GAVULA
GAVULA DESIGN
MELROSE, MASSACHUSETTS

Imagine being fifteen and playing at Carnegie Hall, or showing your painting at the Metropolitan Museum of Art. For some New York public school students, it's not just a dream, as John Gavula of Gavula Design can attest.

"The Fund for Public Schools needed an identity system, as well as collateral, signage and a Web site to appeal to a general audience," he says. "It was kind of unusual because there was no commercial objective. We simply wanted it to capture the joy of the arts graphically."

The aim of the weeklong initiative, explains Gavula, is to celebrate the arts in the New York City public schools, in four gala events hosted at "very, very cool venues": Carnegie Hall, the Apollo Theater, the New Victory Theater and the Metropolitan Museum of Art. To capture the magic, Gavula created simple yet expressive line drawings of figures dancing, playing music, painting and emoting. From Gavula's Massachusetts studio, the illustrations instantly evoke the sheer abandon of creating art, all while being vibrant, youthful, fun and dignified at the same time. The Web site captures the excitement of the students' once-in-a-lifetime opportunity, featuring a spotlight turned on the performers, with a subtle audience watching from along the bottom and the legend, *ADMITS ALL*.

"It makes kids feel really special to be featured in such a broad celebration," Gavula says, "and it shows that the New York City public schools are making the arts accessible by supporting and funding their development."

CREATED BY
John Gavula, Jenna Gavula

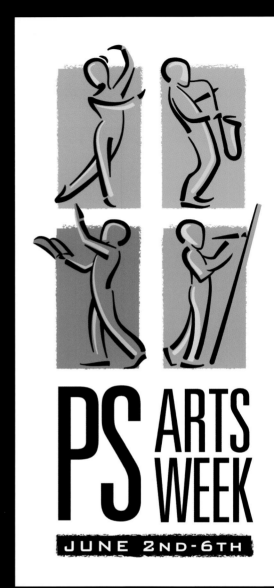

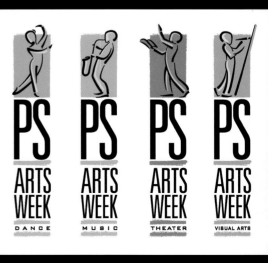

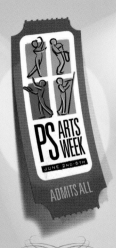

CELEBRATION OF THE ARTS

AN EVENING TO CELEBRATE THE CREATIVE SPIRIT
OF NEW YORK CITY'S PUBLIC SCHOOL KIDS

MONDAY, JUNE 2, 2008, 5:00PM TO 7:00PM
RUTH AND HAROLD D. URIS CENTER FOR EDUCATION
THE METROPOLITAN MUSEUM OF ART
FIFTH AVENUE AT 81ST STREET

Presented by The New York City Department of Education,
The Fund for Public Schools and Studio In a School, in collaboration with
The Metropolitan Museum of Art, and proudly underwritten by Bank of America

CELEBRATION OF THEATER

AN EVENING TO SHOWCASE THE THEATER PROGRAMS
OF NEW YORK CITY'S PUBLIC SCHOOLS

THURSDAY, JUNE 5, 2008, 7:00PM
THE NEW VICTORY THEATER
209 WEST 42ND STREET

Presented by the New York City Department of Education
and The Fund for Public Schools, and proudly
underwritten by Bank of America

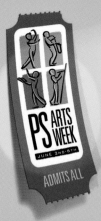

Celebrating Student Achievement In The Arts

The New York City Department of Education and The Fund for Public Schools are pleased to announce P.S. Arts Week, a week-long celebration of student achievement in the arts.

From June 2 – 6, New York City public school students will put their best work in dance, theater, music, and visual arts on display in marquee locations across the city. P.S. Arts Week will begin at the Metropolitan Museum of Art with an opening night reception to celebrate the annual Department of Education juried visual arts exhibition, which highlights outstanding artwork from New York City public school students. The partnership and support of Studio in a School have helped make this exhibition possible.

P.S. Arts Week salutes the outstanding work of our city's young artists and their teachers, and highlights the Blueprint for Teaching and Learning in the Arts , the curricular framework developed by the NYC Department of Education and cultural partners that sets clear standards for what students should know, understand, and be able to achieve in dance, music, theater, and visual arts as they move from pre-Kindergarten through the twelfth grade. Check back soon for new information about venues, times, and performances for our exciting line-up of events.

Office of Arts and Special Projects

OASP provides New York City public school communities with information and resources that will enable every student to achieve a full education in the arts, guided by New York City's Blueprint for Teaching and Learning in the Arts, PreK-12.

The Fund for Public Schools is dedicated to improving New York City's public schools by attracting private investment in school reform and encouraging greater involvement by all New Yorkers in the education of our children. For more information, please visit The Fund for Public Schools

 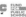

1

ORGANIZATION
Children's Theatre Company

CREATED BY
Victoria Aksamit, Jill Milbery, Ryan Floss, Meenal Patel, Todd Paulson
KNOCK inc.
Minneapolis, MN

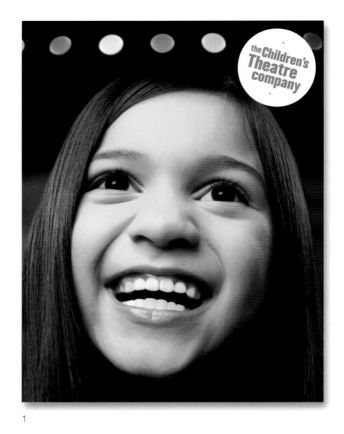

1

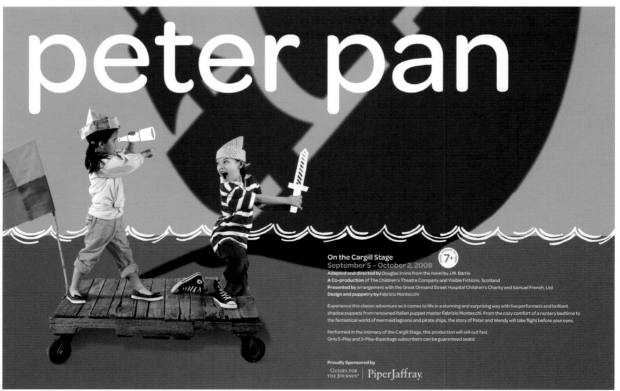

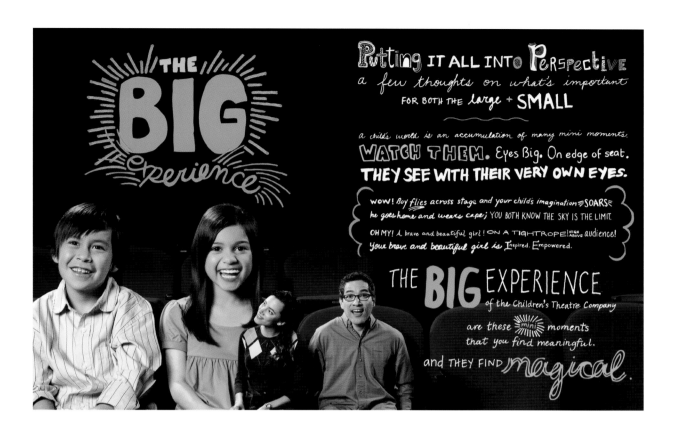

1
ORGANIZATION
Baalbeck International Festival
CREATED BY
Nelida Nassar
Nassar Design
Brookline, MA

2
ORGANIZATION
Colette Naufal
CREATED BY
Nelida Nassar
Nassar Design
Brookline, MA

3
ORGANIZATION
Music for Lifelong Achievement
CREATED BY
Jerry Gennaria, Dan Smith
Paradowski Creative
St. Louis, Missouri

1

2

3

1

ORGANIZATION
Girls Rock Productions

CREATED BY
Joshua Berger, Erica Reininger,
Nicole Weingart
Plazm
Portland, OR

1

1

ORGANIZATION
Central Pennsylvania Festival
of the Arts

CREATED BY
Lanny Sommese

Sommese Design
Port Matilda, PA

1

ORGANIZATION
American Conservatory Theater

CREATED BY
Zach Hochstadt, Jennie Winton,
Tine Reese, Ozzie Thoreson

Mission Minded
San Francisco, CA

1

1 • 2 • 3 • 4 • 5

ORGANIZATION
Young Chicago Authors

CREATED BY
Dawn Hancock, Will Miller,
Antonia Garcia, Andy Luce

Firebelly Design
Chicago, IL

YOUNG CHICAGO AUTHORS

1

2

3

4

5

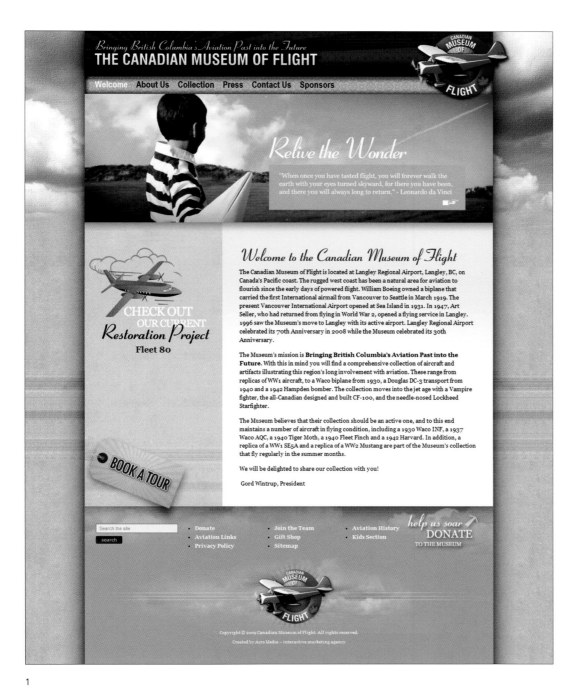

1

ORGANIZATION
The Canadian Museum of Flight
CREATED BY
Jason Poole
Acro Media Inc.
Kelowna, British Columbia

2
ORGANIZATION
Quad City Symphony Orchestra
CREATED BY
Jared Johnson, Eugene Phillips
EP Designworks
Suffolk, VA

2

1

ORGANIZATION
Contemporary American
Theater Festival

CREATED BY
Francheska Guerrero

Unfolding Terrain
Hagerstown, MD

1

1

ORGANIZATION
Oxbow

CREATED BY
Michele Brautnick, Tim Calkins,
Beth Eckhardt

People Design
Grand Rapids, MI

1

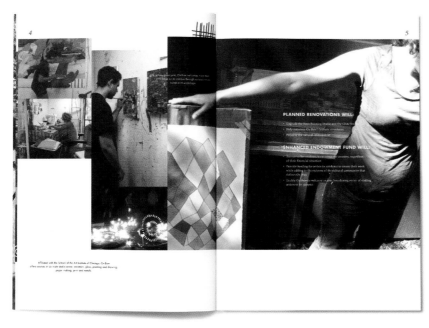

SPOTLIGHT ON
CREATIVE PITCH

**DIAN SOURELIS
NILS BUNDE**
BRAINFOREST
CHICAGO, ILLINOIS

The very name of Dian Sourelis' and Nils Bunde's creative agency, Brainforest, conjures "green." However, there's more to it than just a word. Sourelis, the Chicago agency's Vice President and Director of Sustainable and Community Initiatives, recalls a turning point for the environmentally conscious firm. "Four years ago, while moving our office, we realized we had a lot of really nice stuff," she says, "so we took it to our local school. The art teacher was in tears. We're a twelve-person agency and we thought, 'If we have all this, others must too.'"

That donation became the seed for Creative Pitch, an ongoing program through which the Chicago creative community—individuals, design and ad agencies, paper mills and printers—donate their unused or unwanted materials for distribution to underserved art programs—programs where at least eighty percent of the students live at or below poverty level. Creative Pitch has served over seventy organizations since early 2006, including schools, art therapy programs, afterschool programs and shelters.

"We have two criteria," Sourelis explains. "One, the recipient has to be a degreed art teacher. This is not for craft or play. We are working to help organizations support art education at the highest level. And two, the materials have to be of good quality. High-level, high-quality, *beautiful* materials."

To ensure the continued integrity of the program, the Creative Pitch team monitors recipients regularly. "We visit every school," Sourelis says. "Teachers have to apply, pick [the materials] up and tell us what they plan to do with them."

Even though the vast majority of creations never get a public showing, Sourelis says, the impact is designed to be much more far-reaching. "We're educating the creative community to stop making all this *stuff*. There's no place to put it anymore, and it's so easy."

• • •
CREATED BY
Dian Sourelis, Nils Bunde, Drew Larson, Jonathan Amen

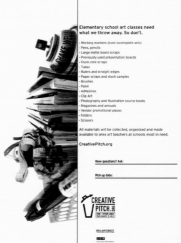

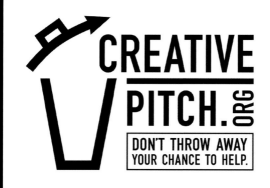

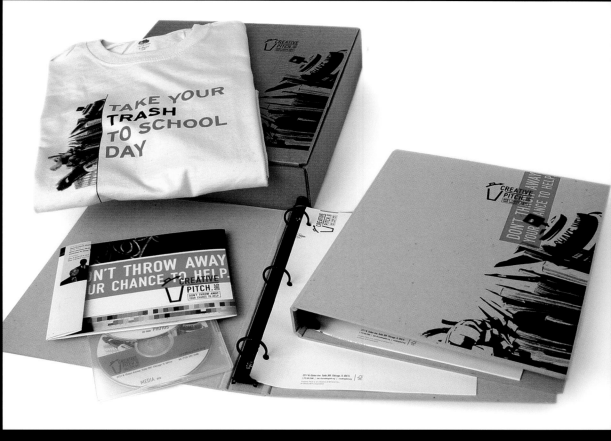

What is Creative Pitch?

In the normal course of business, advertising and design agencies, printers and paper suppliers go through volumes of materials, much of which ends up being thrown out in the day's trash.

To an art teacher, there's gold in those trash bins.

The goal of Creative Pitch is to get this useable material into the hands of art teachers. Individually, many firms do something similar during "spring cleaning." Keep it up. But three elements make Creative Pitch different: coordination, efficiency and timing.

Coordination – a single point of contact for collection and distribution, ensuring a continuous, well stocked supply of materials.

Efficiency – materials are sorted and made available to pre-qualified school art programs, to ensure the neediest schools* are taken care of first.

Timing – whenever our teachers need help. 12 months a year.

*All materials are made available to those art teachers identified by the program as being most in need based on per pupil annual budget and student income levels as reported by each receiving school.

INDEX AND DESIGN DIRECTORY

SPECIAL THANKS

To all of the talented people who brought this book to life:

Jenny Daughters, Cleveland Design
Jenny Goeden, Cleveland Design
Nancy Heinonen, Crescent Hill Books
David Hessekiel, Cause Marketing Forum
Eve Bohakel Lee, Lee Copywriting
Adamo Maisano, Cleveland Design
Lynn McNamee, Cleveland Design
Aynsley Tungate, Crescent Hill Books

To all the wonderful people who have contributed to our success over the years:

Sharon Alama	Joanne Gold	Joe Nardone
Rebekah Albrecht	James Grey	Germana O'Brien
Katie Anderson	Sylvia Hampton	Liz Page
Jeff Arcuri	Ricky Hoyt	Michael Page
John Basile	Jay Hutchinson	Andy Paul
Monrüd Becker	Nan Ives	Debbie Reiner
Ilise Benun	Peggy Jefferson	Ellen Rudy
Lauren Capers	Audra Keefe	Karen Schakarov
Anna Cleveland	Leah Kim	Logan Seale
Wayne Cleveland	Midge Kirby	Hywel Sims
Marcelo Coelho	Lee Lavi	Douglas Spencer
Cynthia Cunningham	Shachar Lavi	Susan Stockton
Bella Delia	Tom Leavitt	Jim Stone
Michael Delia	Katy Listwa	Tirana Swisa
Maureen Doerr	Nancy Machemer	Ahuva Top
John Giglio	Nina Madjid	Reuven Top
Rhonda Glasscock	Colin McLain	Sabrina Lola Top
Deneen Georgette	Bryn Mooth	Julie Vail
Karla Goethe	Steve Morris	Kathleen Wilson